Praise for *Making Masterpiece*

"In the world of TV drama, names and faces appear and disappear with bewildering speed; Rebecca Eaton is immortal and immutable. . . . [She] has made an enormous contribution to the cultural life of America, and, more than that, she is one of the most fun people I know."     —Andrew Davies, *Vanity Fair*

"Eaton weaves an absorbing tale of what began as just a young girl's Anglophilia but would eventually change the viewing habits of Americans. . . . Though the book's most compelling moments are culled from the battles Eaton waged as producer, she manages to put everything in perspective as a highly successful working mother who had plenty to fight for at home as well. . . . In the end, Eaton looks back with unflagging fondness at her life's work and the spectrum of experiences it has brought her."
—*The Hollywood Reporter*

"Eaton recounts these tales with zest."        —*McClatchy-Tribune*

"[An] anecdote-filled memoir . . . Rebecca Eaton looks back on twenty-five fascinating years at *Masterpiece Theatre* and *Mystery!* at PBS."    —*USA Today*

"A treasure house of anecdote and insight, observation and object lessons, *Making Masterpiece* is quietly electrifying."        —*Shelf Awareness*

"[A] thoroughly engaging memoir . . . Eaton is a warm and witty guide to *Masterpiece Theatre*'s storied history, and this lively memoir will appeal equally to *Downton* diehards and longtime *Masterpiece* loyalists."      —*Booklist*

"In addition to these sometimes charming, sometimes bawdy anecdotes, Eaton brings a strong personal element to the narrative. . . . She is able to humanize what is sometimes seen as an impersonal area of the showbiz world. . . . A pleasing blend of memoir and retrospective with a wide audience appeal."
—*Library Journal*

"A delightful trek into the world of TV production and a substantive treat for the truly addicted PBS fan."        —*Kirkus Reviews*

"Rebecca has been the executive producer of *Masterpiece* for twenty-five of its forty years. We Americans are fortunate to have Rebecca at the helm: someone committed to bringing great television drama to the widest possible audience, week after week."        —Gillian Anderson, The 2011 *Time* 100

PENGUIN BOOKS

# MAKING MASTERPIECE

Rebecca Eaton regards her decades-long stewardship of *Masterpiece* as the ideal job for the daughter of an English professor and an actress. She has been the executive producer of the show for twenty-eight of its forty-two years on the air. Awards on her watch include forty-three prime-time Emmy awards, fifteen Peabody awards, two Golden Globes, and two Academy Award nominations.

At *Masterpiece Theatre* and *Mystery!* she extended the programs' reach with contemporary dramas; initiated coproductions with the BBC (*Middlemarch*, *The Buccaneers*); coproduced feature films such as Jane Austen's *Persuasion* and *Mrs. Brown* starring Dame Judi Dench; and oversaw the rebranding of the series in 2008. Queen Elizabeth II awarded her an honorary OBE (Officer, Order of the British Empire) in 2003.

She lives in Cambridge, Massachusetts, and spends time at the family house in Kennebunkport, Maine.

# MAKING MASTERPIECE

25 Years Behind the Scenes at

*Sherlock, Downton Abbey, Prime Suspect, Cranford,*

*Upstairs Downstairs,* and Other Great Shows

## Rebecca Eaton

*with*

PATRICIA MULCAHY

PENGUIN BOOKS

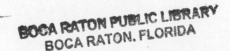

PENGUIN BOOKS

Published by the Penguin Group
Penguin Group (USA) LLC
375 Hudson Street
New York, New York 10014

USA | Canada | UK | Ireland | Australia | New Zealand | India | South Africa | China
penguin.com
A Penguin Random House Company

First published in the United States of America by Viking Penguin,
a member of Penguin Group (USA) LLC, 2013
Published in Penguin Books 2014

Illustration credits appear on page 301.

THE LIBRARY OF CONGRESS HAS CATALOGED THE HARDCOVER EDITION AS FOLLOWS:
Eaton, Rebecca, date.
Making masterpiece : 25 years behind the scenes at Masterpiece theatre and
Mystery! on PBS / Rebecca Eaton  with Patricia Mulcahy.
pages cm
Includes index.
ISBN 978-0-670-01535-1 (hc.)
ISBN 978-0-14-312604-1 (pbk.)
1. Eaton, Rebecca, date. 2. Television producers and directors—United States—Biography.
3. Masterpiece theatre (Television program) 4. Mystery! (Television program)
I. Mulcahy, Patricia. II. Title.
PN1992.4.E25A3 2013
791.4502'32092—dc23   [B]   2013017055

Printed in the United States of America
1  3  5  7  9  10  8  6  4  2

Set in Adobe Garamond Pro
Designed by Amy Hill

*For*
*Katherine Emery Eaton*
*and*
*Katherine Emery Cooper*

# PREFACE

## *Kenneth Branagh*

I vividly recall meeting Rebecca Eaton for the first time in January 1988 in the foyer of the Beverly Hills Hotel. A group of British actors, producers, and directors, myself included, had all flown to Los Angeles, but our plane had been delayed by six or seven hours.

On touchdown, we'd rung her to ask, "Is it still going ahead?"

Rebecca said, "Can you guys still do it?"

We said yes; we'd had a very jolly time on the plane. It was my first trip to Los Angeles, and we were all pretty giddy. I was twenty-seven.

When we eventually arrived at the hotel, Rebecca was standing in the foyer welcoming us, checking if we were good to go after the quickest of quick showers. What I saw was a very classy dame, a very beautiful gal, and somebody whose spirit was unflappable. There was a kind of positive, robust show-biz element to her—nothing threw

her. She had a sense of humor about it. Other people would have been very stressed, but she seemed to think this might be a fun evening.

And so it turned out to be, because we went into dinner with hundreds of television critics, and Emma Thompson, James Cellan Jones (the director of *Fortunes of War*), John Thaw (there to promote *Inspector Morse*), and a number of other people were not only at tables having dinner with some of the critics—we also performed an informal show. Emma sang a song, and I gave some kind of speech. Generally there was a sense that entering Rebecca's atmosphere in this kind of circumstance had a celebratory quality, which has been part of my impression of her ever since.

One of the things that also struck me about her is that for someone who on the surface would appear to be a devoted Anglophile (which she is), she also seems to me to be resolutely American. I've always felt that her taste and critical judgment about what she presents, what she invests in with *Masterpiece*'s money, gives you an interesting insight into the way smart Americans view the Brits.

She has enthusiasm and passion but no slavish worship of all things European or British, no hushed, uncritical admiration of what the Brits do. She casts an appropriate critical eye over what she chooses to present. She knows that the American public won't lap up just *anything* British, or *anything* period on television, without judgment.

Quite the opposite: the *Masterpiece* audience is a highly intelligent and passionately point-of-viewed group. I always felt that Rebecca has a kind of vitality, infusing sharpness and wit to the way things are promoted and to the programs themselves: there's a sense of fun around them. She has fun with the way the Brits are, and she has fun with the way the Americans see the Brits, not only through the vehicle of the programs but even in the way she meets actors and directors and everybody who has the good fortune to go to America to promote their shows.

There are dangers inherent in the word *masterpiece*, but she and her staff have been very inventive and imaginative, making sure that the name itself doesn't suddenly evoke something museumlike or too dry. You have a real sense of a personal point of view in their work.

Rebecca has maintained that passionate and witty approach to *Masterpiece* right across time. She has that gift of enthusiasm and curiosity; and as a result, she's had a big impact on the careers of a lot of British actors. Work on *Masterpiece* is sometimes the only way they have the great luxury of going to America and finding out how people there view their work.

And for many actors, it also happens to be a transition. Appearing on *Masterpiece* can be part of a journey to working more internationally and being seen by a very discerning audience. Rebecca has been a very vigorous and vital custodian of performances that can be seen by an audience that really demonstrates its loyalty—a loyalty, support, and interest she's never taken for granted.

An ability to be vigilant about that, to maintain your enthusiasm and a critical faculty, yet still convey joy and intelligence and wit about what you're doing, and therefore making other people feel the same way about it—never giving in to, "Here's season seventeen, twenty-two, twenty-five," or whatever it is—is a great tribute to an unflagging artistic vitality that sustains all the other hard work it takes to maintain a show like *Masterpiece*.

You're not going to have a *Downton Abbey* every five minutes. You'll be showing some material that's interesting but that might not automatically appeal to that many people. *Masterpiece* has banged a loud drum for a very long time in a way that's still resounding—confirming that television can reach a lot of people with work that might not otherwise be seen so easily.

Rebecca has the toughness a producer needs. If you want to sustain a project, or something that's become an institution like *Masterpiece*,

whilst acknowledging at all times that its longevity is not guaranteed, you need to know when to say no and when to push back a little. She certainly has that capacity to charm, to be bossy and persuasive and curious; but ultimately, you feel that she's on your side—that indeed, she's trustworthy, a friend, someone with whom you can have fun. Promoting shows for *Masterpiece* was never a chore.

Though Rebecca is unquestionably leading the charge, she's a smart enough boss to let other people do lots of talking. Whether it's presenting material, or imagining campaigns and artwork and posters, or introducing new titles, or bringing people in if it's an unknown novel or a difficult set of characters or strange accents, you have to be alive to it and have a team around you who are going to enjoy delivering it. The program, the institution, and the many strands of *Masterpiece* punch way above their weight.

I say, well done, Rebecca, and thank you very much.

# CONTENTS

# CONTENTS

# PROLOGUE

On a warm summer day in 2009, I was sitting on the screen porch of my house in Kennebunkport, Maine, reading an American novel, and falling asleep. My phone rang with a call from Laura Mackie, the head of drama at ITV, the largest commercial network in the U.K. She often tips me off to new British series that I might be interested in for *Masterpiece*. We chat, catch up.

"Rebecca, do you know Julian Fellowes?" she asks.

Just as a writer, I say: *Gosford Park*? *Mary Poppins* on Broadway? I know his work, but not him.

I think he's an actor as well.

She tells me about an upcoming miniseries he's written that she's very excited about: a family saga set on a spectacular country estate, early 1900s; an American heiress whose money keeps things afloat; beautiful frocks; a downstairs "family" of complicated servants. She tells me directly that she thinks it's going to be very good, and that the production needs *Masterpiece* co-production money to fill the financing gap. I've known and liked Laura for years. She has good taste and very savvy television judgment.

I listen, and then I think to myself that the project sounds a lot like a combination of Edith Wharton's *The Buccaneers*, which we'd already done in 1995, and *Upstairs, Downstairs*, of which we'd aired sixty-eight episodes from 1971 to 1975, and which we're about to remake with the BBC. Does *Masterpiece* really need another aristocratic-family-charming-servant miniseries at this point?

Probably not.

I tell Laura, no thanks. We chat about the London weather, and I go back to my book.

I've been very, very lucky in my career, in spite of myself.

# MAKING MASTERPIECE

# ONE

# Letters from Maine

I'm writing this book in that same old house in Kennebunkport. It's where I lived during the summers with my parents, and later with my husband and my daughter. My parents' names, like my husband's and daughter's, were Paul and Katherine. But none of them are here now.

It's a beautiful old house with lots of character, frustrating plumbing, and hallways that take you places you don't expect—it's been added on to for two hundred years. It's a little labyrinthine and spooky because you often don't know who else is in the house when you are . . . and I don't just mean invited guests. My brother and nephews swear there are ghosts; once a psychic, unasked and unhelpful, said that someone was murdered in one of these rooms. So there's history here, of all the families who've lived in this house since it was built in 1800. Big things must have happened here, as they did while my parents were in the house. Their lives had plenty of drama.

My mother, Katherine Emery, was an actress whose career ranged from playing the leading role in Lillian Hellman's *The Children's Hour*

on Broadway in 1932 to appearing as a contract player at RKO in Hollywood in the 1950s, when she had parts in genre films like *Isle of the Dead* with Boris Karloff. Now my daughter Katherine, named after her grandmother, is in theater too.

My father, Paul Eaton, taught Shakespeare and loved the language of the plays. He read history, biography, murder mysteries, and maybe the occasional novel. He was the class poet in his graduating class at Exeter and hoped to go to Harvard to study English. But his father insisted he go to MIT to study naval architecture. Belly-button design, as my father called it. He loved boats and could recite vast amounts of poetry.

I'm telling you about my family and our house because I've got to start somewhere. I've been asked to write a book about *Masterpiece*. It seemed doable at first, but then they asked that it be a book about my life too: *Masterpiece*'s memoir, and mine.

If you're brought up being told not to "make a spectacle of your-self" and not to "draw attention to yourself," how do you go about writing a memoir?

A memoir? I'm sixty-five, but I think I'm thirty-five—way too young to write a memoir. And I haven't kept a journal. My friend Annie snorts at the idea: "Becca, you don't remember *anything*!"

But this is an enviable problem: who gets the opportunity to look back on her life's work and tell it publicly?

The memories that do return are random, and they refuse to fall into any order. Why am I remembering the evening I met Princess Margaret and chose to wear my daughter's plastic barrettes, her "pret-ties," just because I missed her so much? Or the time the head of drama at the BBC, sitting across from me in a difficult meeting, got up from his chair and walked *over* the coffee table and out the door, never to return? Or the matchmaking conversation I had with Bene-dict Cumberbatch at the Golden Globes? The hours and hours of

reading scripts and talking on the telephone merge and seem impossible to animate.

But even as I procrastinate, I love being in this house. I feel very comforted here: in spite of the ghosts, it's the light, the air, and the seasons that make it feel so welcoming. The sun comes into the kitchen, into my bedroom, over the beach, in exactly the same way I remember it did in 1969, when I graduated from college, and in 1986, the year my daughter was born. It shines down on this house and on this town in exactly the same way it did in 1900, when my grandparents were here.

So I've spent a summer rattling around this house with a head full of *Masterpiece* memories. I have a deep desire to do anything besides write this book: I do laundry, pull weeds, go to the dump, make vats of vichyssoise, and then read other people's memoirs and despair because they are so good. I become obsessed with Alexandra Fuller's *Cocktail Hour Under the Tree of Forgetfulness.* I Google everything about her life in Africa and begin to cast the TV miniseries in my head. I cook and eat a lot of lobsters. I don't work on the book.

One afternoon I unearth some disintegrating cardboard boxes and decide to go through them. I find bundles and bundles of letters and photographs of things I've never seen before: glass slides of my father as a two-year-old in a dress in southern New Hampshire; pictures of my mother as a tomboy in Alabama, surrounded by black servants, and then as a very young and beautiful actress. I unearth clippings and reviews for all the plays she ever did, and letters to, and from, her family. I find the eulogy from my grandfather's funeral; I never knew him. I find notes from bouquets sent to my mother on opening nights.

And then I find every letter my father wrote to my mother from soon after they met in the late 1930s, until their marriage in 1945, when my father was thirty-nine and my mother was thirty-seven.

Some of my father's letters are half-eaten by mice. Some are so stained, you can't read them; my mother's handwriting is practically impossible to decode.

In these letters I find out things I didn't know. My parents' love affair and courtship were long and fraught. As a man of his time, my father didn't go into emotional detail in the letters, but I can tell that my mother was ambivalent about giving up her career to marry him. In fact, she seems to have been ambivalent about marrying him at all. There were other men in her life, as there were other women in his. He tries to talk her through "tough passages."

My father sought my mother hard: he truly courted her. He waited six years. In one of the very earliest letters, he is clear that he is ready to get married even then. But they don't actually marry until they are both nearly forty. She kept him at bay. In his letters he remains steady and cheerful, eager to get on with life as he fights for her. There are very few letters from my mother to my father from that time—she was a successful actress in New York, and he was teaching in Boston.

In my father's letters I hear his voice very clearly: he is loving Maine, loving New England, loving my mother. Her voice is hard to hear.

Then—and this part I've always known—they dramatically eloped, days before he was shipped out to the South Pacific during World War II. They had said their good-byes in New York when my father left for the naval base in San Francisco. But my mother suddenly changed her mind, found the last berth on a westward-bound train, and joined him. *Good drama for television*, I think.

They were married, by themselves, at the Treasure Island Naval Station in San Francisco Bay and spent four days at the Mark Hopkins Hotel before he left for a year. When my father came back, my brother, James, was three months old. There are dozens of letters from that year.

It's a long and complicated story, and I'm riveted. This wonderful trove shines a new light on my parents. I'd never really thought about my mother as a woman in her thirties and forties. I always thought she was glamorous, and that was enough for me.

Suddenly I see her at thirty, moody and elusive, not just the beautiful movie star I'd bragged about. Through the letters, I see her struggling to be happy, even as she enjoyed terrific success and the attentions of many men. Though she *was* very beautiful, I think self-doubt was there early too. Later in her life it overwhelmed her. I remember that part.

I see my father heroically pursuing the love of his life, in spite of her deeply discouraging reluctance. He's not just the jovial, multichinned "Daddy" all my friends loved. There's another man inside that man.

It all begins to swarm together in my brain. I realize that right here, in this old house, I may have found the answer to the paralyzing question, How do I write this book? Maybe I've tripped over the really important thing—the stories, and the stories *behind* the family stories that we all have. The ones told over and over—and then the mysteries and secrets. Isn't that what fascinates us about *The Forsyte Saga*; *Bleak House*; *Upstairs, Downstairs*; and even *Downton Abbey*? Isn't that why we're so drawn to books and dramas, even years after they've been written?

So as I read the letters and spread them all over the house in Maine, I relate them not only to my own life but also to the work I do. If you could distill the essence of *Masterpiece*, it might be that it is stories about families. Family stories are sagas: love, betrayal, money, infatuation, infidelity, illness, family love, and family deception. Those stories are our own stories writ large, usually with happy endings, and usually in times and places much more exotic or melodramatic than our own.

And that is what I love most in the world—stories. I love them on

television, I love them in books, I love them in movies, and I love hearing them from the person I'm sitting next to at a dinner party. We all have them, but we forget they're any good or have any rhyme or reason until someone new asks us, with real interest, to tell them who we are.

In this house in Maine, I feel surrounded by stories: my own, my parents', my daughter's, and the ones I put on television. I love them all.

For me, and maybe for you, books and dramas about families and romance have been relaxing and entertaining, but sometimes they've also been painkillers or anesthetics, when family life, self-doubt, lack of romance, or a romance gone badly just hurts too much. I comfort myself with stories that are full of wisdom, wit, and good writing. They provide relief from the difficulties of making a living, having a family, maintaining relationships, and living a life with meaning.

Brought up on a steady diet of classic British literature, I'm amazed at the inevitability of the fact that my life's work has turned out to be as a purveyor of this particular opiate. The kind of drama we do on *Masterpiece* tends to be uplifting—the guy gets the girl, people escape jeopardy, justice is served, and the mystery is solved. But there's something else, something perhaps more worthy: maybe the dramas are uplifting because of the exemplary quality of the writing, the acting, and the production values.

It's not easy to describe the feeling you get when you're in the presence of something well done, the aesthetic reaction you have to a fine ballet, work of art, piece of music, book, or performance. It's a mysterious thing that lifts you and opens you and makes you feel better. It's a very specific and strange connection. I'm sure many thoughtful books have been written about this.

Going for those moments is the reason I like being in this business. The moments are rare, but I would argue that over the years, there have been more of them on *Masterpiece* than on most other

places on television. A perfectly written scene, a moment of transcendent acting, a delicately lit drawing room. . . .

But, I still have to write this book.

In a panic, I call dear Russell Baker—journalist, memoirist (*Growing Up*), *Masterpiece* host, and calming, steady friend—and ask him how to do it. "Keep it simple," he says. "Avoid Latinate and use plain English. Figure out a good beginning and a good ending, and just tell stories in between."

My daughter Katherine, a performer like the grandmother she never met, says, "Just lean into it. Creativity hurts."

Steven Ashley, *Masterpiece* senior producer and a consigliere of thirty years, says, "You can't executive-produce this book. You can't get other people to do it. You have to write it yourself. So hush up and do it."

And I hear my friend Alistair Cooke's unmistakable voice, impatiently explaining to me for the thousandth time how he managed that inimitable style of storytelling in his radio broadcast *Letter from America* and in his introductions to *Masterpiece Theatre*: "I always think of myself as speaking to one person, as if in conversation. Ignore the fact that thousands of people are listening."

So let me tell you some stories.

# TWO

# The Curtain Rises

*Masterpiece Theatre* would never have been born without the 1969 broadcast of *The Forsyte Saga*, a British drama based on John Galsworthy's novels. Remember the lovely, elusive Irene (pronounced "I-REE-nee," not "I-REEN"), relentlessly pursued and eventually raped by Soames Forsyte in the marital bedroom?

Galsworthy, a Nobel Prize winner, wrote a trilogy of novels that follow a successful British family from the 1870s to the 1920s, just as the Industrial Revolution begins to give way to the modern world: the gentry have to adapt to the fact that the sun *will* set on the British Empire. *Downton Abbey*? How many future *Masterpiece Theatres* will till this same garden? How much do we love to hear family stories, again and again?

It's hard to overstate the impact of that broadcast of *Forsyte*: audiences in forty countries adored the twenty-six-part series, as they did in the United States. It aired on NET, National Educational Television. (PBS was still a few months in the future.) At that point "dramatic

serials" were cheesy genre pictures or soap operas. The term seemed to mean schlock, no matter how it was presented. The whole idea of a "limited series" like *Forsyte* had appealed to none of the executives at American networks when it was pitched. They all turned it down, except for NET—even though its main offerings at the time were documentaries and academic courses. *Forsyte* was a blockbuster. Everyone now remembers it as the very first *Masterpiece Theatre* presentation, but it wasn't. *Masterpiece Theatre* didn't yet exist.

My mentor Henry Becton (much more about him later) points out, "The notion that well-produced drama based on literature was a good fit for educational television, as it was then called, began to show us that we could do more than illustrated lectures. After all, Julia Child had great expertise and authority but presented herself in a very entertaining and conversational way that spoke to everybody."

And *The Forsyte Saga*'s success among the "intelligent audience" proved that you could show compelling long-form drama. American network TV at that time was mostly weekly series, movies rerun, and sitcoms. This was before prime-time soap operas like *Dynasty* and *Dallas* and before the dawn of the miniseries.

*Forsyte* was a revelation. Without it, there might never have been *Rich Man, Poor Man* (1976) or *Roots* (1977)—or *Masterpiece Theatre*. The audience numbers it commanded were huge. People canceled evening plans and stopped answering the phone on the evenings it aired.

The game was on; but how to build on the success of *Forsyte*? This was serious. NET had no idea what it had gotten into or what it was going to get out of it.

"Imitation is the sincerest form of television," as Fred Allen said.

WGBH, the Boston affiliate of what was now PBS, was ready to step up—to try harder, as Avis used to say, because Boston, that center of culture and higher education, had originally been passed over when the Ford Foundation set up three production centers: New York,

L.A., and Washington got the nod. It was a savvy executive in New York who had taken the flier on *The Forsyte Saga*.

So who had the idea to grab this tiger by the tail and turn it into a series called *Masterpiece Theatre*? This was all long before my time. Getting the true story of what happened next is tricky. In this instance, success truly had many fathers. Here are a couple of versions from a few of the Fathers.

Christopher Sarson, an Englishman who had been working in children's and educational programming at WGBH, tells it this way: "In June 1970, Stanford Calderwood was hired as the president of WGBH. When he'd been an executive vice president at Polaroid, he'd had considerable experience finding television programs for sponsorship, like the Julia Child cooking series. He also went to England frequently with his wife, Norma Jean.

"Calderwood arrived in the summer and was gone by November 1970. But in that short time he very much wanted to make a name for himself in public television. When I mentioned the idea of taking on more British serialized drama, he leapt at the idea. At that time the BBC was very keen on expanding their presence abroad. They were very taken by the fact that *Forsyte Saga* had been on public television and were very receptive to the idea of someone doing this on a sort of permanent basis."

But according to Henry Becton, then a producer and eventually the president of WGBH, "There's evidence in the files that Calderwood and Norma Jean had already gone to London in the months *before* he took the job, and that he cold-called at the BBC to view tapes of dramatic programs."

Whichever.

Calderwood told BBC executives that if they cut him a deal, he'd find a sponsor to underwrite a program in the United States that would showcase imported British programs. Everything on the new

public broadcasting network needed a corporate sponsor. PBS had come into being, but it was a minimally funded network of just under 200 member stations (there are now 354). Then as now, there was never enough money.

Another Father was Frank Gillard, a BBC television and radio program executive and a frequent consultant to U.S. public television. In a letter written in 1994, when he was eighty-six, he described in detail how *he* had given Calderwood the idea for *Masterpiece Theatre* during the intermission of a Boston Pops concert. An enthusiastic Calderwood had invited Gillard and WGBH's program manager, Michael Rice, to his house in the country the next day, where Gillard voiced concern that no one planned to build upon the achievement of *The Forsyte Saga*.

Back to Henry Becton's version: "At Calderwood's instigation, Michael Rice then assigned Christopher Sarson, who'd been voicing a similar concern, as executive producer of the new show even before a sponsor had been found."

Finding a rich patron would prove to be no easy task. Calderwood made the rounds with videos of the premier episodes of *Vanity Fair*, *Portrait of a Lady*, and *The First Churchills* but was turned down by the first ten or fifteen prospective funders. Finally he was introduced to Herb Schmertz, head of public relations at Mobil Oil.

He was exactly the right guy to meet. Before he joined Mobil, Schmertz had been a labor lawyer specializing in arbitration. And he'd been active in John F. Kennedy's and Bobby Kennedy's presidential campaigns. He was sharp and worldly, loved sophistication, and recognized that the trove of British programming could become a new high-quality brand and, by association, could make Mobil look classy.

Many people credit Herb Schmertz with originating a notion called affinity of purpose marketing. When you associate your corporation's brand with something people love, they feel much kindlier toward you. And buy your product. As Henry Becton points out, "At

that time Herb was looking for vehicles to do this for Mobil. Their goal was to build goodwill not just with the general public but also among those with influence in terms of government and regulation. It was partly a public relations strategy and partly a government relations strategy."

Schmertz asked Stan Calderwood to come and help him pitch the idea of a new show of imported British drama to his boss.

Mobil CEO Rawleigh Warner, Herb's boss, asked them, "Is this the kind of show that people are going to be talking about the next day at the country club?"

Herb said, "Absolutely."

Calderwood proposed that Mobil fund thirty-nine hours of already-made BBC drama for about $390,000, to be run nationally. (The final purchase price was $375,000.) As Schmertz says, "Even in 1970, that was an absurdly low figure, so I was eager to learn more. My management thought it would be a good thing to associate Mobil with public television by underwriting a show like this."

Soon they had a deal.

Compared to the cost of a single hour of commercial television, what Mobil kicked in was very short money. To this day, *Masterpiece* is a kind of financial miracle. You probably couldn't produce one hour of *Mad Men* for the amount of money we pay for a dozen hours of programs with high production values, glorious costumes, and faraway landscapes.

So no matter which Father said what to whom or when, the program that became *Masterpiece Theatre* was an idea whose time, and more importantly, whose sponsor, had come.

"What was extraordinary," Chris Sarson recalls, "was that by the end of October 1970, we were just envisioning this program of British dramas on American public television, and in January 1971, it was on the air. It all came together so quickly."

Even more surprising was that the people in New York who had aired *The Forsyte Saga* so successfully *didn't* envision a follow-up. Henry Becton explains: "In their defense, they were in the middle of transitioning from being an educational network to being a local New York–based public television station. They were preoccupied."

Money for the first season of *Masterpiece Theatre* came both from Mobil and from the Corporation for Public Broadcasting, the federal funder of the newly formed PBS. No fewer than fifteen people made that first trip to London in the fall of 1970 to look at potential programs for the new series; it was a traveling circus.

But what to name this new baby?

When Stan Calderwood was shopping the series, the working title had been *The Best of the BBC*. It's a good thing they didn't pick that one, because over the years many of the most popular shows, like the original *Upstairs, Downstairs* and *Downton Abbey*, would come from sources other than the BBC. The Beeb, as the Brits fondly call it, often gets the credit for *any* English drama shown on American TV, but there are actually dozens of production companies and several broadcasters that have made many of the most memorable shows.

Sarson suggested the single word *Episode* as a title.

In the end, the program's iconic name derived from a combination of corporate strategy and national pride. "I think Herb Schmertz and his associate Frank Marshall at Mobil played a role in calling the show *Masterpiece*," Becton explains, "because they liked the idea of something alliterative with the word *Mobil*. And partly because Sarson was English, they all decided to call it *Masterpiece Theatre*, with *re* at the end in the British style."

Christopher Sarson adds: "Herb Schmertz in particular was upset by the *re* because he thought it was affected. But I said, 'No, this has to be distinctive. And it's an English-created series to begin with. It's got to be *re*.'"

To Sarson's dismay, *The New York Times* refused to acknowledge the English usage, always referring to the show as *Masterpiece Theater*: "I sent a letter to the style editor. He replied politely: *Theater* in *The New York Times* is spelled *ter* instead of *tre*."

And so it remained on the pages of the newspaper of record until *Theatre* was dropped in the rebranding of *Masterpiece* in 2008.

Sarson remembers what happened next: "NET didn't have an on-air host for *The Forsyte Saga*: it just aired the episodes. I decided we'd do an on-camera introduction to each episode, summing up what viewers had seen so far and telling them what they'd see this time. When everyone agreed that a host would be a good thing for the new series, it took me about five milliseconds to think of Alistair Cooke, whom I had known for a long, long time, partly because he went to what I *thought* was my father's school in Blackpool in the north of England, and partly because of his *Letter from America*, broadcast globally on the BBC's World Service."

Sarson might have also thought of Alistair as an ideal host for *Masterpiece Theatre* because of Cooke's visibility as the host of the popular cultural magazine show *Omnibus*, which had run on CBS once a week on Sundays from 1952 to 1961.

"When I called him [Cooke] to propose the job," Sarson says, "he politely declined, saying, 'Absolutely not. I'm putting together my own version of *The History of America* for the BBC, and I want that to be my next foray into American television.'

"So I asked, 'Do you have anybody else to suggest?'

"Being Alistair Cooke, he suggested half a dozen other people quite quickly.

"I said, 'Mr. Cooke, they're all dead.'

"He said, 'Yes, I know. But good luck in your search.' And he hung up."

Sarson interviewed other people, "though no one was a patch on

Alistair. A couple of weeks later he came to Boston and borrowed a WGBH crew to film his series *America*. I went along and tripped him up when he came back from lunch: 'Hey, let's have a drink afterward. You went to my father's school.'

"To which he retorted, 'No, I did not.'"

It turns out that there were two high schools in Blackpool.

"Weeks passed," Sarson continues. "It was now December 1. The opening episode of *The First Churchills* was supposed to air on January first, so we were really down to the wire. Just as the production assistant and I were going to lunch, the phone rang. It was Alistair Cooke to say he'd spent Thanksgiving with his daughter, and she'd convinced him that he should in fact take the job. He figured we'd found somebody else by then.

"The contract was signed, and we got him into the studio."

Alistair's daughter, Susan Cooke Kittredge, explains her father's decision to take the job: "Daddy was so proud of the *America* series: he'd put so much time and effort into its writing and production. Initially I think he thought that if he did *Masterpiece Theatre*, it would somehow interfere with *America*'s potential success. My view was that they'd have different audiences: one was on NBC, one was on PBS. Rather than detracting from each other, one might complement the other. Having them both on at a relatively similar time would increase the viewership for each program.

"I knew he would love hosting *Masterpiece Theatre*. It was so up his alley. He'd have a blast doing on the air what he did anyway at cocktail hour and at dinner parties—holding forth. On *Masterpiece Theatre* there'd be no one to interrupt him.

"We'd been discussing it all week, but as I recall he made up his mind on Thanksgiving—a time when the family had a chance to sit together and talk about things.

"After he went to the phone and called Christopher Sarson, he

probably came back and poured himself a celebratory glass of scotch. Hosting *Masterpiece Theatre* gave him an outlet for his love of the arts."

A complication arose when Sarson asked Alistair Cooke to record the credit for Mobil, and he refused. Cooke didn't want to be associated with any kind of commercialism. So for twenty-five years it was British-born Christopher Sarson who intoned: "*Masterpiece Theatre* is made possible by a grant from Mobil Corporation, which invites you to join with them in supporting public television."

And where did the glorious, famous *Masterpiece Theatre* theme music come from?

In 1962, when Chris Sarson was about to get married, "my wife-to-be and I got on a train run by Club Med in Paris and traveled to Sicily, where we stayed in straw-covered huts on the beach, where the waves washed us to sleep and woke us up in the morning. Up the hill was the main office of Club Med, where they served breakfast, lunch, and dinner. Before every meal, the music coming from the tower was 'Fanfares for the King's Supper,' written by a guy called Jean-Joseph Mouret. Being a good TV producer, I locked it away in my head for a future series.

"Eleven years later, when *Masterpiece Theatre* came along, I could not get this theme *out* of my head. But it was written by a Frenchman: how could you have a piece of French music for an English series? Even as I looked frantically through Purcell and Elgar and Handel, all the time this theme was in my head. Eventually we used it.

"About twenty years ago, *The New York Times* sent a reporter to Club Med in Mexico to do a report on the establishment. The reporter wrote that Club Med was a classy operation because they used *Masterpiece Theatre* music to summon people to meals."

The Fathers had come up with a name, a host, some catchy music, and a title sequence with a Union Jack flapping across the screen to make crystal clear the nation of origin. But what shows would *Master-*

*piece Theatre* broadcast? Where was the next family saga? What was this series going to *be*?

*The First Churchills* premiered on January 10, 1971. As Alistair Cooke famously said, it "was a lulu. Looking back on it, I sometimes marvel that it didn't strangle the program [*Masterpiece Theatre*] in the cradle."

Christopher Sarson chose that show, he recalls, "because it had the word *Churchill* in it, which would be familiar to Americans, and it starred Susan Hampshire, the star of *The Forsyte Saga*. I thought that carryover was important."

Taken from a book by Sir Winston Churchill about his seventeenth-century ancestors, *The First Churchills* had the "opening episode problem." Henry Becton explains: "In a multipart series you have to introduce a lot of characters and get them established, which is hard to do without confusing people and still get the plot moving along briskly at the same time. *The First Churchills* had it in spades, because everyone was wearing wigs. Their costumes all looked alike; you couldn't tell anyone apart."

The show got both good reviews and good ratings, Sarson recalls, "largely because of the way Mobil launched it. They had a big reception. They know how to take care of press people, and they offered a good press package, which in those days was not common in public television. They made damn sure the critics got tapes, and that they watched them."

Though *The First Churchills* wasn't great television, it established the series. And it was followed by excellent adaptations of novels by Balzac, Tolstoy, and James Fenimore Cooper, plus the favorite historical dramas *Elizabeth R* with Glenda Jackson and *The Six Wives of Henry VIII* with Keith Michell.

But success for *Masterpiece Theatre* was not universal and by no means instant. It didn't get chart-busting audiences every Sunday

night, but enough people started making it a part of their weekly routine to indicate a possible future for the series. Alistair Cooke was so uncertain about the show's appeal that he had signed only a one-year contract. He was also a creature of habit with a very careful lawyer. He signed only one-year contracts for the next twenty-one years.

*The First Churchills* nearly landed all those Fathers in jail, or at least got them called up on charges at the FCC. Very early on in the broadcast, a toothsome young woman rose, completely naked, from the bed of the Duke of Marlborough and walked briefly toward the camera.

The phone of the president of WGBH lit up. The man on the line was incandescent with rage and could barely spit out the words: "Do you realize, sir, that you have just committed full nudal frontity?!"

But the series was well and truly launched.

The year 1969 was not only the year that *The Forsyte Saga* gave birth to the idea that would become *Masterpiece Theatre*; it was also the year PBS was created, Neil Armstrong walked on the moon, and the amazin' Mets finally won the World Series. It was the year I graduated from college. August 9, 1969, was both the day of the Manson murders and the day I left New York for London to begin my job at the BBC. It's the date I mark as the intersection of my story and that of *Masterpiece Theatre*. I was twenty-one.

I remember being in a bookstore in Manhattan that day waiting for my night flight to London and hearing the cool, classical radio announcer break in with the news of the Manson murders in California. The world was moving full speed ahead, and there I was, looking for a British novel to read on the plane, searching for a way to be transported back to the nineteenth century. There was an odd logic to where I'd been, where I was headed that day, and where I would end up fifteen years later.

Drama was more or less inevitable in the house where I grew up. My mother, Katherine Emery, was born in Alabama in 1906, the product of a Yankee father from Maine and a southern beauty of a mother who was a lady who lunched, who had a cook and a driver—the life my mother could have had. But while she was a student at Sweet Briar College in Virginia in the 1920s, my mother began to act, and then she did some summer stock with the Surry Playhouse in Maine, and on Cape Cod with a group called the University Players, which included Jimmy Stewart and Henry Fonda. Growing up, hearing about this life, I idolized it.

Her life got even better when she began to get parts in Broadway plays. She had fabulous friends, handmade dressing gowns, and lots of beaux. She became famous. She was given the lead in the original production of Lillian Hellman's *The Children's Hour*. She was twenty-eight, and Lillian Hellman was just twenty-five. Hellman had written a red-hot play about two women who run a private school for girls. Their lives are shattered when one of the girls spreads a rumor, a lie, that the women are lovers.

The play was a controversial hit. My mother got solid gold reviews, nightly bouquets of flowers, and more gentleman callers. The play ran for two years and was banned in Boston. That was 1934. In 1938 she met my father on a beach in Maine, and the letters began.

He was a Yankee from New Hampshire. At that point he was teaching English literature at MIT in Boston and spending every spare minute either on the coast of Maine or trying to see my mother wherever she was. Their lives, their friends, and their interests were as different as chalk and cheese, as the British say, but they were deeply drawn to each other. And they were both plying trades completely made up of stories. His audience was students; hers was theatergoers.

Once my brother and I came along, we became their best audience of all. We loved hearing about the New York days, the romantic

four-day honeymoon in the Mark Hopkins Hotel, and my father's dramatic return from the war to a newborn son. I pictured it all perfectly and played that movie in my head over and over again.

In 1948 the family picked up stakes in Boston and moved to southern California, where my father had been offered the job of dean of students at Caltech. It was an adventurous and supposedly temporary transplanting, much like a British family being posted to another part of the empire. But we stayed for thirty years, and I grew up to be a dark-haired, bookish teenager in a land of blond, nut-brown surfer girls.

My mother had stopped performing on the stage, but by the time we moved to Pasadena, she was making movies. Altogether she made about a dozen movies for the studio RKO. She kept what you'd call "theater hours." When my brother and I got out of bed at seven or eight in the morning, she'd be gone, because it took hours to drive the fifteen miles from Pasadena into Hollywood then, all on small roads. At the end of very, very long days, she'd come home after we were asleep. I remember waking up as she kissed us good night in a dark bedroom with ivy wallpaper. Sometimes she slept till noon to recover.

By the early 1950s, my mother started to turn down parts. At forty-five, she wasn't interested in playing harridans, which was all that was on offer. I remember hearing her say no over and over again to her agent when he called.

I always thought my mother was a star, or at least more of a star than anybody else's mother. She may have been living a life that looked like the lives of all the other mothers in affluent Pasadena, but she had a past.

I think back and wonder if I ever wanted to be an actress. I don't think I dared to because I knew I'd never be as good as she was. I surely didn't want to challenge her for the lead. I was a bit player. In school productions, I was cast as a lineless member of the jury in *Inherit the*

*Wind* and as the maid working for the Boston family in *The Late George Apley*, and I appeared in the chorus of *Once Upon a Mattress*, although I couldn't sing. It was a small school—if I'd had any talent, I probably would have been force-marched into bigger roles. But I loved the productions: the auditions, the evening rehearsals, the stage makeup, and the addictive quality of stage fright and applause.

On Sundays my father and I would go to church, while my mother slept, and my brother probably got into some kind of trouble. I was the goody-goody; he was the "active child." I sang in the choir, though I couldn't carry a tune in a basket, just like my father. Afterward we'd go to the Rexall drugstore, where I'd buy *Photoplay, Modern Screen*, or *Silver Screen*. I couldn't get enough of the personal lives of my favorite stars, or of the terrible things that happened to them: Debbie Reynolds, Eddie Fisher, and Mike Todd and that awful plane crash— poor Liz!

As we sat at the counter, my father would have a cup of coffee, and I'd order banana cream pie and a Coke. Afterward in his office, he'd do paperwork while I sat in the dean of freshmen's armchair and read about Natalie Wood and Robert Wagner. On Sunday afternoons my father would take me to the movies, usually a double feature featuring some of my favorite stars, like Doris Day and Rock Hudson. The movies would put me in an altered state. I remember coming home from *Love in the Afternoon* with Audrey Hepburn as a cellist in Paris, in love with Gary Cooper. I tried to adjust the lighting in our house to look like the lighting in a Paris hotel suite, turning this one on and that one off. And I'd get a terrible hunger for whatever food they'd been eating and try to reconstruct it from the contents of our refrigerator. I discovered that drama can transport you to another world, another mood.

Every June, my family would go Back East by train and spend a few days in New York City, before heading off to the little island off

the coast of Maine for the summer. We would stay in the grand old Gotham Hotel on Fifty-fifth Street and go to Best & Company to buy new outfits. Then we'd have lunch with my mother's fancy friends. I remember having a tuna sandwich at the '21' Club as they mellowed out over martinis.

Then it was off to the theater, usually matinees. Often we saw musicals like *Bye Bye Birdie* and *West Side Story*. When I was older, we saw straight plays like *Death of a Salesman* and *Hamlet*. Afterward my mother and I would discuss the shows. Sometimes she'd say, "The director hasn't been in lately." When I asked what that meant, she explained to me what a director does: how he—and usually it was a *he*—gets a production up and running, but once the wheels are on, the actors keep performing, and the director isn't around much. Every now and then the director might come back and notice where the actors were slipping up or getting lazy. I was learning to deconstruct theater, to understand that it's more than just a dream—that it's discipline and routine.

I never saw my mother perform onstage. She'd stopped by the time I was born in 1947; I rarely saw her in the movies, either. She didn't want me to see them, because she played some pretty scary people. But finally one of her movies came on TV, and I begged and begged and broke her down. But she was right—I shouldn't have seen it.

It was a 1946 movie called *The Locket* with Robert Mitchum and Laraine Day, and she played a rich woman who accuses her housekeeper's daughter (a girl just my age) of stealing a locket. She grabs the little girl and shakes the living daylights out of her. The child's face looking up at my lovely mother's snarling rage was an epiphany for me: normal people can transform themselves when they act.

My brother James (Jeremy to me, Jerry to the world) grew up to be a television executive, too, first at PBS and eventually at Westinghouse and CBS, running stations in Philadelphia, Los Angeles, and San

Francisco. When he was the program director in Baltimore, he used to honor our mother in a very special way. "We had an RKO film package," he says. "Every year on my mother's birthday I would program her movies, including *Isle of the Dead* with Boris Karloff and *The Locket.*"

He remembers that in *Isle of the Dead* there is a scene where our mother is buried alive—while she was pregnant with him.

When I was thirteen and feeling completely unappealing, someone appeared in my life who set my compass straight for *Masterpiece Theatre*. Neither of us knew it, of course, because neither PBS nor *Masterpiece Theatre* existed. But I think Jenny Rheinfrank definitely set my course—straight on till morning. She was twenty-one, and she had lapis-blue eyes, black lashes, curly hair, and a signet ring engraved "V.C."

She was my English teacher, and it was her very first job. She was very cool and loved literature and language. We read *Julius Caesar* and *The Skin of Our Teeth* aloud. I was on fire! I wanted to please her, but more than that, I wanted to *be* her. My friend Candy and I staked out her apartment, hoping to see her through the window. At the end of the year, we cried when she moved back to Ohio, where she would teach English for the next thirty-five years. And when it came time for me to go to college, I knew I had to go to Vassar College—the V.C. on Jenny's ring.

Vassar was like all colleges in the 1960s: a scene of deep friendships, love, booze, dope, sex, music, and politics. There I felt a deepening attraction to all things British. I majored in English, and so did all my closest friends. I spent a week in London during the summer of 1968, when student barricades were being manned all over the United States and Europe. But I was oblivious to that and spent hours in the British Museum leaning over the glass cases that held Jane Austen's spidery letters and Virginia Woolf's enigmatic diaries. They were a miracle to me.

As soon as I arrived in England, I loved everything British: the smaller size of things, the light, the close proximity of history, the damp, the endless flowers, and the food. Yes, the food—baked beans, chips with vinegar, turnips, McVitie's cookies, shandy. One bright afternoon in July 1968, at around two o'clock, I stood near the Wellington Arch in Knightsbridge and thought, "I'm going to go back and graduate from Vassar, and then I'm going to live here." And I did.

But first I had to write a senior thesis. Of course I wanted to do Virginia Woolf, but she baffled me at every turn of phrase. I hadn't discovered Jane Austen yet, so at the last minute I grabbed hold of the only James Joyce book I even remotely understood, *Dubliners*. It was manageable, in spite of the devastating verdict that my English-professor father delivered after a couple of cocktails: "The son of a bitch can't write."

It was 1969, and for all the girls and women I knew, life changed profoundly in those four years of college. In 1965 we had entered, most of us virginally, as freshmen in knee socks and loafers, looking for husbands and studying art history. We graduated in bell-bottoms and white armbands, taking the Pill and attempting to save the world. My brother was being sent to Vietnam; Martin Luther King, Jr., was shot in April of 1968, and Bobby Kennedy in June. I just wanted to get back to England. I never thought about having a career, even though my mother, a working woman who didn't marry until she was thirty-seven, always said that a woman needed something for herself, beyond home and family. I wanted a husband and four children—but not quite yet.

Randomly, someone told me about a program initiated after World War II with Lady Margaret Hall, a women's college at Oxford—a sort of Anglo-American swap deal. Every year, two American graduates, one from Vassar and one from Wellesley, went to work at the BBC, and two Oxford women were sent to NBC in New York.

The job paid about thirty-five dollars a week. As far as I was concerned, the actual job and the pathetic money were of minor interest—this was a way to get working papers, and a chance to live in England. That it involved broadcasting was fine with me but completely secondary. My favorite television shows were *Dr. Kildare* and *The Pat Boone Show*. Radio for me was Top Ten singles. I couldn't imagine being remotely interested in television as a serious career.

Suddenly it was August 9, 1969, and I was on my way to London.

# THREE

## *Upstairs, Downstairs* Take One

*The First Churchills*, with its interchangeable wigs and naked woman, may have been a bit of a stumble-start for *Masterpiece Theatre*, but the show quickly found its feet. Chris Sarson had shelves and shelves of finished programs at the BBC to choose from, and more were being made every year. Adaptations of classics like Dostoevsky's *The Gambler* and *The Possessed*, Balzac's *Père Goriot*, Thomas Hardy's *Jude the Obscure*, Thackeray's *Vanity Fair*, and Wilkie Collins's seminal Victorian detective story *The Moonstone* all aired in 1971–73, with ups and downs in viewership. Still, the Union Jack kept waving every Sunday night.

And then in 1974 a program came along that once and for all put *Masterpiece Theatre* on the map and ensured its place in television history. Jean Marsh and Eileen Atkins, both young actresses and aspiring screenwriters, were the series creators. Originally they saw the show as a comedy set in a British country house.

They're the best people to tell the creation story of *Upstairs, Downstairs*.

Jean: "Eileen and I wanted to work together: was it something to write, or something to produce? Immediately, within a week or two of just chatting, we both thought we should write about something we knew. What makes us powerful? What makes us passionate? Very quickly we started to think about the downstairs people: we *are* downstairs people. We still have a chip on our shoulder. We're only 'just about' all right.

"I didn't go to much of a school. My mother had been a maid. At age fourteen, she went into service, scrubbing and cleaning. She was a very hard-working girl. There were terrible things we could write about, like the way her hands were split. Later she became a barmaid. She was quite lucky inasmuch as she was unusually good-looking. Tall—five foot eight, tall in those days—and thin. She talked like a Cockney, but when people saw her in the street, they said she looked like one of the princesses."

Clearly Jean's mother had a sense of herself. Later when *Upstairs, Downstairs* was under way as a television show, an excited Jean told her, "The show is all about us!"

Her mother said, "What do you mean, 'us'?"

"You know, us—working-class people."

Her mother said, "We're not working class—we're *upper* working class."

Jean's father worked the night shift at a printing plant, where there was "lots of thumping of things around."

As for Eileen, before she was born, says Jean, "her father worked in a grand house. Like me, he was very much a Cockney. Eileen and I started talking about service, and soon there were *pings!* Looking at photographs, Eileen saw a woman standing with a group of people at a bus, probably a horse-drawn bus, ready to go out—an amazing thing, just to have one day off. I think it was her great-aunt. We talked

and talked and talked. It was absolutely clear that we were going to write something about servants.

"There were books that influenced us, like ones by Henry Green. We loved one about two maids in a house in Ireland. We might have played them. It weaved around and around, our thinking about two maids who work together downstairs. The story happened absolutely naturally, but it wasn't settled for ages. Eileen wasn't sure she wanted to do a television series.

"Finally we got in touch with a producer called John Whitney. I didn't want to tell him the idea, because I didn't want him to rip it off. He said, 'Well, would you tell me quickly, because I am having a meeting with the people in our company.'

"I told him, 'It's one of the plainest things you've ever heard about. Let's ask, What's going on downstairs?'"

Together Jean and Eileen had watched the hot hit of the day, *The Forsyte Saga*. "We went apeshit," Jean recalls. "It was disgusting, the way there were no downstairs people in it at all. We thought we'd show what might have been going on downstairs. We were the pith of it."

Eileen also remembers her reaction to the *Forsyte* formula. "One night Jean and I were watching *The Forsyte Saga*, and one of us—we can never remember which one—said that what everyone was loving was the clothes and the food, the fabulous lives they were living on the show. But of course as the daughters of a barmaid and an under-chauffeur, we would have been downstairs doing the cooking and scrubbing the floors. We would have been the skivvies.

"One day a friend of Jean's, an actress named Penny Horner, called to tell her she'd gotten a part Jean had wanted. Jean was rigid with fury. She said to me, 'That's it! I'm going to ring up somebody about our idea—I'm going to do it!'

"Eventually it got to [the writer and producer] John Hawkesworth. I was very hot at the time [as an actress], and they were very interested in me being in it. At the first meetings I was bored out of my skull. In those days it was very male-oriented; they got up my nose. One day somebody used a phrase that drove me crazy—'these two little actresses.' I was sick and tired of being treated so patronizingly.

"We were told to bring in the treatment. I think they wanted it the next day. We didn't even know what a treatment was.

"My memory is that it was all amazingly rapid. We called Jean's agent: 'What do we do? What's a treatment?' Neither of us could type.

"The agent told us, 'If you bring it to us at eight in the morning, we'll have it typed by ten o'clock for the meeting.'

"We stayed up all night and did a page of the idea; then about twelve characters; and a storyline for about twelve episodes. You really can go fast if you're geared up.

"Jean had an idea she thought would help sell it: 'One of the maids is doing the fire, when the master of the house comes down, throws up her dress behind her, and whoops, they're at it!' That was her idea of how catchy it might be.

"My idea was always somber and depressing: 'We've got to see them up at five o'clock, blacking the grates.' It's got to have this real feeling—how awful it was, how freezing. I almost wanted it to be documentary style. Somehow between the two of us, we melded.

"We worked out our roles as maids. Her maid was *spronsy*—chipper. I wanted to be a bit dour and rebellious. Later they changed the script to give my character psychic powers. They thought I could play someone like that, but I didn't want to do it. I'd pulled out [of acting in *Upstairs, Downstairs*] by then. In those days, going into a series was slightly down-market. If people only knew you as that character, you couldn't get other work. It's completely changed now.

"I was thrilled that the show went through the roof, but I never

regretted not being in it. I was never interested in being popular; I was a bit of an elitist."

Jean remembers a bumpy start. "Making *Upstairs, Downstairs* was nearly a disaster. The very first day of shooting was canceled because there was a strike. The people at ITV didn't think the show would be a success, so we shot the first episodes in black and white. Then halfway through, all the executives changed, and the new ones didn't seem interested. They shelved it. About six months later, they said they'd show six episodes, late at night.

"Then one of the top people came up to me and said, 'You know, I don't think it's bad.'

"I was thrilled! He didn't think it was bad—how fabulous!"

The decision of whether *Upstairs, Downstairs* would air on *Masterpiece Theatre* came up just before Chris Sarson moved on, leaving *Masterpiece* to create the children's program *Zoom*. *Upstairs, Downstairs* wasn't an obvious choice for the producers; it was not based on a great and enduring classic, and its fate was a close call. The *Masterpiece* producers almost blew the chance to air it because of an internal dispute over what today might be called the program's "mission."

Chris Sarson was not in favor of including the series, Henry Becton recalls, "because at that point we were defining *Masterpiece Theatre* as serial drama adapted from great literature or history. *Upstairs, Downstairs* was not great literature. It was history, but not really serial drama, because each episode was self-contained. In the end it was high-class soap opera, as Chris saw it."

Sarson offers his perspective: "The first time I saw *Upstairs, Downstairs*, I fell in love with it. I thought it was the best series I'd ever seen in my life—a huge, gorgeous soap opera that was beautifully cast, beautifully written, and beautifully acted. But to me it was absolutely not *Masterpiece Theatre*. I thought it should be on commercial television here."

But Herb Schmertz at Mobil was firmly behind *Upstairs, Downstairs*. And his opinion mattered. Not only was the company hugely powerful Big Oil; it had also been present at the creation of *Masterpiece Theatre* and was its sole funder. Not a penny of PBS money would fund *Masterpiece Theatre* productions until many years later.

Jean Marsh remembers it this way: "At first WGBH didn't buy the show. They said, 'It isn't a masterpiece.' Then Rawleigh Warner from Mobil called the Duchess of Argyle. He was coming to London, and wanted to have dinner.

"She said, 'Well, we can't on Sunday, because we watch *Upstairs, Downstairs*. You can watch if you like, but you must be quiet, and you have to sit with my maid, because she loves it as well.'

"So they had supper with the maid. Then the duchess asked Rawleigh Warner if he liked it.

"He said, 'Like it? I love it.'" Still, Henry Becton adds that "it was WGBH's Michael Rice who cast the deciding vote on airing *Upstairs, Downstairs*."

Michael took into account that at the time Mobil was also funding *Mobil Showcase* on U.S. commercial television and that Herb was perfectly capable of acquiring the rights to *Upstairs, Downstairs* and airing it there. If that had happened, the *Masterpiece Theatre* story would have turned out very differently indeed.

But *Upstairs, Downstairs* did air on *Masterpiece*, and as Rose, the head house parlor maid, Jean's face was on posters on buses and "even trash bins. I had a rose named after my character. Jeremy Brett came up with 'the Jean Marsh, bright red rose, not very good in beds, better up against a wall.'"

Jean wasn't sure Alistair Cooke was comfortable with her as a co-producer of the show: "Alistair was wonderful and interesting, but he seemed to think women were a rung below."

The show was a huge hit both in the United Kingdom and in the

United States. PBS aired it from 1974 to 1977, taking the Eaton Place family across nearly three decades of ups and downs.

Years later Henry Becton and I both attended a reception for the Silver Dagger Award for the best in British crime fiction. Princess Margaret was the event's royal sponsor. Her equerry in the receiving line introduced Jean Marsh: "Ma'am, this is the actress Jean Marsh, who created the rather popular television show *Upstairs, Downstairs.*"

"Oh, yes," said the princess, "the one about *all* the classes."

Jean was getting her dander up. "Well, yes," she replied. "Did you see it, ma'am?"

"No," said Princess Margaret, "I was away."

"For five years?" Jean shot back.

There is irony in the fact that the ultimate "upstairs" man at Mobil had recognized the value of *Upstairs, Downstairs. Masterpiece Theatre* was working fabulously well for its sponsor, convincing people that Mobil was the high-class gas station where they should fill up, especially during the oil embargo of 1974, when gas was scarce, prices were high, and oil companies were looking opportunistic.

These were the halcyon days for public broadcasting sponsorship. Many other companies besides Mobil—then, and for the next twenty-five years—considered it almost a corporate civic duty to fund the shows of this worthy enterprise.

Movers and shakers in Washington were impressed with Mobil's altruistic image, and Herb Schmertz loved swanning around London, being feted, buying shirts at Turnbull & Asser, and then returning to New York, where he was seen as one of the coolest guys in town. He personally had made a brilliant move with *Masterpiece*. He and his entourage—media adviser Frank Marshall and veteran Broadway publicist Frank Goodman—loved the series: the stars, the stories, and the reflected glory. They were interested in every detail.

In 1973 Joan Wilson succeeded Chris Sarson as executive pro-

ducer of *Masterpiece Theatre*, after which she and Henry Becton, then program manager for cultural affairs, settled into a routine that would continue for a long time. A couple of times each year, they and the entourage from Mobil would travel to London to screen programs and be extensively wined and dined by British television executives eager to sell their wares. There were four-course lunches: roast lamb and veg, Stilton cheese, wine, cigars, and brandy all around.

Wrangling Mobil was a delicate task—I would learn just how delicate when I became executive producer in 1985. Henry and Joan took it seriously and managed things smoothly for about ten years. And then something that had nothing to do with *Masterpiece Theatre* threatened to blow everything up.

It was over oil, of course. In 1980 Antony Thomas, a British filmmaker, made a film with the now-executive producer of *Frontline*, David Fanning, called *Death of a Princess*. It was the story of a Saudi royal princess whose uncle had her beheaded for adultery. Essentially it was a window into the lives of women in Saudi society, at a time when there was a shortage of oil, and important people were terrified of upsetting the Saudis. The Saudis were more than just upset about the film.

When the film was shown in the U.K. three weeks before it was scheduled to air on PBS, the Saudis broke off diplomatic relations with Britain. Warren Christopher was then undersecretary of state here, and he came after PBS not to run it. And of course it was critically important to Mobil that PBS do nothing to alienate and possibly threaten its primary source of oil, Saudi Arabia. Mobil too hated the idea that the drama might run on public television.

The trump card Mobil held in this game with PBS, and more specifically with WGBH, was its funding of *Masterpiece Theatre*. If it were to withdraw it in retaliation for this diplomatic "offense," the series would disappear, and WGBH would lose a major source of

funding. No other corporate support at that level was even imaginable as a replacement. Herb Schmertz placed an ad in *The New York Times* condemning PBS for intending to run the film. It was the public television version of the Cuban Missile Crisis, and the atmosphere around the station was charged. I remember seeing Henry Becton and David Fanning tensely conferring in the corridor.

Henry waited for the call from Herb asking him to pull the program. He even organized an alternate method whereby WGBH could feed the program directly to other stations, even if PBS in Washington blinked. But PBS didn't blink. And the phone never rang.

As Henry remembers, "I never heard a word from Herb Schmertz about it. I always thought that was interesting. He did the absolute right thing. He spoke out publicly in the ad but never threatened privately to pull our funding. He never tried to pressure us."

*Death of a Princess* was the highest-rated single drama broadcast on public television for thirty-three years, until *Downton Abbey.* The delicate dance with Mobil continued for years, with Henry successfully guarding the gate—until it all blew up again.

# FOUR

# Apprenticeship

Back to August 9, 1969. . . . I got on the BOAC night flight to London, and two days later, rather dazed, started work at the BBC. I took a double-decker bus from the dingy hostel, which smelled of fried bread, to Bush House in the Aldwych, an elegant, curved art deco block of gray stone. Inside, things were frozen in time: dim corridors, ancient lifts, and dozens of broadcasters and journalists from all over the world who looked like they hadn't been outside since World War II. This was the home of the legendary BBC World Service, the clarion voice of freedom heard around the globe since 1932.

Many of the worried-looking, grayish people carrying scripts and tapes up and down the halls were exiles, refugees who'd come to England to escape fascism or Communism or revolution. I'd been assigned to work on a weekly magazine program called *Science in Action*. Perfect for an English major. The show was produced by a man straight from central casting: frazzled hair, smeary glasses, disintegrating sweaters,

and a large brain. He was Peter Beer, a refugee who'd arrived from Hungary in 1956.

That first morning he showed me around the studios and offices and discovered I could neither type nor file. The only paid job I'd ever had was baby-sitting. He started to twitch.

After an hour or so, I asked politely, "Peter, what time is *Science in Action* on? When can I see it?"

Several expressions crossed his face. He took off his glasses and rubbed his eyes: "It's a *radio* program, my dear. The BBC World Service is short-wave *radio*."

My career in broadcasting was launched, and Peter became a dear and protective friend.

He took me with him as he scurried around interviewing scientists in London, in the west of England, and at British Association for the Advancement of Science meetings (the "British Ass," as he called it) at the universities of Exeter and Durham. Because he included me, I learned about storylines, interviewing, basic tape editing, studio production, timing, and transcripts—the broad outlines of nonfiction broadcasting. The science never interested me, but production did. Once he gave me a piece to narrate for the program, and he nearly lost his job when his boss heard my twenty-one-year-old, all-American, slightly-nasal voice speaking to the world.

This was London twenty-five years out of the war and heading into the swinging 1970s. To me it seemed to be a combination of sweet old people in lumpy coats carrying shopping bags, and mods and merry pranksters in bell-bottoms and beads. I was some combination of both.

I spent that year in my familiar dream state, pretending to be English, just as I'd once pretended to be Audrey Hepburn. I loved London and felt like I truly belonged there. I rode the red buses to and from work and shopped for my chop every evening at the corner

store. I froze without central heating. I went to bookstores and walked and walked, searching for the blue plaques on historic houses, looking for the one that said, "Virginia Woolf lived here."

And I went to the theater whenever I could afford a ticket. I would sit in "the gods," the nosebleed section up high and away from the stage, where the seats cost only a few quid. Seeing the entire stage at once was a challenge from up there, but I had twenty-one-year-old eyes and ears. My favorite theatrical memory is seeing *most of*, and definitely hearing *all of*, Maggie Smith in *The Beaux' Stratagem*, a Restoration comedy. She was, and is, one of my very favorite actresses.

I had various living arrangements. When I first arrived, the BBC put me up in that smelly hostel, but after that I was on my own. Sometimes I'd sleep on a couch or rent a room in someone's flat. Finally, there was a damp "garden flat," half underground, with a pull-chain toilet proudly labeled "Made by Thomas Crapper and Sons." Carnaby Street was in full swing, as was the music scene. At parties there was grass instead of just beer and wine. I remember buying a bag of hashish in Piccadilly Circus that turned out to be a bag of dirt. There was high style—Twiggy and Mary Quant—and low. Hippies were everywhere and people were opting out of conventional jobs.

I'd go between this world and that of my new friends from the British "upper class," country houses and all. Occasionally some nice person would invite me to come down "at the weekend." And I learned, for real, about those rituals of the British weekend that I'd read lovingly about in novels. You "come down" on the train on Saturday morning and alight at a perfect, quaint country station where you're met by your friend, who's wearing a cashmere sweater and pearls. She drives you to the house to meet Mummy and Daddy. You partake of an alcohol-infused lunch, after which there's tennis or "a ramble," then tea, and some friends are invited 'round for drinks and an alcohol-infused dinner. You sleep badly with a hot water bottle

until, startlingly, your hostess "knocks you up" with a cup of early-morning tea. Then comes church, sherry with the vicar, and another huge, boozy meal. You go home on the Sunday evening train. As I recall, I was pretty much drunk the whole time.

That year in England permanently cemented my Anglophilia—but it also made me understand where I came from. My brother was serving in Vietnam, the officer-in-charge of a Swift Boat in the Mekong Delta. Much to my father's chagrin, I had worn a white armband at my college graduation, protesting the war. But in England when I heard anti-Americanisms, I got angry. On those weekends I often heard criticism of both the war and its protesters.

One-sherry-over-the-line during a Sunday lunch, I remember losing it. A supercilious, chilly British lady started to dismiss and belittle the "dirty hippies" who had taken to the streets in protest back home. I got all red and hot and interrupted her with a fairly incoherent but heartfelt defense of the protesters, the war, my brother, my friends, and my country. Then I left the table.

In that moment I hated them all and felt that I was in the wrong place. I loved my own country. In Britain, I went from being antiwar and anti-U.S. government to realizing how deep my American roots actually were.

Without knowing what to call it, I think I was feeling the class discrimination so virulent in England, the rigidity of opinion that can be so typical of British society. In the United States, I never thought of myself as being of any particular class. Growing up in midcentury California was all about classlessness and fresh starts. In England I felt like an outsider. And as an outsider I identified with the underclass.

Of course the British themselves are fascinated by this aspect of their culture, and it's at the core of their dramas. Along with the frocks, the love stories, and even the mysteries, it's what *Masterpiece*

is so often about. How strange that we Americans, so proud of our independence and classlessness, are drawn to it. Could it possibly be that we too come up against class issues, though less visible, every day?

Eventually my London year was up, and in my tiny miniskirt and floor-length maxi coat, I got on another BOAC plane to fly home. It was November 5, 1970, Guy Fawkes Day, and as the plane flew over southern England, I remember looking down from my window to see bonfires burning all across the home counties. I cried and cried. What I didn't fully understand then was the admirable English trait of loyal friendship. The British may befriend you slowly, but once they accept you, they never, ever let you go. Maybe it's a cultural artifact left over from the days of the empire, when the British were posted for years in faraway places but faithfully wrote to, and remembered, old and new friends. Fifty years later I still see my lovely boss Peter Beer as often as I can.

I landed back in America at a particularly fortuitous time for someone stumbling into public broadcasting. PBS had gone on the air in 1970, in spite of a chronically underfunded business plan. Most interesting to me was a new *radio* outfit called National Public Radio, which was just being created—it sounded much like the BBC World Service I'd just left. I still wasn't quite ready to implement my "husband and four children" plan; my mother's maxim to "create an independent life for yourself" still rang in my ears. I spent a wonderful, emotional Christmas in the old house in Maine with my parents, my unharmed and decorated brother, Jerry, safely home from Vietnam, his wife, Karen, and their newborn son, Timothy—a child born, as my brother had been, when his father was at war. Then I tried to find a job.

I sent a rather feeble "please hire me" letter to the radio managers of the public broadcasting stations in the three cities where I could

picture myself living: San Francisco, Washington, D.C., and Boston. Miraculously, Bob Carey at WGBH radio in Boston called me in for an interview and offered me a job. For that break, I've always credited equally my Vassar degree, my BBC credentials, and my miniskirt.

He didn't pay me at first—I guess you'd call me an intern today. But eventually I became the facilities booker, the programmer, and the arts producer for the FM station. In those early days I did interviews and edited tape and made dear friends, people in different departments who would go on to become the creators of the solid-gold programming for which PBS is known: Paula Apsell, Elizabeth Deane, Austin Hoyt, Nancy Porter, Judy Stoia, and Kate Taylor.

And of course, Henry Becton, my once and future mentor. He was then the producer of *Catch 44,* a pioneering public-access television program. Given the counterculture ethos of the times, the name was, among other things, a riff on the novel *Catch-22.* Public access meant giving real people an opportunity to use the public airwaves. Henry came up with the idea in an era when democratizing media was in the air. "We wanted to break down barriers," he explains, "and give everyone a chance to be heard. There weren't many requirements for coming on. Being part of a group, not an individual, was our only real filter. We took them on a first come–first served basis."

Even though *Catch 44* was just a local Boston show and its audience was teeny, it was written up on the front page of *The Wall Street Journal.* The BBC copied its format, flying Henry over to London for a week to show its producers the ropes.

I was one of three people hired to work on the show. I guess Henry had noticed me when I was the producer of a radio arts magazine called *Pantechnicon.* As head of his college radio station, he'd come to the conclusion that radio is great training for television. "In radio," he says, "you get to understand the essence of a program without the machinery and the visual stuff getting in the way. And people in radio

were usually anxious to move into television, not to mention that they were used to lower pay!"

The staff of a public-access show, he felt, had to be secure enough (or more accurately, calm enough) to deal with a whole range of people, from nutcases to highly accomplished professionals. Since I'd done a general arts show on radio and apprenticed at the BBC, he thought I might be right for the job. And as "a feisty person, and a free spirit," as he describes me, I fit right in. Feisty? Well, maybe—compared to Henry.

Public-access programming wasn't exactly what I'd had in mind, but I responded to the siren call of television. I distinctly remember hosting a local Balkan dance troupe, whose members spoke no English but worked up a prodigious on-air sweat.

For the next ten years or so I did my apprentice work in television, still not ambitious or particularly committed to broadcasting. But I loved my life in those years in Boston: single but always attached, in semidomestic relationships; living in an attic apartment; reading; going to plays and movies; and growing a lasting family of close friends. My brother was working in public television, too, in Connecticut. Our jolly father died suddenly in 1975 after years of bourbon, cigarettes, and no exercise. He was only sixty-nine. I felt the great responsibility of keeping my mother happy and alive.

I'd spend the weekends with her in the house in Maine, where she and my father had retired, and we'd watch *Upstairs, Downstairs* together. She loved Alistair Cooke. Thinking back, I have a strange image of myself sitting on the couch in an old bathrobe, meeting my future "employee." He was wearing a suit from Savile Row.

Somewhere in those years I had another epiphany, much like the one I'd had in London near the Wellington Arch in 1968, when I'd known exactly what I wanted to do next in my life. Sitting on that couch with my mother a few months after my father died, we were

watching a documentary series called *Civilisation*, by Sir Kenneth Clark: a thirteen-episode BBC behemoth that had the skill and audacity to explain Western civilization through Clark's choice of art, architecture, and philosophy. It was British, visual, beautifully written, and full of stories—PBS was extremely proud to air this example of high-mindedness and intellectual prestige. In that very 1960s and 1970s public broadcasting way, it was useful.

I was wired with excitement for days. If something so interesting, beautiful, uplifting, educational, and entertaining could be on television, then this thing—documentary making—might be perfect for me, a combination of what my mother and my father had done. It was a different kind of storytelling, but it felt right for a bookworm child of the 1960s who loved drama but felt she had to stay behind the scenes, far from center stage, and stick with the facts.

In the next few years, and in my next few jobs doing nonfiction at WGBH, I learned the lessons of good program making: how to tell a story; how to pace an emotional journey; how to pull the audience along by good writing and editing; and how to keep them continually connected to the key character in the story, whether it's a little guy working in the circus for a *Zoom* film, or John Updike going back to his family home in Pennsylvania, or Patrick Ewing, in his senior year, becoming the most heavily recruited high school basketball player in history.

I was drawn to that kind of portrait documentary filmmaking because it was an excuse to go deep into people's lives. The subject of such a film might not know himself what his story is; you have to find it by engaging him and getting him to lead you there. What I loved about working in documentaries was that it was so hands-on: it was producing, writing, editing, directing, and even acting, in whatever way it took to get your subject to open up to you.

I did two programs about John Updike. I'd created an interview show for local television with the premise that we'd go to the home

of a well-known Boston person or celebrity and talk about his or her life. We had a gigantic mobile unit, more like a moving van or a fire truck, that would invade driveways and tear up lawns. We'd set up lights and cameras and film the guests in their natural habitat before sitting them down for the interview—kind of an Edward R. Murrow rip-off.

John was his charming, flirtatious self and talked to me in the same way he talked to every other woman who walked the earth— flirtatiously. We spent two days in his house, and I have an excruciating memory of wandering around alone while the camera and lights were being set up, opening the drawers of his bedside table, and looking into his medicine cabinet.

I think he was more or less pleased with the piece, and we stayed in touch. Then the BBC contacted me because it wanted to do a full-scale documentary about him. Since I had access, I became the co-producer with a BBC director.

The premise was to go with John back to his childhood home—a farmhouse in Shillington, Pennsylvania, outside Reading—to meet his mother, and then to walk around this little town where he'd grown up. The footage was intercut with clips of Updike reading some of the things he'd written about those places. We also shot him at his home in Massachusetts, strolling through the Metropolitan Museum in New York, and going to see his publisher at Knopf.

I stayed out of his mother's drawers.

Because of the work with John Updike, my interest in documentaries became even more specific: I liked making portraits of living people rather than investigative or historical pieces. Over the next few years, I did profiles of all sorts of people: the ballerina Violette Verdy, two UAW workers buying out their GM plant in New Jersey, and a dapper Swiss hotelier building a luxurious new Westin in Boston. Each program taught me the fundamental steps of producing.

I think it's the same process for producers of anything and probably for directors too. First you settle on an idea you love, or at least one you think you can manage. Then you persuade other people to give you the money to make it—always more than they want to, and less than you need. Then you must communicate your vision to the people who actually have their fingers on the creative triggers: documentary subjects, actors, cameramen, lighting directors, editors, composers, and so on. And you must continually persuade everyone—interviewees, crew, business affairs people, actors—to do things they might not necessarily want to do, and not to do things they want to do, which could be disastrous to your idea.

You work hard to stick to your vision while still being open to the possibility that someone else's good idea, or just the serendipity of events, could change things dramatically for the better. You have to stay firm and flexible; it's like holding a yoga pose for months. And you must always push to reveal something new: an insight, a juxtaposition of images and ideas, a unique expression of an emotion, a piece of information.

I found this process to be exhilarating and extremely uncomfortable. Producing is a task of constantly negotiating obstacles and coming up with solutions to problems over and over again. You get terribly discouraged and panicky. Then suddenly you tap into something where ideas take off and fly, almost on their own. And you hang on for dear life. I suppose it's the nature of creativity, and I think it must be the same for artists, dancers, writers, potters, architects, and even parents—anyone who makes something out of nothing. It's a combination of hard work and grace.

I have a theory about successful producers, drawn from my own experience and from looking around at other people in the business. When my brother and I were young, our parents started drinking a lot. Eventually they both became alcoholics. We involuntarily joined

the club of children of alcoholics, with all that that entails. When there's an alcoholic in the household, almost everyone else winds up playing supporting roles—or becoming producers.

Often if you scratch the surface, you find that producers are people who've been particularly vigilant caretakers in their families: worried that things won't get done, keeping an eye out, smoothing things over, and tying up loose ends. They're hyperresponsible—exactly the quality you need in a producer. Interestingly, my brother Jerry became a producer, too, but in commercial television.

In 1980, after a complicated life of fame, wonderful friendships, a loving family, and stuggles with ill health and depression, my mother died. Her death released me from what I had thought was my duty: to watch out for her and make her happy; to be her producer and supporting actress to her star turn. She died in Maine at seventy-three in the same hospital where my father had died. I remember comforting myself by thinking, *It's time—they were old.* And then I looked around at my peers and relized no one else's parents were dying yet.

About a year later, I met an extremely creative man, a sculptor named Paul Cooper. Suddenly I woke up to where *I* was in time—thirty-five, and a long way from the four children I'd drawn pictures of, and named, when I was ten: John, Mary, Susie, and Tom. Paul and I fell in love, lived together a few years, and produced our own perfect wedding in Kennebunkport. Then we launched ourselves into the next intense twenty years.

Meanwhile, *Masterpiece Theatre*, Alistair Cooke, Mobil, Henry Becton, and Joan Wilson (*Masterpiece*'s second executive producer) had motored along well from 1971 to 1985. The series had gained audience, won awards, and acquired a fantastic national profile. People all

over the country declined dinner invitations on Sunday nights and refused to answer the phone after nine p.m. They put the kids to bed early, or plopped them down on the couch next to them, in order to watch *Masterpiece Theatre*; they wanted uninterrupted appointment television. There seemed to be an unquenchable thirst for British costume drama.

One of my favorite cartoons from *The New Yorker* shows an elegant lady standing on a curb loaded down with suitcases. The driver of a yellow cab refuses her business, saying: "Sorry, lady, it's time for *Masterpiece Theatre*."

Actress Elizabeth McGovern, born and raised in Los Angeles, was a true believer long before she was cast as Lady Grantham in *Downton Abbey*: "*Masterpiece Theatre* very much shaped my personal dream and my image of myself as an actress. I don't come from a remotely show-business family; they were never moviegoers. But when *Upstairs, Downstairs* came on, my granny and my mom and I had a ritual of setting up folding chairs in the kitchen, where we had a tiny little black and white TV. We were glued to it every Sunday night. The show was a great soap opera, but it also gave you a dose of a culture that wasn't your own, so it was easier to escape into.

"I liked the cultural identity it provided more than American soap operas. I was growing up in L.A., which I loved, but I identified more strongly with the culture my ancestors had come from. All this went into my twelve-year-old psyche. It wasn't just *Upstairs, Downstairs*; it was also the experience of sharing it with my mom and my granny."

Gillian Anderson, *X-Files* star and future *Masterpiece* host, was born in Chicago and moved to London at age eleven, so that her father could go to film school there. After moving back to the United States, she watched *Masterpiece Theatre* "with nostalgia" for her time in England: "I remember seeing an interview with Glenda Jackson [playing Elizabeth I] and being riveted. I was watching with my mother, who

said, 'Now *this* is an actress.' At that time I was already taking acting classes. At age twelve I auditioned for the Grand Rapids Civic Theater's production of *Alice in Wonderland*. I didn't get the part.

"There was always a sense that *Masterpiece Theatre* set the bar; that what was shown there allowed actors to be the best that they could be."

Not only was *Masterpiece Theatre* firmly ensconced in the American cultural landscape: sweeter still, *Masterpiece* had absolutely no competition from other U.S. broadcasters to buy these British programs. *Masterpiece* was the only real U.S. partner that was available to the BBC and the commercial broadcaster ITV. Joan and Henry had the pick of the crop and were the most popular people in London when they'd come to town scouting for programs.

One interesting exception was the beautiful production of Evelyn Waugh's *Brideshead Revisited*, the mother of all British upper-class family sagas. It starred Jeremy Irons, Laurence Olivier, Anthony Andrews, Claire Bloom, and in Yorkshire, Castle Howard, the stately family "pile" called Brideshead. Produced by Granada Television, it aired on the commercial network ITV in the U.K. WNET, the public television station in New York, snapped it up and aired it as an eleven-week miniseries on its program *Great Performances* in January 1982. But now, in the mists of time, few remember that detail; everyone assumes it was a *Masterpiece*. I still get compliments on it.

Remember *I, Claudius* (1977)? The Lord Peter Wimsey mysteries (1972–75)? *The Six Wives of Henry VIII* (1971)? Joan Wilson would screen finished programs like these until her eyeballs spun freely in her head. *Anna Karenina*, *Vanity Fair*, and *The Golden Bowl*. Henry tells me that she didn't necessarily love them all, even if she knew they'd be popular. She told him she'd had to screen *Poldark* (1976) standing up, so she wouldn't fall asleep. She was happier with *A Town Like Alice* (1982), *Danger UXB* (1980), and of course, the first TV version of *Pride and Prejudice* (1980). People began to request the

theme from *Masterpiece Theatre* to be played as the processional at their weddings: forget the bride, here comes Alistair Cooke.

Herb Schmertz and the group at Mobil were content and supportive and didn't seem to interfere much. They poured millions of dollars into publicity for the series, almost more than they gave toward production. Over the years they spent nearly $250 million on British drama—a quarter of a billion dollars. No wonder PBS loved *Masterpiece Theatre*: it cost them nothing. No wonder Herb continually checked his mail for notification of his honorary knighthood from the queen. But it never came.

Henry Becton had become president of WGBH in 1984, and Joan Wilson had married the English actor Jeremy Brett, who played Sherlock Holmes brilliantly. By this point, *Masterpiece Theatre* had aired the backlog of great British programs, and the shelves at the BBC were thinning out. The British broadcasters were now asking Henry and Joan to commit to programs by not only watching finished shows on cassette but also by reading scripts of proposed programs, or even treatments. The job of executive producer of *Masterpiece Theatre* had undergone an evolutionary change.

Everything was rosy until Joan Wilson was diagnosed with pancreatic cancer in 1984. At the time, I was on a leave of absence from WGBH, where I'd been producing documentaries. I was working on an independent feature film for *American Playhouse*, written and directed by Jan Egleson, when I got a call from Henry asking if I would help him out by reading and evaluating programs and scripts for *Masterpiece Theatre* during Joan's illness.

I thought it odd that Henry would ask me to read scripts. After all, I had primarily done nonfiction work. But I threw myself into it, writing Vassar term papers rather than breezy synopses and critiques. Was this finally the payoff for reading all those English novels and for having been raised on a rich diet of good theater and Doris Day movies?

Jeremy Brett was performing in a Broadway play and couldn't get up to Boston very often to see Joan in the hospital. Henry was there every day, as well as holding down the fort at *Masterpiece*. I knew he needed an extra hand, and I was flattered that he'd asked me.

Joan Wilson died on July 4, 1985. She was only fifty-seven. I remember reading her obituary while sitting on the screen porch of the house in Maine. I literally felt a shock, a jolt, because suddenly I realized why Henry had been sending me those scripts to look over and comment on. He'd been auditioning me—trying me out. He had known how sick Joan was—although the rest of us didn't—and he'd been considering me for the job of executive producer of *Masterpiece Theatre* in the event of her death.

I was pretty sure I didn't want it.

When *The Jewel in the Crown* had aired in 1984, *Masterpiece Theatre* was at the top of its game—a zenith from which it would almost immediately begin to decline. But nobody, least of all me, knew this yet. I loved *Jewel*. It was an adaptation that only improved Paul Scott's great novels, *The Raj Quartet*. It was fourteen hours long, cost millions to make, and was expensively filmed on location in India by Granada Television, the producer of *Brideshead Revisited*. It was both a tragic love story and a brilliant study of British racism, class, and the end of the empire. It won more than twenty international awards, including a Golden Globe and an Emmy, and it sparked a rebirth of interest in Indian rugs, mirrors, pillows, clothes, and food in Britain and America.

So what was my problem with the *Masterpiece Theatre* job? Disdain. Being the executive producer of *Masterpiece Theatre*, I thought, would mean becoming an administrator, a manager of other people's work, rather than a "creative" person who actually made programs. It would be like becoming the spy who comes in from the cold, leaving the exciting work outside for a desk job pushing papers.

But my husband, Paul, and I had worked out a deal when we got married. He was a sculptor—an even iffy-er source of reliable income than documentary making—and we decided that if and when we had children, I would be the primary breadwinner, and he'd stay home. He was a much better housekeeper anyway. So we decided that maybe I should apply for the *Masterpiece* job—it would mean more money and less travel.

Then I got some behind-the-scenes prodding from the brilliant and enigmatic Peter McGhee, vice president for national production at WGBH. I didn't know him very well—yet—and was rather scared of him. But he knew who else was on Henry's short list, and as it turned out, he was championing me.

He called me: "Go talk to Henry."

So I did and got more interested. But was I excited? Did I really want this job? I was just trying it on. I threw my hat in the ring, thinking I was a long shot. Dozens of people were applying. Gradually it dawned on me that this could be a fantastic opportunity for me, and for us.

Paul remembers there were three finalists for the position. "Henry Becton gave them all a book to read and report on as a potential miniseries. I think it was *The Mill on the Floss*. Rebecca worked very hard on it. But after she got the job, Henry told her she was the only one who'd actually read the book. He could tell from her treatment that she'd taken the assignment seriously."

As Henry tells it, "I'd known Rebecca for a long time and trusted her judgment and taste. She'd worked at the BBC, and knew the Brits, and British broadcasting. This job requires spending a lot of time in London, where she'd be comfortable. And she came from a theater family. British acting culture is not like Hollywood: it's theater-based, quite different from the acting culture here, even today.

"One of the key skills for the executive producer of *Masterpiece*

*Theatre* is fixing things that are made for the British audience but need to be redone somewhat for an American audience, or that are pretty good but may need tweaking. I thought Rebecca could do that because of her training in documentaries."

He may have thought I was capable of handling famous people because of the John Updike films. Obviously he didn't know about the bedroom drawers and the medicine cabinet.

Henry adds: "I interviewed a couple of outside candidates, but I could see that this wouldn't be just a job for Rebecca—it would be a passion."

A few weeks went by. I went to meet Herb Schmertz's consigliere, Frank Marshall, who lived in the middle of nowhere in Vermont. I flew up from Boston in a tiny little crop duster of a plane. A gigantic brown limousine met me at the Rutland airport and proceeded to get seriously lost on dirt roads and cow paths. Hours later we arrived at Frank's chic farmhouse. I chattered away for the afternoon and then flew back in another bumpy crop duster. I felt awful and took it as a sign that the whole *Masterpiece Theatre* idea was a fool's errand. Apparently it *was* a sign, but of something else entirely.

I continued to feel rotten for a week until we realized I might be pregnant. In those days, before the pink and blue sticks you can now buy at the drugstore, you had to take a "sample" to your doctor's office, then go away and wait for the call.

On the Friday morning of Labor Day weekend, we made the drop. Then I went to work. By five p.m., I'd had no call, so I closed my office and went downstairs, where Paul was waiting in the car. But I'd forgotten my raincoat and had to run right back in. As I was turning the light out, the phone rang: it was the doctor, confirming that we were going to have a baby.

Outside again, I told Paul; his eyes filled up, and we hugged. I remember that he grabbed the steering wheel, and I could literally see

him realize that our life had just changed. But I was still coatless.

As I ran back to my office, I heard the phone again. This time it was Henry, offering me the job of executive producer of *Masterpiece Theatre*.

"Henry," I said, "I just found out I'm pregnant."

There was a nanosecond of silence at the other end of the line as Henry, a Harvard Law School graduate, deeply familiar with antidiscrimination laws, contemplated his choices. He rallied: "Congratulations! We'll figure this out!"

Back outside to Paul, still waiting, still stunned, in the car. When I told him about Henry's call, he was floored. Our life had just changed, again.

And I realized I still had no coat. As I opened the car door, he grabbed my arm and begged, "Beck, please, please, don't go back in there!"

Of course I took the job. Managing a career and a baby and a marriage was what we all did then. In fact, I think my generation of comparatively well-off women felt it was our fiscal and social responsibility to do it all, even though many of us were older mothers and vastly underestimated the physical and emotional stamina it would require. And executive producer certainly seemed like a relatively easy desk job. I thought, *how hard can this be?*

# FIVE

# The Learning Curve

Joan Wilson had been a very successful and popular producer. I inherited a series that was in excellent shape. It had a recognizable name, a prime slot, an inventory of great shows, and most of all, a loyal audience. My job, as I understood it, was to keep it all that way—to preserve *Masterpiece Theatre*, to be the captain on whose watch the good ship would not go down.

When I started, the entire operation of *Masterpiece Theatre* consisted of three people and me, working in two little rooms in an upstairs corner of WGBH: Pauline Mercer, the genteel and truly feisty administrator; Dali Cahill, the witty and eccentric postproduction manager; and Nathan Hasson, the secretary, who loved Edith Wharton. They were very welcoming; I felt accepted as part of the family. I was pretty sure that my job was (to fuse a couple of clichés) to keep a firm hand on the tiller and to try not to fix what wasn't broken. Things turned out to be much more complicated than that, as most good dramas do.

The first time I sat down in Joan Wilson's chair, at Joan Wilson's desk, I had to ask myself, *Okay, how are you going to do this?* As a queasy, pregnant woman, I was trying to figure out how to run a major TV series and keep my breakfast down at the same time. But worse, I realized that in spite of my winning pitch to Henry, I had seen practically none of the *Masterpiece* programs that had aired since 1971. We were currently in the fifteenth-anniversary season, but *Upstairs, Downstairs* was really the only one I'd watched in the early days, and more recently I'd seen *The Jewel in the Crown*.

So I wasn't a regular *Masterpiece* viewer—I wasn't even a *Masterpiece* fan, really. Yet here I was, head of the show. To catch up on the fifteen years of shows I'd missed, I took cassettes home to view in the evenings, but the one thing you can't do when you're pregnant is stay awake. I was very scared, as well as constantly ill. At least I'd already read the books the shows were based on—most of them.

I started the job in September 1985, and in October Henry and I went to London with Herb Schmertz and the Mobil contingent. We were treated, as usual, like visiting royalty, wined and dined and driven around town with a car and driver. The British producers needed American money, much as their government had during most of the twentieth century, and just as the Crawley family on *Downton Abbey* needs it from Cora and her rich American relatives.

I had morning sickness every morning, noon, and night. Between jet lag and British delicacies such as quail's eggs and sturgeon, I was miserable. Henry was extremely good to me. As the father of three, he knew what I was going through. He booked a suite at the Dorchester. I think it had once been Elizabeth Taylor's, and it was painted an unfortunate green. British producers cycled through, describing their projects to us in an endless stream. I excused myself often.

The pitches were often done over drinks, tea, and four-course

meals in dining rooms all over London. You'd barely recognize them as pitches. They'd come in the form of witty conversation, wonderful stories, inside scoops, and beautifully told plots. Occasionally Herb would pitch an idea back to them that he wanted to see made, like a show about the intelligence agency SIS, the precursor to MI6. The producers would nod and beam back at him, taking notes, thinking they knew who buttered the bread, and on which side.

In addition to hearing these pitches, I remember taking frantic, copious notes and guessing at the proper spellings of the names of books and actors I'd never heard of. I quickly learned that my key relationships would be with the broadcasters who green-lit the dramas. I needed to understand their taste and inclinations.

One night at the private White Elephant Club, Mobil threw a party to introduce me to the British television community: it was very nice, but I had to spend most of the time in the ladies' room. The keen-eyed, kindly John Mortimer, creator of *Rumpole of the Bailey* (1978) and father of many, noticed my distress and told me funny stories to distract me. I loved him forever for that.

Back in Boston, we plunged into the celebrations for *Masterpiece Theatre*'s fifteenth-anniversary season—fifteen years of programming that I was only remotely familiar with. Mobil loved to throw parties, and British actors love to be flown over to America, first class, to be lionized. The legendary New York publicists Frank and Arlene Goodman brought over veritable boatloads of British acting royalty: John Hurt and Siân Phillips from *I, Claudius* (1977); Hugh Laurie and Stephen Fry from *Jeeves and Wooster* (1990); Diana Rigg; Ian McShane from *Disraeli* (1980), who would later become better known as Al Swearengen on *Deadwood*; Ian Richardson; and Nicol Williamson, who played Lord Mountbatten during the last years of the British Raj in India, in a piece we aired called *The Last Viceroy* (1986).

It was as if we were throwing the most amazing Hollywood party ever—but with all British actors, and in Boston. It wasn't just a party; it was human proof of the unique assets of *Masterpiece Theatre*.

*Vanity Fair* critic James Wolcott, a television reviewer at *The Village Voice* early in his career, observes: "American audiences wouldn't have seen the work of actors like these if it hadn't been for *Masterpiece Theatre*. On American television, you really identified the American actor with the role. James Arness *was* Matt Dillon; James Garner *was* Rockford. The actors on the Ponderosa, that's who they *were*.

"On the *Masterpiece* shows, you were seeing trained Shakespearean actors, many of them, who could do a lot of different things. It was acting that was not totally role-identified."

That year we took the big group of British actors, accompanied by Alistair Cooke, on a triumphal tour of the United States—Boston, New York, Los Angeles—a kind of victory lap of parties and interviews. It was a publicity junket, of a kind that is common now, particularly for the cast of *Downton Abbey*, who are practically on a transatlantic shuttle; but back then it wasn't done very often. The actors would get all dolled up to meet their public, sign autographs, and be utterly charming. Then they'd schlep their suitcases to waiting limos and go on to the next city. They talked, smoked, drank, and argued late into every night. They'd all worked together—and probably slept together—at some point in their careers, and they loved having the chance to catch up. Nobody tells a behind-the-scenes story better than a British actor.

But there was one small crisis. Nicol Williamson was a temperamental man who'd famously walked off the stage during a performance of *Hamlet* in London the year before. Playing Lord Mountbatten in *The Last Viceroy* was his first performance since then. Alistair Cooke, who was a journalist and a student of history who'd known many major twentieth-century figures, gave an extensive

interview to the *Los Angeles Times* in which he offhandedly declared that he had known Lord Mountbatten, and Nicol Williamson was no Lord Mountbatten. Williamson exploded.

Alistair was appalled at his own lack of judgment. We all quaked, thinking that Williamson might assault Alistair if they met in the hotel corridor. Frank Goodman managed to keep them apart, and Williamson flew back to London. This of course became instant fodder for more late-night stories and hilarity. And it was my first introduction to the complicated person who was Alistair Cooke.

When I took over at *Masterpiece Theatre*, I was in complete awe, and somewhat terrified, of Alistair. My first meeting with him was wintry and formal. He had liked Joan Wilson and worked well with her. He did not like change. In fact, every time he came to Boston to film his introductions, he stayed in exactly the same room at the Ritz, a suite overlooking the Public Garden and the swan boats; he would instantly rearrange all the furniture to his liking.

His routine as the host of *Masterpiece*—or the headwaiter, as he called himself—was always the same. We'd send tapes of the finished programs to his home in New York, a beautiful rent-controlled apartment overlooking Central Park. He'd screen the programs, bang out the episode introductions and closes on an old manual typewriter, and fly up to Boston on the shuttle. He would bring with him the one and only copy of whatever he had written. He would never, ever send anything ahead of time. This was a journalist who knew how to manage editors.

The night before the taping, I'd come to his hotel room, and he'd offer me a drink: scotch on the rocks. After a cocktail or two, he'd say, "All right, let's get to work."

Then he'd read me what he planned to present on the air. He didn't hand me a copy to edit; he would just read it. As nerve-wracking as it was, it was the right way for me to experience what he was planning

to say. This was Alistair Cooke, the master of direct, familiar communication with an audience. Reading what he had written on the page would have been very different from listening to him say it.

We'd discuss it a bit, or more accurately, I'd sit back and listen to Alistair, one of the great journalists and broadcasters of the twentieth century, talk about anything he wanted to talk about. After another drink, I'd reel home.

Fast-forward a few years. After I'd earned Alistair's trust, he would listen to my suggestions, reject many of them, and occasionally embrace one enthusiastically. Then there was the time we were re-airing episodes of *I, Claudius* for some anniversary series or other. He had rewritten his introductions. As usual, he filled me up with scotch, then read me his plot summaries for episodes one, two, three, four . . . I was supposed to time them with a stopwatch and give him my comments.

His introduction to episode five, however, was deeply complicated. I struggled: Claudius's grandmother Livia does *what* to Julia? *Where* has Germanicus gone? Who *is* Agrippina? I told Alistair the introduction was too confusing.

"I know, *I know*," he sputtered. "One day I'm just going to say, 'Good evening, I'm Alistair Cooke. Screw the plot! Watch the program.'"

I always wanted to needlepoint those words on a throw pillow and give it to him.

The day after the "evening rehearsal" with me, his routine was to come to the studio at WGBH and greet everyone in a distracted sort of way. Then he'd head over to a place we'd built on the soundstage called his "corner," a little pseudostudy with a table and a chair and a lamp, surrounded by black screens. Alistair used it just for going over his scripts and for downtime—it wasn't where we filmed him.

The real sets were more elaborate. Everyone seems to remember Alistair in a red-leather wing chair in a library; he never had one. In fact, he was filmed sitting in a different purpose-built set for every single

miniseries we ever did. Each one was designed to go with the show he was introducing. For instance, for *The Bretts*, a show about a British theater family in the 1920s, we created a red-velvet box seat supposedly in a London theater. For John Mortimer's *Paradise Postponed*, we put Alistair in what looked like a village pub—he was the only patron.

Over the years, Alistair Cooke sat in perfect drawing rooms, music halls, cafés, and baronial dining halls but never, ever in a red-leather wing chair. They were sets, imaginatively done by two gifted set designers, Fran Mahard and Clint Heitman, expertly built by Co Bennett, and subtly lit by Chas Norton.

Admittedly the sets were a bit of an indulgence, but in those days we had a generous budget from Mobil. We would start with a wide shot, which allowed you to see this gorgeous room, but by the end we would zoom in on Alistair in close-up, and it didn't matter where he was.

Coming into the studio, Alistair would go to his little corner and memorize what he was going to say in his introduction. It was sometimes three to four minutes long, and he took about half an hour to memorize it. Then he'd come out, sit down in whatever set we were using that day, and say, "Right. Are you ready?"

Impatiently he'd repeat, "Are you *ready*?"

No wonder he was impatient, considering what he had in his head. The director David Atwood, who'd been working with Alistair for years before I came on, would roll tape. Alistair wouldn't miss a word. He wouldn't stop in the middle and say, "I've got to go back." He'd *tell* the introduction to the audience, and he'd do it flawlessly. Every now and then we might have a problem with a light that wasn't right, or a camera with a glitch, and we'd have to stop. Can you imagine how hard it was to say, "We have to go back, Alistair—can you please do that again?"

He always said he had only two rules for broadcasting: "No makeup, and no teleprompter." He explained that "unless you are a

superb actor, you can look like a man thinking aloud only when you are actually doing it."

He had amazing powers of memorization. His daughter, Susan Cooke Kittredge, remembers that he put himself to sleep every night by reciting Shakespeare's plays. She went with him once to Rockefeller Center to record his weekly BBC radio show *Letter from America*, and the engineer said, "Alistair, you're fifty-two seconds over." He offered to do it again.

"Then he'd cut fifty-two seconds, not by speeding up or slowing down, whichever was required, but by altering sentences or changing a paragraph, all without writing anything down. And he'd come in right on time.

"Interestingly, I am a minister and write sermons. My father's deadline for *Letter* was always Thursday and sometimes Friday. Mine is Sunday. I always wanted him to send me his *Letter* so I could just deliver it on Sunday morning."

*Letter from America* had been so popular in London that years later, when I met Princess Anne at a reception, she told me she'd been in love with Alistair Cooke her whole life. She remembered listening to his program on Sunday mornings.

She said, "My brother Charles"—that would be Prince Charles, the heir to the British throne—"and I would be in the car on the way to church, and we heard it on the radio. I loved listening to him."

I have an image of these two little royals listening to Alistair in the back seat of the Daimler—or the Rolls, or the Bentley.

Alistair told me that when he met the queen, she seemed to know very well who he was. She told him, "I listen to you in the bath on Sunday mornings."

He always said he wasn't sure what to do with *that* image.

In the *Masterpiece Theatre* introductions, he would be the Alistair Cooke everybody loved, relaxed, telling a story as if just to you. He

had completely mastered the art of speaking to an audience of one, of making every viewer or listener feel that he was speaking directly to him or to her.

After performing a *Masterpiece* intro, he'd retreat to his on-set corner and erase it from his mind. Then he'd memorize *another* three or four minutes for the next episode. He'd do as many as six or seven intros a day. From start to finish, each one would take about forty-five minutes, between memorizing, taping, and then perhaps retaping.

While he was in his little corner learning his lines, everyone would tiptoe around the outer set, whether it was a pub or a box seat. From behind the screen would come a cloud of smoke; he was puffing away on a forbidden cigarette. Lots of times he set off the smoke alarm at WGBH, and the entire company would be out on the street.

It took incredible mental control to do what Alistair did. The way his mind was wired was a gift, but he was also the product of a British education, which had been full of memorization and lots of reading. And of course he'd been an actor at Cambridge. He was truly a man of many parts.

His daughter, Susan, adds: "With his phenomenal memory, my father was sort of the original Mister Google. I don't know what he would have done if Google and computers had been part of his life, because he would have spent the entire time researching facts and absorbing and memorizing them. He could tell you when Churchill had a cold, and why that affected his ability to sign some treaty that altered the course of the war."

At one point Alistair had flown up to Boston the night before we were to shoot, as usual. I was supposed to go to the Ritz to meet him, but he called and said, "Rebecca, I'm sorry I can't meet you tonight. I'll tell you more tomorrow."

The next day I got another call: "I'll be at the studio a bit late."

At eleven a.m., Alistair came in and said, "Let's get to work."

It turned out that when he'd arrived in Boston, he discovered he'd left his scripts in New York. Rather than get someone in New York to go to his apartment and fax them to us, he got up in the morning in Boston, went to the airport, flew back to New York, took a taxi to his building, went up to his apartment, got the scripts, got back in a taxi, drove out to LaGuardia, and got on the next shuttle—with the same, startled crew—back to Boston.

I think he was probably annoyed with himself for having forgotten his material and would never have inconvenienced anyone to bail him out. Or perhaps he didn't want any of us to know what had happened. He was an extraordinarily vigorous man, hardworking, responsible, and very proud.

Soon after we began to work together, I learned that he was a very different person offscreen. The thing that made him the perfect presenter was that what you saw on television was, in a way, a character he'd created—a persona he inhabited. Alistair Cooke's role at *Masterpiece* was to be aspirational, a great fit for the ultimate aspirational television series. He was a person whom women admired and men wanted to be. In fact, his own life had been aspirational. He'd come from a working-class background in northern England. His brother, a butcher, had stopped school in the eighth grade. His father, an iron-fitter, acted as a Methodist lay preacher on the side.

His daughter, Susan, fills in: "Sensing that my father was not going to follow in his family's footsteps, his grammar school teacher practically beat the Blackpool accent out of him. It wasn't that my father put on airs and tried to change the way he spoke: he was not *allowed* to speak in the local accent.

"Certainly he was ambitious as a youth. He wanted more, and he went out and got it. People always used to say he was urbane, a word he hated, because he found it so hoity-toity. I don't think he saw himself as urbane at all. He saw himself as grittier than that."

Alistair Cooke made his way as a working journalist after graduating from Cambridge. His daughter observes that "he wanted to be Noël Coward. When Alfred Cooke got to Cambridge, he added Alistair as a middle name and called himself that from there on in."

Though he never signed a contract for more than one year at a time, Alistair was the host of *Masterpiece Theatre* for twenty-two seasons, beginning with the show's premiere in 1971 and continuing until he retired in 1992. He was such an icon that even shows like *Sesame Street* had a *Monsterpiece Theater*, hosted by Alistair Cookie (an alter ego of Cookie Monster).

Alistair Cooke was the perfect combination of reporter, gifted writer, historian, and handsome actor. Those of us lucky enough to have known him offscreen also knew him as an avid but average golfer, a marvelous jazz pianist, a cartoonist, and a wicked mimic. He could do his hero Winston Churchill to a fault. I think originally he might have wanted to be a doctor, if not an actor. He loved talking about the science of people's ailments but he was a bit of a hypochondriac, and he was afraid of blood.

His daughter, Susan, says: "The fact that he was a really good mimic is a clue to why he was such a good writer—he had a superb eye. He would notice things other people didn't and could extrapolate much larger truths from small things. In the way someone twisted his or her hair, or cocked an eye, or walked, he could discern something more about the person. A great deal of his journalistic style involved looking at the nitty-gritty of how things worked and how people lived, and what that said about their country."

The quintessential onscreen Englishman had become a citizen of the United States, the country he truly loved, in 1941, and was a nearly lifelong resident of his adopted city, New York.

At the beginning, I wasn't sure how I should be with Alistair. What could I possibly offer, as a green producer, that this man didn't

already have? Gradually, over years, I realized it was quite simple: he needed clear, honest feedback about his work, reliable consistency in his routines, and an eager audience for his brilliant cocktail hour performance. That I could do.

I remember the moment Alistair relaxed and accepted me as a friend; it was because of his fabulous wife, Jane, a woman with as much heart as Alistair had brains. She was a painter and extremely observant and intuitive about people. She came up to Boston with him sometime in that first year—1985, 1986—and we met in his "reorganized" suite.

She looked at me and then jumped a little, smiling her gorgeous smile. "Alistair!" she said. "She looks just like Susie!"

It was true: we both had prematurely white hair, and we did look similar. I was in.

Susan Cooke Kittredge says: "They just sort of took Rebecca under their wing. I think it had been difficult for Daddy in some points in his life to be around professional women, given his upbringing. But Rebecca was so indefatigably charming and bright and inquisitive that she won him over very quickly."

It wasn't quickly—and I never tried to win him over. Alistair was of my father's generation, and being with him reminded me of my father and made me miss him less.

Alistair and Jane were quite a couple. He was terrible about submitting his expenses to *Masterpiece Theatre*. He would use his own money to pay for his plane tickets to Boston, his taxis, even his hotel bills, and then he wouldn't submit the receipts for months. Pauline Mercer, our very Yankee budget manager, would be tearing her hair out because she couldn't reconcile the books. Over a period of years, Alistair would be out thousands of dollars. Jane discovered it and was furious with him.

She came up with a brilliant ruse to get him to produce his

receipts. She used to cut Alistair's hair—he didn't go to a barber. But now she refused to cut his hair until he submitted the lot, which at this point was two or three years' worth. A handsome man, perhaps a bit vain, Alistair submitted the receipts promptly from then on.

My husband, Paul, remembers "the Alistair and Jane Show. They'd talk back and forth, back and forth, disagreeing about everything. Then Alistair might say, 'Well, what do you think, Paul?'

"I'd say, 'Well—'

"He'd interrupt: 'Yes, on the other hand . . .' He wanted to be center stage, and he was very good at it. He was tremendously entertaining. He just couldn't stop."

# SIX

# Mastering *Masterpiece Theatre*

*Masterpiece Theatre*'s "little sister" *Mystery!* was six years old when I came on board, and I discovered immediately that she was a very large thorn in Alistair's side. About eight years earlier, in a moment that can only be described as heaven on earth to a public broadcaster, Herb Schmertz at Mobil had called Henry Becton and said, "If you're interested in putting together a second series, we'd be interested in funding it."

The British were producing more quality crime dramas than the *Masterpiece Theatre* schedule could squeeze in. Audiences had loved Ian Carmichael as Lord Peter Wimsey in the Dorothy L. Sayers mysteries, and the programming pipeline was engorged with high-end murder and mayhem. Of course, Henry said yes, and suddenly PBS was offering not one but two prime-time English drama series, fifty-two weeks a year, which it would continue to do for the next twenty-one years.

But Alistair got peeved—and stayed peeved. He loved John Mortimer's books about the contrary but principled barrister Horace Rumpole, consumer of cheap claret (Château Thames Embankment)

and devoted husband of She Who Must Be Obeyed. He longed to write introductions for the television version of *Rumpole of the Bailey*. But Henry and Joan wanted to put *Rumpole* in the first season of the new *Mystery!* series. Alistair fought to keep it in *Masterpiece Theatre* but lost. This was all before my time as executive producer; I was trailing around after Patrick Ewing and Violette Verdy making documentaries in those years. But apparently Joan and Henry felt the new series should have an entirely different feel from *Masterpiece*—more whimsical and tongue-in-cheek. Whimsy isn't the first thing you think of when you think of Alistair Cooke.

So Joan Wilson had more Mobil millions to produce a second series, and she really went to town. Herb Schmertz, who was looking more like a Medici prince every day, suggested that the on-air visual style of the series could be based on the fabulously witty and slightly macabre artwork of Edward Gorey. Gorey had gone to Harvard and had lived in Cambridge, a remarkable figure even in that nest of eccentrics, because of his full-length raccoon coat and high-top sneakers, to say nothing of his marvelously semighoulish drawings and books. He liked the idea.

Joan and WGBH's brilliant designer, Chris Pullman, hired the animator Derek Lamb to come up with a concept for the series's opening sequence: black and white Gorey figures in various precarious or dubious situations. Then Joan created the set where the host would deliver the series introductions. It would be an eerie room in a bizarre, Gorey-esque mansion stuffed to the gills with *objets*: antique furniture and books, crystal balls, birdcages, ratty taxidermy, dusty baubles. And in the midst of it all would be a host dressed in an elegant tuxedo inviting the viewers in. They hired Gene Shalit to do the honors, but after a year, they moved on to Vincent Price—perfect.

Apparently there were only two artistic disagreements with Edward Gorey: was Normand Roger's tango theme music the right

fit? And should there be an exclamation point in the title: *Mystery* or *Mystery!*? The answers, of course, were yes and yes.

If I thought when I started as executive producer that I was in trouble with my lack of knowledge about previous shows on *Masterpiece Theatre*, I was really in the soup with *Mystery!* I didn't read or even *like* mystery novels. My mother had been addicted to them, and throughout my childhood, she'd lie on her bed for hours in the afternoon reading Ngaio Marsh and Erle Stanley Gardner. I don't think I was "jealous" of them. I don't remember wishing she'd put down the books and pay attention to me. I just didn't get it. Why would you read any more of those things after you'd read one? They seemed so schematic: murder, suspects, and solutions.

Puzzles make me nervous. What I love in fiction is to be transported, not to have to work at the logic of something—and figuring out whodunit feels like work to me. I love getting close to one character and joining him or her on an emotional journey, not a forensic one. Good thing I hadn't gone into all of this with Henry.

*Mystery!* had been in my "portfolio" when I was hired. In 1980, when *Mystery!* was created, the small *Masterpiece Theatre* production team had simply absorbed the extra work for this entirely separate series, airing on Thursday nights. But *Mystery!* was still relatively unknown, and *Masterpiece* had been the object of my focus.

I realized pretty soon that reading a mystery is one thing but working on the television version is quite another. Mystery novels and television drama series are a match made in production heaven. They're both about repetition: the murders and crimes in each book or each episode might be different, but the pattern of chaos and then orderly resolution is identical. And when you throw in a compelling hero (the detective, the private eye, Miss Marple or Sherlock), the formula is complete. In storytelling, especially on television, there's great audience satisfaction in repetition.

I did love P. D. James: her Adam Dalgliesh mysteries, the TV adaptations of them, and the woman herself. She dives into psychological detail with her characters, and her stories always have a moral sensibility at their core. She goes deep into a different world with every book she writes: medicine, the church, and publishing. We did *Death of an Expert Witness* (1985), *Shroud for a Nightingale* (1986), *Devices and Desires* (1991), and lots more.

Phyllis (the P in P. D.) says people love mysteries because justice is served, and questions are answered. When someone, usually our hero (and therefore us), figures out the murder, we're provided with an emotional and aesthetic feel-good moment.

Watching mysteries on television provides a feeling that says all's right with the world; now at least one of life's unanswered questions is settled: *that's* who did it.

Phyllis says: "The mystery is an affirmation of a moral law that murder is wrong but men are responsible for their own deeds; and however difficult the problem, there is a solution. All this, I think, is rather comforting in an age of pessimism and anxiety."

As it turned out, my very first programming decision in my new job was to choose a series for *Mystery!* The broadcast schedule for that first year, 1985–86, was already in place when I came on. So my job was to decide what we should buy or co-produce for broadcast the following year. There were stacks and stacks of cassettes to screen and scripts to read, and I plunged in. I sat in Joan's chair in that little upstairs office, reading and screening for days.

Then I came across an already-made program whose central character was a soulful romantic, intuitive, irascible, impatient, and, I felt, lonely. He fit perfectly with Sherlock Holmes, Adam Dalgliesh, even Peter Wimsey and Miss Marple. He was played by a handsome actor with a certain sadness around his heart: catnip for women, I thought, because he's catnip for me. How effective that this character had no

personal life to distract us from the issue of whether he'd be able to solve the mystery. Women will rush to him, thinking *I'm the one who can make this man happy.*

John Thaw as Inspector Morse in the Colin Dexter mysteries—I thought it might work, and it sure did. We aired *Inspector Morse* for thirteen seasons, from 1988 to 2001; and the series's descendants became *Inspector Lewis* and *Endeavour.* And Morse had fans in high places, as I found out one year at an awards ceremony in London. Princess Margaret was the royal patron for the Crime Writers' Association, which gives prizes for mysteries. Henry Becton and I went to the ceremony, where the princess stood in a receiving line wearing a floor-length evening gown, a tiara, and an evening bag.

These evenings have a very strict protocol. No wandering around and chatting up royalty. An equerry introduces you, after which you are supposed to make small talk for about ninety seconds. This proved to be quite heavy going with Princess Margaret. The poor woman had a rather speckled past, and she did enjoy a cocktail. Diana Rigg had told us stories of weekend parties she'd attended where no one slept because Princess Margaret wanted to stay up all night playing games and drinking. There were long periods during which the princess was hors de combat.

I shook her hand as the equerry told her that I was the co-producer of many British crime dramas. When he mentioned the Agatha Christies, the Hercule Poirots, she looked blank—she had no reaction at all.

Then he added, "Oh, and *Inspector Morse.*"

Princess Margaret lit up like a Christmas tree: the mere mention of Morse's name was electrifying. She looked around: "Morse! Is he here? Where is he?" Apparently the whole royal family loved Morse; it's a little hard to picture, but they watch a lot of television. *Inspector Morse* was one of their favorites.

*Mystery!* had other friends in high places, among them my old

"friend" John Updike. He and his wife, Martha, particularly loved David Suchet in *Agatha Christie's Poirot*, but they'd often miss an episode, and John would send me one of his famous postcards asking for a cassette. I kept them all.

My first year (years, actually) is a queasy blur. My learning curve was straight up, and I was also carrying, bearing, and raising a baby. Henry must have doubted his decision to hire me a thousand times. The *Masterpiece Theatre* train was barreling down the track, but before I could even begin to help him, he had to teach me how. And of course, it wasn't just a matter of picking out shows that I fancied, or ones that I thought Americans would respond to: I had to learn how to do the business deals and how to acquire the broadcast rights for programs.

Until the late 1980s, there hadn't been much competition for British drama in this country. *Great Performances*, our PBS sibling, would occasionally show interest in a production, but after *Brideshead Revisited*, they'd gone pretty quiet. Worryingly, however, the new cable entity A&E, formed in 1984, had signed a deal with the BBC that gave them a first option on drama. There were ways around it, but it was complicated.

One of the first and most essential things Henry Becton taught me was how to negotiate and close a deal. It's not something regularly taught in "Romantic Poets" at Vassar College.

Henry had gone to Harvard Law School, and as I discovered when I tried to negotiate my salary with him, he was one of the thriftiest men around. He taught me to negotiate incrementally, in small bites; to be fully aware of the competition; and to know what your counterpart really needs to bring a deal home. He tried to teach me to remain detached, neutral enough that if I lost a property, I could instantly take the long view and walk away, with no regrets, convinc-

ing myself that the project was probably not good enough, anyway, and that there'd be other properties, and so on. I caught on to the negotiating-strategy part pretty quickly, but I've never yet been able to learn the comfortable-detachment part.

Paul and I were expecting our baby in April, but that month came and went—no baby. I was supposed to finalize the *Masterpiece* and *Mystery!* broadcast schedules before going on maternity leave. This meant I had to decide on, and acquire, about a dozen programs to be shown every Thursday night on *Mystery!* and every Sunday night on *Masterpiece Theatre* for the 1986–87 season. I worked and worked and got bigger and bigger every day. Clearly this baby wasn't coming out until I got the job done.

I finished the schedule on Friday, May 1, and sent it to PBS. The next day I went into labor, which lasted for nearly four days. It went on and on. At the very last minute, they decided to do a cesarean—good idea.

As I was being wheeled into the operating room, the nurses were making small talk to keep me calm: "Rebecca, you're going to have a beautiful baby. Do you have a job?"

"Oh, yes!" I said.

"What do you do?"

I was pretty drugged up and seriously sleep-deprived. I remember saying, horizontally, but in a loud, stentorian voice, "I'm very important. I'm the executive producer of *Masterpiece Theatre*."

Just before I went under, I remember seeing the two nurses rolling their eyes.

Beautiful Katherine Emery Cooper, named for my mother, arrived at dawn on May 7, 1986, all nine pounds and twelve ounces of her. The professional-strength show of lavish floral arrangements and stuffed toys from British broadcasters told me that I'd truly arrived in show biz.

As for being a working mother, it never stopped being hard. I had to handle a demanding job while an infant or a toddler or a big girl was waiting for me to walk in the door every night—and I couldn't wait to see her. As tired as I was, I missed her all the time. I wanted to be with her. The fact that every day I was handing her to her father made all the difference in the world. I didn't have to worry about her safety or well-being.

It was a huge gift, and I never could have managed any of it without Paul. We never had a nanny. I missed Katherine's first step, among many other things, and I had to be away from her on frequent trips to London. She seems to have forgiven me, though I haven't forgiven myself.

It was hard enough to leave her to go back to work when she was three months old, but the worst time was going to London when she was about five months. I missed her so terribly. After an exhausting trip of wining and dining and wheeling and dealing, on the way home in the taxi I was so excited that I babbled to the taxi driver I was going to be seeing my baby, after my first trip away. He was a family man. He understood and floored it.

When we pulled up at the house, Paul came out to meet me, walking down the steps holding Katherine. I got out of the taxi, and when I saw them, I burst into tears—which made Paul burst into tears. Then the taxi driver burst into tears. Katherine laughed and bounced.

Now in her twenties, Katherine says, "I don't buy into this narrative that I suffered because of my mother's dedication to her job. She was an incredibly caring, present, 'there' mother. To me there is a real value in the fact that she was able to have that career, pursuing things she loved outside the family that were way more important than if she'd been there to make me sandwiches. And she *was* there, most of the time. Often I'd visit her at the office; she took me along with her a lot. She made it a kid-friendly place."

I know it was hard on Paul, a big, burly guy trying to squeeze in time to make art, having to go instead to the playground with all the au pairs, endlessly cleaning, shopping, cooking, and doing laundry. He was the only Mr. Mom around then.

As he remembers, "They did an article about me and three other caretaker dads in a local paper because it was so unusual. Katherine was maybe three at the time. It was difficult; there were no standards. As a man who's the main caretaker, how do you talk to the women— the mothers, the teenage baby-sitters? Are you a threat because you're a male? You have to figure out the boundaries. At that point there were none, so you had to sort it out situation by situation.

"And if you hired contractors, guys, to work on the house, they'd say things like, 'Boy, you got it made here! This is easy street.'"

Katherine reflects on having a dad as primary caretaker: "Growing up, I was always proud that my mother was someone who worked. That wasn't true of all of my friends' mothers. And I was equally proud that my dad was home with me. Of course there were awkward moments.

"Because my dad did so much of the hands-on child care, changing diapers and feeding and all that, there may be ways in which I interact with the world that are more masculine. Maybe being raised by him made me more confident, though my mother is also an incredibly confident, competent person. I often went clothes shopping with my dad, who's a huge bargain hunter. Sometimes it was a little strange, even though he has great taste. I remember salesladies being a bit puzzled.

"As an undergraduate, I trained as an actress, and I did theater in high school. But I started out as a visual artist. I was always drawing and painting and making stuff with my dad. It was a fantastic way to grow up—making art together."

Still, it was very emotionally expensive for Paul and me to raise a child this way; it cost us. It didn't turn out to be the kind of motherhood I'd looked forward to. Other mothers would say, "Are you

kidding? Staying home is so boring!" But I wanted to experience it for myself. Even though my mother had had a career, I wanted that big family.

My generation of women wanted children, but we were also so aware that when executive opportunities came along, we had to take them. There might not be such chances again.

The payoff is to hear my daughter say: "To me, one of the most important things about being a good parent is showing the value of paying attention to what you think is really important—of pursuing a passion. For some people, that *is* just their family; they want to be there for those eighteen years. For others, it's being a television producer, or a sculptor. As someone who's trying to follow her passion in performance arts, it's invaluable to have a woman role model.

"I have two. I never knew my grandmother, but to me she was always sort of a guardian. I don't think she's literally watching over me. But I have her name, and I've always felt a connection to her even though I never met her. She's a complicated figure because though she's an inspiration, I also know how much pain she caused her family. I like to imagine her when she was about my age: glamorous, ahead of her time."

Later Paul and I tried to have more children, but we lost five babies, including a set of identical twin boys. By the time we found a doctor who could offer us a treatment plan we were out of steam.

Paul remembers: "Rebecca's job took a lot out of her. Still, I knew she was lucky to have a job she loved. That's something I always wanted but didn't find. To have somebody you love have that is a wonderful gift. I was in no ways resentful. I was just happy that she could do what she found so satisfying.

"Our family issues had more to do with other things. Rebecca would always try and fix things. I'm more reflective. Sometimes if you just talk about things, they fix themselves. She was always very proac-

tive in wanting to go out and have a plan, which may be a good quality in a producer but can cause problems in a marriage."

During that first year at *Masterpiece Theatre*, after I'd met Alistair Cooke and adjusted to his particular ways, it was time to meet Vincent Price. He lived in Los Angeles and would travel to Boston every summer for two weeks to tape a year's worth of *Mystery!* introductions. If meeting Alistair had been intimidating to me, meeting Vincent was something else entirely and scary in a different way. He and my mother had worked together and had once been great friends; he'd come to my brother's third birthday party. She'd always said that in spite of their creepy, horror-movie public personae, Vincent Price and Boris Karloff were two of the kindest, most courtly men she'd ever met. My fear was that Vincent wouldn't remember her as fondly as she had him, or that I wouldn't equal her in his eyes. I didn't even know if he realized I was her daughter.

I remember the moment he walked into the tiny offices at WGBH: he was tall, elegant, and slightly stooped. He hugged Nathan and Dali and Pauline—the staff he knew. And then he stopped in front of me. He opened his arms wide and said, "You look just like her."

All would be fine.

Working with Vincent was a joy for everyone. He was a man full of grace—he had a generosity of spirit and genuine warmth. I think I've known only one other person with this true humanity: Derek Jacobi, who has been a friend to *Masterpiece* since *I, Claudius*.

Vincent Price loved good food and good art and told endless raunchy stories. We were a tight team for those two weeks a year, holed up in a windowless green room between takes: Vincent in his Gorey mansion tuxedo; Sandy Leonard, master of introductions; Louise Miller, the makeup artist; and sometimes Vincent's wife, Coral Browne, the Australian actress who could be even bawdier than her "Vinny."

Eileen Atkins, who knows everything about everybody, tells my favorite Coral Browne story: "At some point in London, Coral is coming out of early morning mass. The actor Charles Gray, reeling home after an all-nighter, sees her on the church steps and lurches over: 'Oh, Coral, I've got such a story to tell you.' And she says, 'Keep away, Charlie, keep away—I'm in a state of fucking grace.'"

Vincent taught me a life-changing lesson that first year. I hadn't known it, but a big part of my job as executive producer of *Masterpiece Theatre* would be public speaking. I had to act. I was the figurehead on the great ship *Masterpiece*, and I had to go out and give speeches, make remarks, and tell witty stories to assembled groups of donors, fans, and the press. I hadn't spoken publicly since my eighth-grade speech contest, during which I nearly died of fright—and which I lost. And of course in my own personal family drama, I thought I was never to be on stage; that was my mother's job. My job was to make sure she was there and happy. Being in the limelight was for the star. I was much more comfortable backstage.

The night I met Vincent, I had to introduce him to a roomful of 250 of his fans, who also happened to be wealthy public television donors. I laboriously wrote out what I would say and practiced in front of the mirror in the ladies' room. Then it was eight p.m.: show time. In the big studio at WGBH, with an audience somewhere out there in the murky depths, I shakily started to read my introduction. Eventually I dared to take my eyes off the page and look up. I saw alert, smiling faces. Nice people. This would be like fish in a barrel, candy from a baby. I was preaching to the converted. All of them wanted to hear what I had to say about *Vincent*.

I could see them listening—and realized two things. First, this wasn't about me; it was about what I was saying. I was a vehicle, a source of information about Vincent. *Get over yourself.*

Second, the audience *wanted* to like what I said; they wanted to

enjoy themselves, and I had the power to help them do it. Power? I put down the paper and started talking right to them. They were listening; I was talking; we were connected. I'd never felt anything like it. And then they laughed at something mildly witty that I'd said. I felt startled and absolutely wonderful. I extrapolated and embellished and finally wrapped the thing up, having gone on for about ten minutes too long.

Vincent beamed. Then he said, "Look at that! Her mother was an actress, and it's in the blood."

I had savored for that brief moment the thing that makes actors act and writers write: the power of connection. Vincent had given me permission to feel it. Unbelievably, public speaking was never terrifying again. And even more miraculously, it became something I rather liked. Still, the only way I can do it is to remind myself constantly that it's not about me: it's about what I have to say and how I say it.

So that first year rattled along. I worked with Alistair and Vincent and then . . . Ken and Emma. That would be Branagh and Thompson. Both were in their midtwenties then, and they'd just met (and had fallen in love) as the stars of what we hoped would be our next *Jewel in the Crown*. It was a BBC project called *Fortunes of War*, and was based on Olivia Manning's *Balkan Trilogy*, three novels set in Bucharest in 1939–41, which tell the story of Guy and Harriet Pringle, a young married couple engulfed by World War II.

Ken and Emma had been in some small British films and television programs but were virtually unknown in the United States at this point. They came out to Los Angeles in the winter of 1988 to help us publicize *Fortunes*. Their plane made it halfway from London to L.A. and had to turn back—mechanical difficulties. They finally arrived, bright and charming, and they never drooped.

Ken claims not to have felt pressured by coming to television after the huge success of *The Jewel in the Crown*: "I was twenty-seven, and was just wildly excited to have a job that was going to take nine months

to shoot, and would take me to Egypt and Greece and Romania and Yugoslavia. To me it seemed unutterably glamorous. And it came with food and air travel—all pressure was therefore lifted.

"I was fascinated by this unknown pocket of the Second World War. It was such a massive conflict, but we were exploring some of the highways and byways less traveled. The story of people adrift in Bucharest, and then adrift in Alexandria, in a strange subculture of the British Council and its attendant relationships, I found very interesting. I loved being an owl-spectacled, would-be academic in a glamorous but forgotten part of the war."

At our press conference, the reporters didn't really know who Ken and Emma were, but they'd discovered that Emma had done standup comedy at Cambridge. Suddenly, instead of asking about *Fortunes of War*, they insisted that she do her Mort Sahl routine, right there on the spot. I panicked, but she didn't. She just thought for a minute, stood up, and delivered. I was standing behind her on the stage, frozen with sympathetic stage fright, and can only remember staring at the flawless skin of her beautiful back.

Ken has remained a great and loyal friend to *Masterpiece* and seems to understand better than most actors what a *Masterpiece* broadcast can do for a British actor's career.

As he sees it, "*Masterpiece* and PBS have an audience of very inter-connected and influential people, and certainly people who like books and watch films, and who, in fact, also employ people in our business. *Fortunes of War* was well watched within the world of my work."

Because of the things he's done for British television and *Master-piece*, Ken says, "you suddenly find yourself in a relatively remote part of the world—in a country town in Australia or somewhere—and someone comes up to tell you they saw you in *Masterpiece*. Or you're told, very passionately and specifically, that the World War II period drama that screened in 1988–89 was where they saw you—and

depressingly, 'That's the best thing I ever saw you do.' Naturally, you try and draw their attention to the other twenty-five years' worth of work as well."

Twice a year, just as we did with Ken and Emma, we at *Masterpiece* still pack up and go to Los Angeles to be part of the Television Critics Association's two-week-long publicity meat market. It's really a relatively efficient way for all the networks and cable companies to present their upcoming programs (and preferably their toothsome stars) to two hundred or so television writers who've come from Des Moines or Orlando or Seattle, to live in hotel rooms, ask questions at press conferences, do interviews, and file stories. Since *Masterpiece* doesn't have an advertising budget, it's one of our main opportunities to get press attention. The commercial networks lay on big stars, lavish meals, and huge neon signs. PBS has to rely more on the quality of the programs to speak for themselves—and they do.

The *Masterpiece* sessions are very well attended, and with some egregious exceptions, they go along pretty smoothly. In 1988 Elizabeth Hurley (yes, *that* Elizabeth Hurley) was the star of a program we did called *Christabel*, written by Dennis Potter, the true story of an English woman married to a German officer in Berlin in 1938. When Elizabeth came to Los Angeles with her then-boyfriend, Hugh Grant, the press asked only questions about her hair; I thought that *his* hair was altogether more interesting. The whole thing was excruciating.

Over the years and in many places we've had fun with so many British actors, writers, and producers: Ian Richardson, Derek Jacobi, Gillian Anderson, Ian Holm, Zadie Smith, David Tennant, Rufus Sewell, Sam Neill, and of course Helen Mirren. The list goes on and on. There have been actors just on the cusp of becoming Hollywood-famous: Clive Owen (*Second Sight*, 2001); Ioan Gruffudd (*Great Expectations*, 1999); and lately, Benedict Cumberbatch and Martin Freeman (as Sherlock and Dr. Watson in *Sherlock*, 2010–13).

And then of course there's the *Downton Abbey* crowd.

After the first season was aired in 2011, we brought a group of the actors over from London to talk to the press. There was polite interest. Then in 2012, after the huge success of season two, we brought over Julian Fellowes and Gareth Neame (the executive producers), Elizabeth McGovern (Lady Cora), Hugh Bonneville (Lord Grantham), Michelle Dockery (Lady Mary), Jim Carter (Mr. Carson), Rob James-Collier (Thomas), Sophie McShera (Daisy), Joanne Froggatt (Anna), and Brendan Coyle (Mr. Bates). And at each stop, things got wilder and wilder. We had to register the actors under false names at the hotel and accompany them practically everywhere they went. They couldn't take a step without eager fans with iPhones begging them for pictures. That's the contemporary equivalent of an autograph, apparently.

A truly startling moment was at the actual Television Critics Association news conference for *Downton* in July 2012. There were more than one hundred seasoned, neutral, and objective journalists in the room. The cast walked in, and the "journos" went nuts—clapping, hooting, and whistling.

Before the end of the question-and-answer period, Hugh Bonneville whispered to me: "At the last question, can you ask me something about Lord Grantham?"

I said, "Sure. Why?"

He said, "Wait and see."

He got the last question; but as he started to answer, he rambled. I knew something was up. Everyone else in the room was getting a little uncomfortable, wondering if jet lag had caught up with him.

Hugh started to loosen his tie and shirt and got more and more agitated. Finally he stood up and turned his back to the audience, then whipped around and opened his shirt. He was wearing a "Free Bates" T-shirt. The room just roared.

One reporter asked Brendan Coyle, who plays Mr. Bates: "On the

*Downton Abbey* quiz on the *Masterpiece* Web site, you can see which character you're most like. Have you played?"

After a pause, Brendan said, "I have. I'm Lady Mary. And I'm very pleased about it."

The youngest actor we've ever brought over was little Daniel Radcliffe, who debuted in show business as our David Copperfield in 1999 and morphed into Harry Potter two years later.

The story of Daniel's experience in *David Copperfield* is certainly worth a brief detour in this narrative. Simon Curtis, the director, tells about the film's evolution: "Maggie Smith had signed on, because she wanted to play Aunt Betsey. Then because we had Maggie, we could get it written, by Adrian Hodges, and carry on from there.

"When we were casting the young Copperfield, a director friend of mine told me, 'If you're casting a kid, cast a kid you like.' The very first boy we saw was Daniel Radcliffe. His parents had put him up for Copperfield, and I really liked him. He came back for a recall. As the casting director walked him across the room in preparation, he winked at me, which made me laugh. I think that was the hundred-million-dollar wink, considering where he went next."

Daniel's not so sure: "I can honestly say I would never have had the confidence to wink at that age. I wouldn't have the confidence to wink at a director now, even one I know well—that would just be so presumptuous. If I did that as a kid, I'd be well impressed with myself.

"If you look at *David Copperfield* and at the early Harry Potter films, you can see that I do occasionally have a weird kind of one-eyed blink. When I was young I had a lazy eyelid or something.

"But in retrospect, maybe I did wink. There's a very good chance that I was just so full of youthful hopes that hadn't quite been knocked out of me by puberty yet. Who knows how things start? Who knows what gets you a job? It's kind of wonderful that it all started with something like that."

Simon: "Daniel had his tenth birthday on *Copperfield*. When we were doing publicity, he was often asked if he would be up for playing Harry Potter. He and his family always said no. But Chris Columbus, the director of *Harry Potter*, told me that a lot of Daniel's being cast as Harry was *David Copperfield*. When Maggie Smith was cast in *Harry Potter*, she said, 'He's the boy.' She's a huge fan of his."

As Daniel tells it, "Funnily enough, my dad had actually worked with Maggie; he'd had a tiny scene with her in a film twenty-something years earlier. So there was definitely excitement in the household about the fact that I was going to be meeting her. She was a huge star, as she is now. As a young kid, I wasn't really aware of a lot of her films, but I was aware of her as a presence, and I was very conscious that she was a Dame.

"I walked up to her, and said what could be viewed in retrospect as one of the most important sentences of my life, because she was the person who recommended me for Harry Potter: 'Nice to meet you; would you like me to call you 'Dame'?

"I was nine, and I thought she might be offended if I didn't call her that.

"She just burst out laughing, and said, 'Absolutely not!' She was always incredibly kind to me. In *Copperfield* I had a scene in the bath. So my first seminude scene was in fact with Maggie Smith."

Back to Simon's version of events: "Daniel could act, but on *David Copperfield* he had a lot to learn. He really enjoyed being on the set. My memories are of him taking the soundman's headphones and exploring them.

"Then one day we were doing a scene with Zoë Wanamaker and Maggie Smith and Trevor Eve in a lovely country house. We were ready to shoot; where was Daniel?

"The others in the cast said, 'Actually, he's down looking at the fishpond.'

"I said, 'Oh, God, I'd better go and have a talk with him.'

"I sat him down and said, 'Daniel, I know filming can be very boring, but we're on a journey. I don't know if you want to be an actor or not, but I can guarantee you that whatever you do, never again will you play the title part in a great British novel with actors of this caliber.'

"Of course, I was completely wrong. He went on to play Harry Potter with every great British actor in the business. But at the time, it seemed like the right thing to say. He probably thought I was just an old man pontificating.

"Daniel was never crabby. He had to get used to the rhythm of things, but he was a lovely boy to have around. I feel very proud that he's become such an impressive young man and such a dedicated actor. I remember in one of the *Harry Potter* interviews, someone said to him, 'What's it like playing your second magician?' They thought the *David Copperfield* on his credits was referring to the other one."

Back to the press conference in Los Angeles: I remember Daniel sitting up straight in his chair, feet hardly touching the ground, as he thoughtfully and respectfully tried to answer questions about Charles Dickens. After he was back in England, he sent me one of the very few actor thank-you notes I've ever had.

Dear Rebecca

Thank you for giving me such a good
time in Pasadena I had a great time..

Love Daniel Radcliffe

Much happened at these semiannual press junkets. British actresses from damp London have become pregnant (by their husbands, of course) after two or three days in a five-star hotel room in sunny southern California in January. I've accidentally come across secret costar trysts at Hollywood sushi restaurants and heard late-night rumpy-pumpy noises coming from unlikely suites. One very famous "detective" had a manic episode and charged thousands of dollars' worth of camera equipment to his room. Even classic, classy British actors can misbehave.

I loved the time we assembled four "detectives" all at once: Inspector Morse, Sherlock Holmes, Lord Campion, and Hercule Poirot (John Thaw, Jeremy Brett, Peter Davison, and David Suchet). What a great picture! For the most part, the actors have been really good sports about this aspect of being on *Masterpiece* or *Mystery!* They've come to Los Angeles at our request instead of staying home for wedding anniversaries and children's birthdays. They seem to understand how much we need them and have been, without exception, charming and professional to work with. One of my greatest pleasures in this job is sitting over long dinners listening to British actors tell stories and laugh.

There was the time that Colin Firth (*Nostromo*, 1998), long before he was Mr. Darcy, listened intently as Alex Kingston (*The Fortunes and Misfortunes of Moll Flanders*, 1996) talked about her difficulties with her husband, Ralph Fiennes (*Prime Suspect*, 1992), who had left her for Francesca Annis (*Cranford*, 2007). Life's plots can get pretty complicated too. . . .

Sometimes the trips were shockingly short because of the actors' or writers' busy schedules. Dear Andrew Davies, with a script deadline looming, once got on a plane in London, drank a lot of free first-class booze, had a wine-soaked lunch when he landed in L.A., made perfect sense at the press session for his adaptation of *Wives and Daughters*

(2002), drank freely throughout dinner and into the night, then got on the free-booze flight back to London the next morning. And he remembers every detail of the trip. . . .

My favorite press tour moment of all was with Helen Mirren. It was the day of her sixty-fifth birthday, but she'd agreed to a press conference to publicize the very last episode of *Prime Suspect* (2006). We had edited a compilation reel of footage from all the *Prime Suspects* Helen had done over fifteen years. It was spectacular. She and I walked into the room just as it started. The lights went down, and I watched her face as she looked up at the big screen. She was literally watching herself grow older.

Her eyes went very wide, and then she smiled a lovely, tender smile at all these versions of herself. And said quietly, "Goodness. . . ."

So very English.

# SEVEN

# The Balancing Act

I managed to get through that first year relatively intact. Although I missed Katherine's first step, I didn't miss her beaming, chortling welcome every night at six when I got home. As all working mothers know, that's when the second job begins: cooking dinner, bathing, negotiating bedtime diversionary tactics, and storytelling. Then a large glass of wine, an attempt at conversation with a tired Paul, or a stab at screening a potential *Masterpiece* program: then a too-short sleep—until six a.m., when a small body encased in a pink sleeper would appear at my eye level, ready to play.

In those first years I remember traveling to London to find programs for *Masterpiece*, sometimes staying for a week at a time: lots of food and drink, beautiful hotel rooms, glittering actors, impeccably tailored producers—mostly all men.

I would get back to Boston, walk in the door, and Katherine would leap into my arms: "Mummy, let's play Cinderella! You be the prince!"

And I would—I'd be deep into her fantasyland even before I had my coat off. I had to. No wonder she's in theater now.

My workdays and -weeks in Boston developed a pattern that continues today. I would read scripts and screen hours of programs, either those we were in the process of co-producing or finished shows that were available for us to acquire. I'd spend hours on the telephone discussing projects with producers, directors, distributors, or business affairs people. I would meet with our publicists to strategize how to get the word out about upcoming shows, which talent to bring to the States, and how to structure trailers for PBS to air. I'd give press interviews, meet with major donors, travel around the country visiting local PBS stations, and beat the drum for *Masterpiece*. In the early years, I'd make pilgrimages to New York to meet with Mobil. I'd constantly work and rework our budgets.

Once I more or less found my footing in those early years, I realized that there was nothing predictable about this "desk job." Although the funding from Mobil was miraculously secure, and the British were reliably producing quality drama, there was always, always, some kind of challenge.

In 1988 sweet Vincent Price, seventy-seven by then, was getting frail and beginning to look worryingly uncertain in his introductions for *Mystery!* I knew it, but I didn't *want* to know it. How in the world could I fire Vincent Price, who was not only an icon but also a friend of my mother's?

I avoided it for a year. Then, completely in keeping with the perfect gentleman he was, he addressed the problem for me. He asked for a private conversation and told me he wanted to stop. He was matter-of-fact and held my hand as I teared up.

Sandy Leonard, who knew the *Mystery!* ethos inside and out, immediately suggested Diana Rigg as Vincent's successor. She was a favorite with our *Masterpiece* audience because of her mysterious and

tragic Lady Dedlock in the BBC's 1986 version of Charles Dickens's
*Bleak House,* and a favorite of men all over the world because of the
black leather catsuit she'd worn as the crime-busting Emma Peel in
*The Avengers* back in the 1960s—oh, and because of her performance
as well.

I had met Diana in 1985 during the ill-fated Alistair Cooke/Nicol
Williamson press junket. So one Sunday I simply called her at home
in London to ask if she might be interested in the job. She answered
the phone with the most incredible din reverberating in the back-
ground. In her elegant, Royal Shakespeare Company voice, she said
yes, she was very interested, but could we talk another time? The dogs
were fighting, her daughter, Rachael, was being bullied by one of her
stepbrothers, and she had to get the joint out of the oven and onto
the table for Sunday dinner. I immediately loved this other version of
the sex symbol in a catsuit.

Diana was a natural fit for many reasons, beginning with her
friendship with Vincent Price and Coral Browne. Listen to her tell
the story:

"As far as I was concerned, it was a great honor to host *Mystery!* I
didn't regard it so much as a job. And it was especially an honor to
be following Vincent Price. I'd known him since we filmed *Theater
of Blood* [1973], which is a cult movie now. Coral Browne was in it,
along with a lot of other wonderful character actors, like Dennis Price
and Robert Morley.

"Vincent and I spent just about every day together, because we
were in every scene. He asked me to a charity evening, something
called Cowardly Custard, a selection of songs by Noël Coward at a
theater in Los Angeles. In the interval I went to the loo, and Coral
Browne was there as well, in the adjacent cubicle.

"I heard this unmistakable voice saying, 'It's a long time since I
fancied anybody of me own age, but I fancy Vincent Price!'

"On the way home together in the car, Vincent said to me, 'Do you know, it's Coral's birthday next week, and I don't know what to get her.'

"Vincent was renowned for being stingy. I said to him, 'Vincent, you have it on your person, and it won't cost you a penny.'

"And they got together and got married."

In the summer of 1989, Diana arrived in Boston for two weeks of taping, complete with trunkloads of her own gorgeous clothes and, best of all, the family jewels that had come her way through her marriage to Archie Stirling. The diamond and pearl choker would become one of her onscreen signatures for *Mystery!* The crew was dazzled by her. After being dressed and made up by the "painters and decorators," as she called them, she'd stride into the cavernous, dark studio, a full five foot ten inches in stiletto heels, with perfume drifting in her wake.

She'd call out "Morning!" in her famous voice. Classically trained, she'd do some vocal warm-ups, then deliver the introductions in perfect takes. She was literate, smart, and (off camera) as bawdy as Vincent. Over lunch she'd tell us the best London theater and royal gossip: who was doing what, to whom, and how often. She was our blog and our Twitter feed.

Diana took the job right away: "I loved the work because I loved the programs. This was PBS showing English television and English actors at their very best, although I wasn't really an Agatha Christie or Poirot type. It was the American mystery novels that I loved: Raymond Chandler, noir.

"When Rebecca and I worked through the scripts together, we were completely *d'accord*. We understood each other. Whatever I suggested, she largely took on board. It was easy-peasy, though it did take me a certain amount of time to get into the style of presentation so that it would be seamless.

"To become the storyteller, the presenter, you drop quite a lot of obvious personality traits. You need to be positive, but without the curlicues of a personality. I needed to feel comfortable with the persona of the presenter and do it without flourishes. You must believe what you say—be sincere, with no embellishment.

"I've always had the theory that actors and actresses should be able to do everything, including musicals and tragedies and comedies. Presenting in this way seemed another branch of what one should be able to do, and do well."

The second year Diana was with us, we co-produced with the BBC one of my very favorite miniseries, *Mother Love*, starring . . . Diana Rigg. She played an elegant monster of a mother who loves her handsome son so much that she systematically picks off every single person who gets close enough to him to threaten her supremacy: friends, coworkers, wife, and ultimately, him!

In the role, Diana wore her famous thick dark hair slicked back in a bun and purred her diabolical plans directly to camera: "Puss-cats, I simply *must*. . . ."

Her character was a Freudian archetype for the ages, and I am sure she had men all over the world shriveling in fear. Diana, the onetime leather-covered sexual obsession, now the host of *Mystery!*, had the delicious task of introducing herself as the ultimate ball-busting mother in *Mother Love*.

*Mother Love* was the first time I'd worked with the writer Andrew Davies, who would gradually become the virtual house scribe for the BBC and for *Masterpiece Theatre*. He would eventually adapt *Middlemarch*, *Pride and Prejudice*, *Sense and Sensibility*, *Emma*, *Moll Flanders*, *House of Cards*, *Bleak House*, *Northanger Abbey*, and *Little Dorrit*, among others. But this was the first time I saw the genius way in which Andrew can read a so-so novel like *Mother Love* and transform it into a witty, lucid, cliff-hanger of a screenplay.

Andrew was thrilled with Diana's interpretation of his words: "I thought it was a great bit of casting, because the mother in the book, and the character I'd been imagining when I was writing it, was a small, blonde, rather weaselly sort of person, who got round men in that way and enslaved her son. Without needing to alter any lines, Diana Rigg turned her into this scary monster, a kind of operatic figure. I thought that was splendid and extraordinary. *Mother Love* wouldn't have been anything like it without her performance."

Diana, who claims she is not well educated, is formidably bright, well read, and curious. We would spend hours talking about books and history.

I love what she says: "Rebecca and I have got quite a lot of our tastes side by side."

She'd grown up in India and loved to travel. We would share books back and forth, and gradually we moved from a purely professional relationship to a friendship. It was that admirable British trait again, of befriending people slowly, then holding them fast.

She would bring little gifts for Katherine ("How's the heiress?") and include me in family occasions if I happened to be in London: the celebration of her CBE when the queen dubbed her "Dame Diana" at Buckingham Palace, and her installation as the chancellor of the University of Stirling near her home in Scotland. She loved the part of each year when she and Archie would spend time at his gorgeous ancestral estate, Ochtertyre, a big stone house with acres and acres of land. Diana played the regal hostess for annual fishing and shooting parties, which of course brought in some paying customers. When I visited, she insisited that I sleep in the grandest of the guest rooms, full of blue silk and a huge canopied bed. In that old, familiar ritual, she would bring me my early-morning tea herself. It really was like being in a *Masterpiece Theatre* production.

Diana can be very intimidating: maybe it's self-defense, the kind

that a beautiful woman in show business in that era (or in any era, maybe) needs to have to protect herself from being exploited or manipulated. Diana can call up a sudden stony coolness when she's not pleased. My mother used to do it too, and it completely rattles me. When it happens, I don't know where I stand, and I instantly assume that I've done something dreadfully wrong.

And on one occasion with Diana, I did do something dreadfully wrong. My daughter's school was having an auction to raise money. I offered "Lunch with Diana Rigg." It sold immediately, at top dollar.

When Diana arrived in Boston for our usual taping, I said, "Oh, by the way, there's a family coming for lunch later this week."

"Who are they?"

"They're a family from Shady Hill School. They put in the high bid for lunch with you."

Silence: she handled it the way my mother would have, which is not to say anything but to shut down. Diana got stony and wouldn't look at me for the rest of the day.

I crawled to her and said, "Diana, I know that was wrong. I'm very sorry."

Diana explained, "I've been sold many times. What I minded was not being asked in advance."

And on we went.

I don't think I realized just how good an actress Diana is until the summer of 1990. She arrived in Boston as usual with all the trunks and the jewels. We taped for days, lunching, chatting—our ordinary routine. She was a bit quieter than usual and religiously excused herself every afternoon at one p.m. to make a call to her twelve-year-old daughter, Rachael, who had just started her first term at boarding school in England.

When Diana went back to England two weeks later, the story broke that her dashing husband, Archie, had come to her just before

she'd left for Boston to tell her he was having an affair with Joely Richardson, Vanessa Redgrave's younger daughter, who was then in her twenties. Diana was fifty-two.

As it always does with this kind of story, Diana's and Rachael's lives changed completely that day. We knew nothing about all this at the time, and Diana never said a word, nor even pleaded a headache. She had had to send her "Rachie" away to school and then get on a plane for Boston. Can you imagine? That's a true mother-career balancing-act moment.

I didn't know it at the time, but during those weeks in Boston, Diana would cry in her hotel room at night, come to the studio, and tell no one what was going on except Louise, our wizard makeup person who had to repair her face for the relentless TV close-ups. And then Diana would walk into the studio: "Morning!"

It was a very private, bravura performance.

Diana and I have talked about it since; and as hard as it was, she says that hosting *Mystery!* saved her bacon: "Fate seems to smell out the people to kick in the teeth. You have a divorce, and at the same time, there's no job. At that point I wasn't short of money, but just to get out of England was a lifesaver."

She reflects: "Being a host on *Mystery!* broadens your profile, certainly in America. A weekly slot on television did me a huge favor in that respect. After that, I entered a rather wonderful late flowering in the theater, where I did a lot of heavy roles: *Medea, Phaedra, Mother Courage, Who's Afraid of Virginia Woolf?*, and *Suddenly Last Summer*."

I loved the example that Diana presents: a strong working woman who evolves from classically trained ingenue to powerful, sexy crime-buster, to internationally famous, constantly working actor in theater, movies, and television. Her career has lasted over fifty years; now in her seventies, she has recently had fun with parts in *Doctor Who* (with her daughter, Rachael, who is now also an actress, appearing in

*The Bletchley Circle* on PBS), and as Lady Olenna Redwyne, the "Queen of Thorns," in *Game of Thrones*, a perfect role for a regal woman.

Life at *Masterpiece* fell into a reasonably comfortable rhythm in the late 1980s and early 1990s. We had good, solid, ongoing *Mystery!* series like *Inspector Morse*; P. D. James's Adam Dalgliesh stories, starring Roy Marsden; Joan Hickson as Miss Marple; *Rumpole of the Bailey*; and of course Jeremy Brett as Sherlock Holmes. *Masterpiece Theatre* was a bit thinner, but we did present *Silas Marner* (1986) with Ben Kingsley; John le Carré's *A Perfect Spy* (1988); and of course, *A Tale of Two Cities* (1989). The Mobil money was flowing nicely.

Occasionally I'd be reminded that I wasn't pleasing all of the viewers all of the time. I saved one letter written immediately after the broadcast of an apparently disappointing program: "Well, Rebecca. . . . You've produced another bomb, another dud loser . . . the fact is that you're a terrible executive director [*sic*]. You lack focus and direction. So we've shut off still another Rebecca Eaton bomb."

But things were generally going smoothly. I could enjoy small Katherine's childhood, and at least pretend that I was the mother I had wanted to be. These were the years of almost constant pregnancy and miscarriage; and my ideal family of four children never materialized. I was over forty by then. How had I ever thought I could manage a working life with four children?

I truly didn't think much about work at night or on weekends when I was home. Perhaps I might have had a much bigger and more profitable career if I had. I played with Katherine and did "boutique housekeeping," as Paul called it: a little laundry, ironing, shopping at specialty stores, and cooking—never touching a vacuum, a bathtub cleaner, or a rake. He did all that—and the school pickups, and sports, and drum lessons. Often dressed in splattered painter's overalls,

chewing on an unlit cigar, he'd show up alongside the J. Crew, pearl-earring mothers to pick Katherine up at school.

He and Katherine were tight, and I never worried about her well-being when I was away from her. But I wanted so much to stay close to her, to know everything about her. I think our relationship could have become even more hothouse and helicopter-mom-ish than it is, except for the serendipity of having the Ross family for neighbors. Rachelle and John—he the son of a child psychiatrist, and both of them from large, happy families—lived two doors away, and they eventually had six daughters. They swear they don't know how this happened.

Their girls—Robyn, Kaleigh, Martha, Gwyneth, Charlotte, and Fiona—became like sisters for Katherine, a child who I always thought should have had siblings. They taught her about competition, something hard for an only child to know.

Rachelle kept my parental feet on the ground, not so much by offering advice but by being the kind of confidante, sounding board, and fellow traveler that parents everywhere need. We'd talk groggily on the phone at seven every morning as Paul brought me cups of extra-caffeinated coffee in bed. We would share war stories and heart-ache about our kids, then get up and do it all again. She gave me context for raising Katherine. My favorite memory is of talking to Rachelle one morning at six-thirty, she in her bed, I in mine, bed-room doors shut, no children allowed for the moment. While we were talking, she got a little knock on her door.

I heard her end of the conversation: "Yes? Is there blood? Is any-one unconscious? Okay then, you girls work it out. I'll be down in a minute."

But at work there were a few clouds on the horizon. While most of the programs we were doing at *Masterpiece Theatre* and *Mystery!* in

the late 1980s and early 1990s were pretty good, and our audience was spectacularly stable, there were no real hits on the order of *Upstairs, Downstairs* or *The Jewel in the Crown*. Some of the titles seemed, even then, creaky and obscure. Even Sir Laurence Olivier reprising a bit of his Archie Rice character from *The Entertainer* in our *Lost Empires* (1986) didn't really move the needle with viewers or reviewers. *The Bretts* (1987–88), about a theatrical family like the Barrymores, missed the mark, failing to be the new hot item. I nervously spent some political capital by resisting Mobil's wish that we commission a full thirteen-episode, second series of *The Bretts*, a pet project for Herb Schmertz and his sidekick Frank Marshall that I'd inherited from Joan Wilson.

When I dug in my heels and resisted, I think Herb took Henry Becton aside to ask him who this upstart young woman thought she was. In the end I committed to six episodes.

*Masterpiece Theatre* had made its name in period drama: costumes, carriages, and country houses. *Period* didn't have to mean seventeenth or eighteenth century: anything set before 1950 made the cut. Modern detectives like Inspector Morse and Adam Dalgliesh were doing well; but *Mystery!*, we thought, had a different kind of audience. I began to notice that some of the most interesting projects being pitched and made in England were contemporary stories, edgier and more realistic, but still beautifully written, and often featuring our favorite actors. I wondered if we should broaden the *Masterpiece Theatre* concept to take advantage of them.

Some were adaptations of books, and some were written directly for television. I remember a couple of miniseries that I, personally, found riveting. *Edge of Darkness* (1986) from the BBC, was about a policeman who vengefully investigates his daughter's murder and wades into a world of nuclear espionage. It never made it to U.S. television, but it was remade as a feature film with Mel Gibson in

2010. And of course there was Dennis Potter's *The Singing Detective* (1986) from the BBC, starring Michael Gambon—a hallucinatory, groundbreaking musical film noir (later shown on PBS but not on *Masterpiece*). If I loved these shows, wouldn't *Masterpiece Theatre*'s loyal viewers love them too? I wasn't sure. . . .

Younger drama commissioners were coming on board at the BBC, at its commercial counterpart ITV, and at the relatively new Channel 4. They wanted to break out a bit and make their marks. But did our audience *want* to be broken out? Did they want to sit on their couches at home and watch some young Englishman make his mark? Our viewers were Anglophiles of the first order, but their version of Anglophilia was escapist time-travel to the old England of their heritage, of their dreams, or maybe of their favorite books.

At a routine screening in London, I was shown, almost accidentally, the first episode of a miniseries that was so good it gave me the shivers. *A Very British Coup* was adapted by Alan Plater from a not-so-good 1982 novel about a hugely popular Socialist prime minister who is brought down by his conservative enemies when they discover his personal secret. It was a classic conspiracy tale with no famous actors, just great writing and very moving performances. It was unlike anything *Masterpiece Theatre* had done, but something told me it was the right project to dangle in front of our audience to test their appetite for contemporary material.

Henry Becton agreed, but Mobil's adviser, Frank Marshall, did not: "This is not what we signed on to do at *Masterpiece Theatre*."

Herb Schmertz had never been in favor of contemporary shows on *Masterpiece*, either: "I felt that there was no venue other than *Masterpiece Theatre* for costume drama and historic drama, and that there was no need for another source of contemporary drama."

Maintaining the boundaries with Mobil was always a delicate task. But in this case, Henry thought they had a point. They had

originally signed on as the funder of classic costume drama, not conspiracy thrillers.

The political stakes had gotten higher in 1988 when Herb Schmertz resigned from Mobil, shortly after attending a board of directors meeting in a Savile Row suit, a silk pocket square, a matching tie . . . and an earring. He must have grown tired of corporate culture and was having a little fun with it.

His version: "I'd been at Mobil for twenty-two years and one month, and I wanted to have my own consulting business. And things were changing."

Our new "godfather" was Pete Spina, who was more of a New York street fighter than the elegant Anglophile that Herb was. Pete was new: his commitment to funding *Masterpiece Theatre* was untested, and Henry and I realized that challenging him so early in the game could threaten the series. In fact, he asked us *not* to buy *A Very British Coup*. But we did, looking beyond this one show to the world of shows that its success might open for us. We believed strongly that *Masterpiece Theatre* could not survive in the long term by just relying on centuries gone by: we had to start including contemporary material.

*A Very British Coup* got brilliant reviews and strong ratings, and it won the 1988 International Emmy for Best Drama. Eventually even Mobil liked it. It was broadcast in more than thirty countries. But buying it had been a dangerous victory, for me at least. Losing a battle of authority was not an event that a man like Pete Spina would forget.

We were on our way with new modern themes for *Masterpiece Theatre*. The audience seemed willing to forgo the frocks every now and then and enjoy present-day stories, so I kept looking for likely projects. The frock dramas still decorously filled the schedule, of course. We did *A Tale of Two Cities* that year, and also one of Alistair Cooke's all-time favorite programs, *The Charmer*, the life story of a cad.

A big title came along the year after *A Very British Coup* aired. It was a complicated international story about heroin: how it grows as a beautiful flower in Pakistan and ends up killing people's beautiful children in London. It was told from three points of view: a Pakistani farmer, a German drug runner, and a British crime-busting official whose daughter is addicted to smack.

I thought it was too much—too real for an audience who looked to *Masterpiece* for relief from real life.

My husband, Paul, famous for falling asleep during the opening credits of most of the British dramas I brought home, sat bolt upright on the couch for this one—all six hours of it: "You *have* to take it, Beck."

Rather reluctantly, I did. It was called *Traffik*, and it won the International Emmy for Best Drama in 1990 and in 2000 became the basis for the Oscar-winning movie *Traffic*.

I like to bask in the credit for successfully introducing contemporary material into the *Masterpiece Theatre* schedule, until I remember my hesitation about *Traffik* and my boneheadedness about at least two other projects.

In 1991 Granada Television sent me a script about a young woman in the British police force. Granada was the company that had made *Brideshead Revisited*, *The Jewel in the Crown*, and *The Adventures of Sherlock Holmes* starring Jeremy Brett. Based on that track record, you'd think the appropriate response to this well-written script would have been an instant yes. But I said no, confident that a story about a woman, tough but tenderhearted, working in a man's world—and so obsessed with her job that she had no personal life—was much too like an American cop show to be of interest to our audience. It was just a police procedural, set in London and later Manchester, England.

Then Granada cast Helen Mirren to play the lead, DCI Jane Tennison. I knew Helen's work a little because of her rather racy roles in

some independent films, like Peter Greenaway's *The Cook, the Thief, His Wife & Her Lover* (1989); but that still didn't stop me from continuing to say no.

Henry happened to read the script, and he saved me from myself: "Rebecca, are you *sure* you want to turn this down?"

Even Mobil liked *Prime Suspect*. What could I have been thinking?

I hope Helen doesn't know about my hesitation (well, she will now . . . ), because not only did she become an international movie star but she's also one of *Masterpiece*'s favorite actors and has generously been a glamorous, charming press darling for us. We never had any money to advertise *Prime Suspect*, so Helen did endless interviews, features, teas, and screenings—the really heavy lifting of publicity. She also agreed to do something I asked her to do, which I now think was a bit beyond the call of duty.

Lou Noto was then the CEO of the Mobil Corporation. He was a smart, tough man with great taste. He genuinely loved *Masterpiece Theatre* and was very taken with Helen. He asked me if she might be interested in having dinner with him.

Okay: this was Lou Noto of Mobil, one of the most powerful men in corporate America and the source of my bread and butter. I didn't think Helen would be interested in having dinner with anybody— she was working very hard—but I was pretty sure she'd be interested in helping to ensure that *Masterpiece Theatre*, which was co-producing her *Prime Suspect* series, remained solvent. She agreed.

Returning from a business trip to Doha, the capital of Qatar, Lou stopped off in Manchester, where Helen was shooting *Prime Suspect*, took her out to dinner, and flew on to New York. Impossible to cite cause and effect, but Mobil continued to underwrite *Masterpiece Theatre* for several years. Helen Mirren was always great copy because— like Meryl Streep and Emma Thompson, my two other favorite, beautiful Smart Women actresses—she is very honest. These women

say what they really think to the press. They all come from solid stock—hardworking families—and seem unbedazzled by their own immense celebrity. They use it to speak truth to power, as well as to everyone else. They play and laugh a lot.

As a child of the 1960s, brought up in the nursery of feminism, and as the daughter of an independent woman with a successful career, I look on these women as the very best kind of girls we can be. They are sensual and sexy to men and women alike, opinionated, loving, smart, and informed. They are raising their families carefully, keeping them out of the limelight for as long as possible; and they use their star power to support other women and causes they believe in. They are the good girls.

Since her 2006 Oscar for *The Queen*, Helen has moved on to the promised land of movies and does very little television anymore, except for HBO, of course. But I remember how she referred to the seven *Prime Suspects*. We called them "PS1, PS2, PS3," and so on. She called them "PMS1, PMS2," etc.

As I sit here revisiting my close call with *Prime Suspect*—how I was so certain our audience wouldn't go for it—horrible professional memories of close calls that didn't turn out so well are cropping up.

One week in April 1988, I was on a "shopping trip" in London, staying at a lovely art deco hotel, the Berkeley. I had had an exhausting few days making the rounds of producers and broadcasters, being pitched many good, great, and awful projects. Late one afternoon a small package arrived from Granada Television—the people who'd made *Brideshead Revisited*, *The Jewel in the Crown*, *The Adventures of Sherlock Holmes*, and *Prime Suspect*—remember? There's an alarming pattern here. . . .

Inside the package was a cassette and a note asking me to look at the tape as soon as possible. If I liked the program for *Masterpiece*

*Theatre*, we could do a deal; otherwise the producers would try to release it as a feature film. I was tired and looking forward to dinner that night with John Mortimer and his wife; I just wanted a nap. But crankily, I asked the porter for a VHS machine to be set up in my room. It took an hour and several hotel employees, but eventually I sat down to watch the tape. The quality was bad; the picture was very dark, and the audio was rough. After a half hour or so, I had seen enough. The *Masterpiece Theatre* audience would absolutely *not* want to see a film about a working-class Irishman, disabled from birth, who could control only . . . his left foot.

A year later, in April 1990, Daniel Day-Lewis (as the poet-painter Christy Brown) and Brenda Fricker (as his mother) both won Oscars for their performances in *My Left Foot*. After I passed on it for television, the producers had found a theatrical distributor immediately. It was snapped up by Miramax, then owned by the legendary Weinstein brothers.

I still haven't completely recovered from that episode, not only because the film would have been a major coup for *Masterpiece Theatre*, but, worse, because Daniel Day-Lewis is now, has been for twenty years, and always will be, my favorite actor in the world. If I had been thinking straight enough that day to do a deal on *My Left Foot*, I might have met him, breathed his air, and maybe even talked to him about future projects. But now he's gone, disappeared into the thin air of Hollywood and feature films, just like the magician he is.

*Masterpiece Theatre* survived that mistake and has actually dipped into other feature film waters over the years. We've aired two of Kenneth Branagh's Shakespeare films, *Henry V* (1989) and *Much Ado about Nothing* (1993), both made while he and Emma Thompson were still together. The films were released in movie theaters first, then aired on *Masterpiece Theatre*.

Starting with *Fortunes of War* way back then and continuing straight through to the current *Wallander* series, we've featured as much of Ken's work as we can. He's not only starring in the mystery series *Wallander*, he's also one of its producers. *Wallander* is based on a series of Swedish books by Henning Mankell about a lonely, obsessive, kindhearted, but difficult detective. (Hello, Inspector Morse? Inspector Lewis? DCI Jane Tennison? DCS Foyle?) Ken is keenly aware of how he can help us promote *Masterpiece* and his show in the States. He's never failed to answer our call.

"I think people admire *Masterpiece*'s longevity and understand that that has to be earned—and that it represents a constituency of viewers," he has remarked. "As a Brit watching it in America, you start to see the work gathered together as you have not seen it, even though you may have been exposed to it in other places. It feels coherent and brings together various bodies of work to create something that's perhaps greater than the sum of its parts. In so doing, *Masterpiece* adds a weight and heft to the work it presents.

"It also presents the material with enthusiasm and passion and intelligence—and a sense of occasion. In England we don't have the introductions on the shows as aired on *Masterpiece*, whether by Alistair Cooke or by those who followed him. The respect paid to the work itself is something to be relished. The presentation imparts excitement about watching it, which is a really special thing."

There are two feature films that I'm very proud to have been involved in: *Persuasion* (1995), directed by Roger Michell, and *Mrs. Brown* (1997), directed by John Madden. As it happened, I backed into both of them, becoming involved when they were just television scripts, not yet movies.

In 1994 the BBC proposed that we co-produce Jane Austen's last book, *Persuasion*. It's my favorite Austen, the quintessential second-chance love story. Anne Elliot has been persuaded by an overprotec-

tive lady friend not to accept the proposal of the man she loves, the dashing Captain Wentworth. The captain, wounded and angry, has sailed away, and Anne has resigned herself to the spinster life. Six years later, when the book begins, he returns—and is soon seen in the company of another lady. Anne, of course, has never stopped loving him. Pride and misunderstanding continue to keep them apart; then as Captain Wentworth prepares to depart again, Anne receives his good-bye letter.

At the very dramatic last minute, she flies through the streets of Bath trying to find him—and she does. What a story, for any of us who have had, missed, or longed for, a second chance at love.

I was disappointed that the script was only a single two-hour film instead of a luscious six-part miniseries that we romantics could have sunk our teeth into, but I agreed that *Masterpiece Theatre* would coproduce *Persuasion* as a television film. Things went along fine as we developed the script, until we came to the very last scene. Nick Dear, the adapter, wrote it very much the way Jane Austen had: Anne flies through the streets of Bath and finds Captain Wentworth, and they are reunited with a few gentle words and a chaste touching of hands.

I thought our audience would go nuts with frustration and irritation if, after two hours of rooting for Anne and the captain and longing for their reunion, they couldn't see them kiss. Never mind that in Jane Austen's time, there never would have been such a public display of affection. I suggested that the captain and Anne could slip into the shadows behind a column or something and thereby avoid the wrath of the purists—the Jane Austen police.

I argued my case passionately—and with lots of laughs—with the director, Roger Michell, who finally said: "Look, I'll shoot the scene two ways. They'll kiss in the American version, and they'll touch hands in the British version."

After the film was shot but before it aired, the feature film com-

pany, Sony Pictures Classics, saw a print, loved it, and offered the BBC and *Masterpiece Theatre* good money to show it first as a movie, before its television broadcast. We all agreed, and I'm proud to say that the final scene in *all* versions of the film, and even the international poster, featured a delicate, heartfelt kiss between Captain Wentworth and Anne Elliot.

*Mrs. Brown* also started life as a TV movie with the BBC, until Harvey Weinstein sniffed it out and made it a feature film. Once again the Miramax money helped pay for future *Masterpiece Theatre* productions, and the movie gave *Masterpiece* a bit of Hollywood limelight.

To me, *Mrs. Brown* is a brilliant example of how a small event—in this case, a little-known relationship—can be the entry point to a larger historical story. Queen Victoria was crowned when she was sixteen; her reign lasted sixty-three years. Someday perhaps there'll be a majestic ten-hour miniseries telling that story. But *Mrs. Brown* focused on just the one or two years following the death of Victoria's beloved husband, Albert, a time when she descended into an isolated, detached grief that threatened the monarchy. Into her life came a robust Scotsman, John Brown, a gamekeeper, or ghillie, who pulled Victoria out of her darkness and literally back into life. They became inseparable: people snickered and called her "Mrs. Brown."

Their story was a small moment in Victoria's life, but it was dramatically perfect. Judi Dench immediately agreed to play Queen Victoria, but who'd play the Scottish ghillie? Douglas Rae, the producer, had the brilliant but slightly harebrained idea to send the script to Billy Connolly, a big, brash, often raunchy Scottish stand-up comic—not an actor, a comedian. Billy read the script, liked it, and relayed his acceptance with one condition: he wanted to play Victoria. As I said, he's a comedian. Douglas convinced him that Judi would look better in a frock.

Billy and Judi were wonderful together; but Billy, enthusiastic and untrained, never performed two takes the same way, driving the director John Madden around the bend for much of the shoot.

Judi was nominated for an Oscar, and we all went to Hollywood for the 1997 Academy Awards. It was the same year *Good Will Hunting* was nominated, and it won Oscars for Matt Damon, Ben Affleck, and Robin Williams. I have three memories from those Oscar festivities: (1) seeing Robin Williams with a doily on his head, being Queen Victoria in a skit at a Miramax party, while Judi Dench spouts f-bombs, playing a tough guy from South Boston; (2) accidentally stepping on Julie Christie's train on the red carpet and getting a filthy look from her; and (3) offering handfuls of Kleenex to Matt Damon's stepfather, who wept copiously when Matt won.

Oddly, as I write about *Mrs. Brown*, I remember exactly what I loved best about that film, and how much it resembled another project, one that got away and became a movie without us. That was *Truly Madly Deeply* (1990), and it tells the story of a woman, played by the luminous Juliet Stevenson, who, like Victoria, becomes a widow. Her husband dies suddenly, but she can't bear to let him go and imagines him still in her life.

Both movies are about grief: Queen Victoria's for her dear Albert; and Nina's—Juliet's character—for her husband, Jamie. How remarkable and risky it was to make a popular film about this most delicate, indescribable, deep, universal human emotion. How do you show real grief—and even more subtle, the emergence from grief—in a two-hour movie?

Both movies caught the very moment, in scenes with Judi and Juliet, when a bereaved and mourning person finally turns away from sadness, lets her beloved go, and starts her way back toward life. What a lovely contribution.

# EIGHT

# A Changing of the Guard

About five years after I arrived at *Masterpiece Theatre*, the BBC proposed a project for co-production that I thought would be perfect for us. Well, it was, and it wasn't—and therein lies a tale.

*Portrait of a Marriage* tells the story of the highly unusual marriage of the writer Vita Sackville-West and the writer-diplomat Harold Nicolson. It's part a memoir written by their son, Nigel.

Like many female English majors of the 1960s—and probably even now—I loved reading about the Bloomsbury group: Vita, Virginia and Leonard Woolf, E. M. Forster, Lytton Strachey, and the rest. They were smart bohemian writers and artists living in London and in beautiful country houses in the 1920s, '30s, and '40s, avant-garde and privileged. In 1991 *Masterpiece* had aired Eileen Atkins's brilliant "monologue" of Virginia Woolf's essay "A Room of One's Own," then and now a feminist manifesto and a gorgeous piece of theater in Eileen's hands.

*Portrait of a Marriage*—a miniseries to be adapted by Penelope

Mortimer, the *first* Mrs. John Mortimer (by the way, when he married his second wife, also named Penelope, he called his company New Penny Productions)—seemed just right to me.

The story was set in London, in Paris, at Vita's extremely photogenic family estate, Knole, and at Sissinghurst, where Vita kept the famous gardens on the grounds of the castle where she and Harold lived. There would be lovely frocks and drawing rooms. With so many things sounding right, what could go wrong?

Vita and Harold were a famously interesting and drama-worthy couple: both of them continued to have homosexual affairs even after they were married, but their relationship remained deep and enduring. I thought our audience was ready for a bit of nontraditional sex. The book certainly covered the unusual aspects of their marriage. In fact, the television script was pretty much all about Vita's love affair with the English socialite Violet Trefusis. Interesting, I thought, oblivious to the cultural storm clouds gathering over the project. Though the love scenes between Violet and Vita were fairly discreet, they were still scenes between two women; you couldn't get around that, and when PBS heard we were co-producing it, some executives became restive.

Two years before, in 1990, *American Playhouse* had aired *Longtime Companion*. In 1992, *Great Performances* from WNET was about to air *The Lost Language of Cranes*, a gay love story based on a novel by David Leavitt. PBS was stepping out and acknowledging gayness in its dramas. Earlier, in *Brideshead Revisited*, even though Sebastian was clearly a gay man, and we could infer that the character played by Jeremy Irons was bisexual, it was all veiled. There was no veil in sight in Leavitt's tale, and none whatsoever in *Portrait*.

In my world, and in the "sophisticated" worlds of New York, Los Angeles, and San Francisco, homosexuality seemed on its way to becoming culturally acceptable. The Stonewall riots had happened

twenty years before; the AIDS epidemic had touched millions of families. People were coming out every day. But public television stations in some parts of the country might not have agreed that the program was acceptable for their audience. After PBS screened the British version of *Portrait*, they asked us to look into toning it down.

I think we took out some toe sucking, and we trimmed some other scenes to meet time constraints—not much, but enough to cause trouble in the gay activist community. The word got out that we were "cleaning up" the show. It didn't help that the BBC producer gave a very damaging interview, saying, "I suppose these Americans [meaning me] didn't know what they were getting into."

American gay rights groups manned the barricades and started a media campaign against the editorial policies of PBS. The Gay and Lesbian Alliance Against Defamation (GLAAD) organized a protest. Everyone was mad, and we hadn't even aired the program yet.

Mary Silverman, the BBC's representative in New York and the woman with whom I'd done the deal, went to work on our behalf: "I called the head of GLAAD and their press person and said: 'Are you crazy? Do you ever want to see anything gay on television—particularly on *Masterpiece Theatre*? In your zeal, will you make it impossible for this kind of thing ever to be done again?'

"I explained [to GLAAD] that *Masterpiece* had to edit the program, primarily for time. And I'd seen the parts of *Portrait* that had been cut: most were boring and repetitious. Many involved Violet Trefusis weeping, which she did quite enough of throughout.

"I added that if their goal was to see true depictions on television of how gay people live their lives, it was crucial that they back off. I also explained that no rape scenes had been cut, as rumor had it—just more of Violet in tears.

"The whole thing had been blown out of proportion. GLAAD had been willing to start a war about something that was basically in their

interest. What was important was that Rebecca was presenting an honest depiction of this relationship that was at the very least bisexual. If Vita had lived today, I doubt she would have been married."

Just as the production was turning into a potential public relations disaster, I got a phone call from Larry Kramer, an award-winning playwright (*The Normal Heart*), head of the AIDS awareness group ACT UP, and a major and always articulate, if challenging, figure in the gay rights movement. I'd never met him. But in the most immediate, warm, and engaging way, he asked: "Rebecca, what's going on?"

Before he unleashed the forces of ACT UP, he wanted to get the full story.

"Larry," I said, "let me explain what we're doing here."

We had a long, thoughtful conversation. He asked to see the outtakes; I told him I couldn't do that. He was a sophisticated and experienced activist and understood editorial policy.

After an hour or so of good conversation, he said, "I trust you, Rebecca. Don't worry, I'll calm people down."

And he did. But after we got that business settled—which, by the way, generated a great deal of free publicity for the broadcast—I discovered that we had another problem, right in the family. Alistair Cooke refused to introduce *Portrait of a Marriage*. He had never objected to a program before, but he was in a real lather. It wasn't just that he'd personally known and admired Harold Nicolson—of whom he could do a priceless imitation. Nor was it because of the lesbian love scenes (at least I don't think it was)—Vita's lifestyle was well known to him and to most of the world.

It was because he strongly disapproved of children who write revelatory, tell-all books about their parents. He really and truly felt that it was unfair and immoral, particularly if the parents were dead and unavailable for comment. He made his case to me again and again.

I knew that if he recused himself from the program, the press would

have a field day; GLAAD and ACT UP would come after us again; and both PBS and the BBC would be enraged. But how do you order (Sir) Alistair Cooke to do something he feels morally unable to do?

You don't. You find an intellectual argument that might coax him out of the corner into which he has painted himself. And thank God I inadvertently discovered the right argument as I was rereading Nigel Nicolson's preface to his book:

"When my mother, V. Sackville-West, died in 1962, it was my duty as her executor to go through her personal papers. . . . I took a final look round her sitting-room in the tower of Sissinghurst (a room I had entered only a half a dozen times in the previous in thirty years), and came upon a locked Gladstone bag lying in the corner of the little turret room that opens off it. The bag contained something—a tiara in its case, for all I knew—and, having no key, I cut away the leather from around its lock to open it. Inside there was a large note-book in a flexible cover, page after page filled with her neat, pencilled script. I carried it to her writing-table and began to read. The first few pages were abortive drafts of a couple of short stories. The sixth page was headed 'July 23rd, 1920,' followed by a narrative in the first person that continued for eighty more. I read it through to the end without stirring from her table. It was an autobiography written when she was aged twenty-eight, a confession, an attempt to purge her mind and heart of a love that had possessed her, a love for another woman, Violet Trefusis. . . .

"Although V. Sackville-West left no instructions about her autobiography, and as far as I know had never shown it to anyone, I believe that she wrote it with eventual publication in mind. It assumed an audience. She knew that I would find it after her death, but did not destroy it. She wrote it as a conscious work of art, in such a way that it would be intelligible to an outsider . . . There are passages in the manuscript suggesting that the writing of it was for her much more

than an act of catharsis. She refers to 'possible readers' of it. She believes that 'the psychology of people like myself will be a matter of interest' when hypocrisy gives place to 'a spirit of candour which one hopes will spread with the progress of the world.' That time has come now."

I think Alistair was relieved when I brought this passage to his attention. He saw that Nigel was doing nothing less than carrying out his mother's expressed wishes. As a journalist, Alistair hated the thought that by refusing to do the introduction, he would become part of the story. And he had absolutely no appetite for public, or even private, confrontation. So he found his way through the moral thicket. He was honest in his introduction to the first episode:

"Good evening, I'm Alistair Cooke.

"Tonight we begin a story, a dramatization of a true and extraordinary marriage which requires from me a very personal introduction indeed."

Then he told the tale of the book's publication in 1973 in England and the backstory of its protagonists. Here's the part where it got personal for Alistair:

"Here was my problem. The book was written by their son Nigel Nicolson, and that to me was a trauma. I may be a lapsed Methodist, but there are some forgotten values that can be shocked into life again, and I'd been brought up on the Old Testament. I knew that the sin of Ham was seeing the nakedness of his parents. How about staging the nakedness of your parents? And the Commandment, 'Thou shalt honor thy father and thy mother.' But if you can't do that, the decent least you can do is not to rat on them when they're dead.

"So I felt I could not conscientiously introduce the dramatization of such a book. Then last Christmas I came on the book again and read it over. I must have been blind with distaste the first time because my scruples crumbled under the weight of the discovery that Vita Sackville-West's autobiography and diary, the substance of the book,

is an agonized, candid account of the whole affair, and she makes it clear as a bell that she wants it published to the world. And so she did, and here it is."

In 1991 Alistair was eighty-three years old, and the round-trip shuttle voyage between New York and Boston was becoming a strain for him. He still loved the work, and his prodigious memory never dropped a word when he recorded his introductions. But he knew it was time to stop. He wanted to devote his energies to his first love, his weekly talk on the BBC World Service, *Letter from America*.

The BBC engineer now came to his Fifth Avenue apartment to record the talk, saving Alistair the fifty-block trip to the New York studios. Once, I believe, he even recorded the talk from a hospital room where he was laid up.

On May 21, 1992, he made his decision.

He sent Henry and me his retirement news in a very Alistair-like letter, which of course I still have, typed out on his manual typewriter.

I take my text, as you'd expect, from *King Lear*:

". . . 'tis our fast intent
To shake all cares and business from our age
Conferring them on younger strengths."

In his note he quoted letters from concerned viewers: "Are you sick? You look tired. . . ."

He quipped: "I guess the masked lighting over my bad eye didn't work very well."

It was time to stop.

After twenty-two years, how should we say good-bye to Alistair Cooke, and more important, how should *he* say good-bye to his

devoted *Masterpiece Theatre* audience? He was synonymous with the program, and we wanted to do something special, as our audience was bound to feel the same kind of separation anxiety that we were experiencing. How could we make it special—but still appropriate to Alistair's understated tone?

We set the date for his last taping. It would be the final episode of Joseph Conrad's *The Secret Agent*, a rather unmemorable program except for Alistair's "extro," the few words he often said at the end of a program, summing up or looking ahead or giving a little piece of history. This extro would be one for the ages.

Even though I went, as usual, to his hotel room at the Ritz the evening before, and even though I drank the requisite two giant glasses of Scotch, Alistair didn't read me his extro or give me a copy. He was a sly one, a true master of the moment. He wanted no one to know what he intended to say in his final television words until the moment the next day when we recorded them in the studio.

I tried to match him—sly for sly—by secretly inviting his family to join us in the control room for the taping, then for a party afterward. His wife, Jane, came, as did his daughter, Susie; her husband, Charlie Kittredge; and Alistair's son, John. I sneaked them all into the jam-packed control room as Alistair "learned" his lines out in the big studio.

Finally he came onto the set, impatient as always, and barked, "Let's go, please!"

Susie remembers: "Right before he filmed, he did what he always did, which was to spit on his fingers and then grease back his hair with his spit. It used to gross people out. But you could tell in the production room that people were almost starting to cry when he did that, because they knew they were seeing it for the last time. They were so lovely and had such affection for him."

You could practically hear us holding our collective breath. And this is what he said, perfectly, in one take:

"That is the end of Conrad's *The Secret Agent*. And I'm sorry to say that as far as I am concerned that is the end of *Masterpiece Theatre*.

"I was hired for two years, and they turned into twenty-one . . . I don't have many more miles to go, but I do have promises to keep before I sleep and one or two ambitions, among them an insane desire to shave a stroke or two off my golf handicap, so then I can say with King Lear: '. . . it is our fast intent to shake all cares and business from our age, conferring them on younger strengths, while we unburdened crawl toward the practice tee.'

"And so, I just want to say to all those men and women and tots who down the decades, either in the mail or in the flesh, have told us what they liked and why, a very grateful thank you. So good-night and good-bye."

David Atwood, the director, said, "Cut," and we were all silent.

Stuffing down an urge to weep, I walked out to Alistair as the composed professional he expected me to be: "Well done, Alistair. Thank you."

Then the family trickled out, and he was amazed and gobsmacked. A grand party ensued in Studio A, with the *Masterpiece Theatre* crew and staff and some Mobil people in attendance. We presented Alistair with an excess of gifts, some of which he liked (twenty-two bottles of Dewar's Scotch, his drink of choice, one for each year of his reign as the *Masterpiece* host), and an Al Hirschfeld line-drawing portrait of him, which he thought resembled him not at all and which he stuffed in a closet back in New York.

We went out for a long dinner at the Hasty Pudding Club at Harvard. (He'd been a student there in 1933 and years later, had *not* been given the honorary degree they'd offered him because he was ill on the scheduled graduation day. Harvard's policy is "No rain checks," which made Alistair furious.)

He and Jane returned to New York the next day, and the news of

his retirement broke. Reporters managed to get his home number and started calling him for a statement. He avoided comment by answering every ring, "Hospital for Special Surgery—how may I direct your call?"

How do you replace Alistair Cooke? As soon as he announced his retirement, people came streaming out of the woodwork to apply for the job—actors, writers, broadcasters, an old girlfriend of my husband's, and one of my classmates from second grade.

We conducted numerous focus groups to see which candidate might be a comfortable fit for loyal viewers long accustomed to the patented Cooke touch. Did the new host have to be English? Did he even have to be a "he"? The novelist and biographer Lady Antonia Fraser was one name tossed into the proverbial hat.

Others included John Updike ("His nose is a turn-off," sniped one viewer of the video clips we'd assembled; "Needs a British accent," said another); David Attenborough ("I'm used to seeing him in the desert"; "Makes too much noise when he breathes"); former member of the Monty Python brigade Michael Palin ("Likeable and funny"; "Would take *Masterpiece* in a new direction"); Kenneth Branagh ("A black tie presence, people would respect him"); and *New York Times* columnist Russell Baker ("Congenial and friendly, easy to listen to"; "Gentlemanly and mature"; "Trustworthy").

The beloved columnist and memoirist Russell Baker didn't seem like a natural for a role associated with British drama, but in fact he'd worked in England as a young journalist and had even covered Queen Elizabeth's coronation. There is a very sweet picture of him from that day all dressed up in top hat and tails. And as he reports in his memoir, the accessory to his coronation ensemble was a brown bag lunch! His name came up very early in the search. Journalist Christopher Lydon had worked with Russell at *The New York Times* and now worked at WGBH. He saw him regularly during summers on Nantucket and he thought he would be perfect.

But Russell's first response to our inquiries was not positive: "Only a fool or a suicidal maniac would follow Alistair Cooke."

So our search went on for a year. We bought ourselves some time by having guest hosts for the 1992–93 season of *Masterpiece Theatre*: Stephen Fry, Hugh Grant, and Linda Ellerbee. Over-the-transom suggestions poured in, some more helpful than others: "My eleventh-grade history teacher at North Quincy High School, Michael Hurley. He was tough and could tell a story. And he enjoyed doing it."

Ken Branagh was on our short list. When I rang him, he took the call at home.

He was honored and overwhelmed to be considered, he said, because Alistair Cooke was one of his heroes. After we talked about it for a long time, he said, "I'm so sorry, I have to get off the phone. I'm burning my dinner in the oven. My wife's away; I have to ask her whether she thinks I should do this."

At the time his wife was Emma Thompson. Apparently he saved his dinner but not the marriage—and he didn't take the job.

As Ken explains, "I considered it a great honor to be asked. One of the things I found attractive is that one would end up seeing a lot of really good work sooner, and in a more concentrated form. Your attention would be drawn to things you were likely to love, and that in itself seemed like a fantastic treat.

"But hosting *Masterpiece Theatre* seemed to carry with it what turned out to be, for a man of my tender years, an onerous responsibility—to follow in the footsteps of a fellow who carried such effortless authority, and a sense of history. You felt that everything that Alistair Cooke said was born out of a fantastically well-traveled man, a man of great cultivation and taste. It was a tremendous marriage of him with the brand; the two reflected each other.

"Essentially I felt I was not the act who could follow him. He was a kind of national figure, with a Cronkitean *gravitas*—and he was such

an international man, with that wonderful mid-Atlantic accent that seemed to travel the world. Alistair Cooke had this unusual, perhaps even unique, relationship with the American audience. Somehow he was already a friend of the family. Partly by virtue of his years—by the breadth of his experience—he carried the sense that you could trust him. He was the Good Housekeeping Seal of Approval on this material.

"I really thought about the offer to host the show. It was thrilling to be asked, but it was an impossible job for me."

And then we asked Michael Palin. I'd had a terrible crush on him for years, and in a deluded way, I'm afraid I thought that by offering him the *Masterpiece Theatre* job, I could finally meet him. He is of course an educated and charming man as well as a Python, and he was already a television natural in his travel series.

I found a way to contact him and arranged to meet him for tea at the Hyde Park Hotel in London. I'd heard he liked fruitcake, so I ordered piles of it. He was his world-famous "nice" self, and though I tried every possible argument, he finally said he was too busy with his other projects. I gave up and told him I hoped they'd all fail miserably.

He said, "Well, so much for the legendary kindness and generosity of the American people." We had a big hug, and he left with the extra fruitcake.

Back in Boston, as we got more focused, we realized we'd be best off with a solid journalist like Alistair.

We'd left Russell Baker alone for a year, but we kept coming back to his name. Somewhat counterintuitively, we loved the fact that he was American: it seemed to balance things out. When we asked Alistair about hiring him, he replied without hesitation: "Yes, yes, Russ Baker!"

Alistair Cooke and Russell Baker had many things in common: both were former beat reporters; both were very well read and loved politics, literature, and the movies. Both came from modest back-

grounds and had moved up in the world as a result of their educations, Alistair's at Cambridge, Russell's at Johns Hopkins. And both had a dignified—and inviting—presence that suited both our material and our audience.

We went back to Russell. This time he said yes, in his very Russell way: "I'd rather be the man who follows the man who follows Alistair Cooke, but I'll do it."

As he remembers it, when his secretary said he had a call about hosting *Masterpiece Theatre*, he'd initially thought that someone was pulling a prank: "I told her not to bother answering. Then they called back, and I realized that they were really asking me if I wanted to do it. Coming to say yes was a slow process, though hosting the show was always an attractive idea."

A few months passed. He was still mulling it over. We had stopped looking for other candidates, and I was really ready to close the deal. I flew down and took him out to lunch near his home in Leesburg, Virginia. I remember seeing him standing in his kitchen in a tweed jacket and thinking how tall and handsome he looked. I'd loved his memoir *Growing Up*, and his description of his smart, demanding mother, who, never completely satisfied with or approving of him, reminded me of my own. We made a lot of small talk, and then over coffee he said, "My wife Mimi and my daughter Kasia think I should take this job."

Strangely, this was a replay of Alistair's eventual acceptance of the host's job with the prodding of his daughter, Susie. In both cases, I think their families were encouraging Alistair and Russell to try something new, something that would get them away from their writing desks and back into the company of people.

Still, Russ Baker had concerns about Mobil's sponsorship of the series: would taking the host's position be seen as compromising his position as a columnist for *The New York Times*?

Russell explains: "I thought there was a possible conflict of interest between the *Times* and Mobil. When I went to the paper's publisher—then Punch Sulzberger, as I recall—I was told no, I shouldn't do it. That was the decision handed down.

"When I told Rebecca I had a rejection from the *Times*, she went to Henry Becton, who approached Sulzberger and suggested that my hosting *Masterpiece Theatre* wouldn't create a conflict. Punch went back and discussed it with his other advisers. In the end I think his son [Arthur Sulzberger, Jr., now the publisher of the *Times*] was in favor of allowing me to host *Masterpiece Theatre*, which settled that aspect of it."

Henry Becton affirms that "Russell had been told it was against their editorial standards to have a commentator appear in another medium. I suggested to Sulzberger Jr. that this didn't make sense, because Baker wouldn't be doing anything political or in public affairs. Being a host on *Masterpiece* was completely noncompetitive with the *Times*. I pointed out how good this was going to be for Russell, who was one of their beloved commentators, and how good it would be for the *Times*."

And as Russell Baker told me at lunch, the fact that his wife and daughter loved *Masterpiece Theatre* helped him along in his decision.

He adds: "To tell the truth, *Masterpiece Theatre* didn't mean to me what it meant to them: my wife watched it religiously. I was aware that it was a popular show, and I'd admired what I had seen. Alistair Cooke was a big attraction because I'd known his work as a journalist when I was in London in the *Manchester Guardian* office. Cooke wrote for the *Guardian*. His stuff that came in from America was wonderful. I greatly admired him.

"When I saw him on television, I thought he was aces. His commentary on *Upstairs, Downstairs* was a great lecture on the culture of the late Victorian–early Edwardian age. I couldn't possibly have done

anything that good. My interests were more in literature than in history. He would be a hard act to follow."

In the end, Russell Baker was incredibly brave to take the job, given his lack of experience in broadcasting and Alistair Cooke's legendary skill. Alistair had been on the radio for years when he took the role as host. Russell had done radio and TV sporadically in connection with his work at the *Times* and his books, but he was no seasoned professional when it came to staged performance.

Russell was hard on himself. His biggest on-air challenge was managing his hands. He explained that he automatically moved his hands when he was thinking; they were searching for typewriter keys. We gave him glasses to hold, then a book. We encouraged him to try sitting on his hands, literally.

He says: "Rebecca knew I was not meant to be an actor. She put up with my problems on air because what she wanted was a writer, I think. We never really licked the problem with my hands: try as we did, I couldn't stop them. When I wasn't thinking about hands, the hands were thinking for me. Her crew started shooting me so that you couldn't see my hands. There were a lot of mug shots."

We made a decision right away to change the look of the set. For Alistair, we'd created an entirely new environment keyed to each program, but we built one Russell Baker *Masterpiece* Host Set, which we took in and out of storage for each new series. It was customized for each title with show-specific props but always against the same backdrop.

Producer Erin Delaney fills in: "Though the furniture came and went, the walls and the fireplace and the French windows were all part of the basic Host Room, which was kind of a country home in an unspecified time, though determinably in the past. We always threw in a few contemporary pieces too. If you took away the Victorian furniture—that armoire there, and those candlesticks there—you could work wonders with lighting."

Russell Baker hosted *Masterpiece Theatre* for a dozen rich years, from 1992 to 2004. During his tenure this most American of low-key, self-deprecating geniuses presented such British productions as *Middlemarch, Moll Flanders, Jeeves and Wooster, Wuthering Heights, Great Expectations*, the first season of *Foyle's War*, and *Prime Suspect 4*.

Among his favorites were the Dickens adaptations. "We did books not so often cited," he says, "like *Martin Chuzzlewit* and *Our Mutual Friend*, and *Bleak House* as well as *Great Expectations*. In college I'd been an English literature major, because I was lazy. I didn't know why I was in college, and that was an easy thing to take a degree in. Hosting the show gave me a chance to read all the books I should have read in school. I finally earned my degree through *Masterpiece Theatre*."

In those days, the introductions to the shows were two minutes long, sometimes two and a half. Then they were reduced to a minute. Russell says it was like doing a ballet in a phone booth—something he'd done before: "Writing my column for the *Times* was like doing ballet in a phone booth too. I'd learned to think in 750-word ideas. At the same time, the language you write to be read is completely different from what you can say on television intelligently. I had a lot of trouble adjusting to that.

"Writing for publication, you use a lot of 'which' clauses: the sentences can wander on and on. But for television you have to keep it short, because it has to be spoken. If you run out of breath in the middle of a sentence, you have to shoot it again. Reading my columns for the *Times* took a few minutes. Reading those 750 words aloud would have gone on all night. At the end I was getting them down to 200 words or less."

He found other differences between the printed text and what he could present on the air: "In print, I could use rather often long Latin words, or just tricky words. You can't do anything tricky in television."

Erin Delaney directed these studio segments: "You could tell how

much Russell Baker liked what he had written just from how he presented it. He owned the words slightly more. Sometimes you could tell he was still thinking, 'Hmm, not sure about that sentence.' It was very interesting to watch a writer perform."

Russell would generously send me his scripts before the shoot, which Alistair never did; but he wasn't keen on revising, either.

**The New York Times**
229 WEST 43 STREET
NEW YORK, N.Y. 10036

RUSSELL BAKER

Dear Rebecca —
These can be cut,
sliced, pared, slashed,
carved, pruned, trimmed,
condensed, abridged,
curtailed or sheared,
if you want me never to
speak to you again.
yrs
Russell

Leesburg
Jan 10/97

Unlike Alistair, Russell Baker used a teleprompter: "I stuck slavishly to it. Whenever I veered off the prompter script by a phrase or even a word, the director called for a retake."

Russell also had a completely different reaction to his days on the set: unlike Alistair, he really seemed to like the camaraderie and chatter.

"Writing the column was done sitting in a dark room, roaming around on the inside of my skull. It was very lonely—me interviewing myself constantly. In television you were in a big room with lots of different kinds of people with different motives and ambitions and theories, disagreeing with you. It was like being in a big family. And the people were highly skilled. Some print people, at least in my case, tend to come to television feeling a little condescending. I discovered that that's a terrible mistake, because it's filled with extremely smart and skilled people whose company I enjoyed.

"I just loved the TV work, though I never really quite mastered the mechanics of acting. Rebecca is just about the best superior I've ever worked for. What really impressed me—having worked for the *Times*, where we had a lot of executives, not all of whom were competent—was her competence. She loves what she does and works at it intensely."

We all loved Russell Baker, a democrat with a small *d*, who is interested in everyone's story—amused by life.

He looks back on the key differences between his approach to hosting and that of Alistair Cooke: "From this distance, it now strikes me that Alistair was a natural teacher. His work was a series of solid and enjoyable lectures sparked by the material. By contrast, I don't have the patience to teach; I am a natural student, and the pleasure I took in *Masterpiece Theatre* that I tried to convey to the audience was a sensuous delight that a student found in the material."

Russell is extraordinarily hard on himself and considers himself lazy. I can't help but credit his mother for this. During one of the

taping days, his impatience with himself just boiled over. But the way he dealt with it made us love him all the more. It was near the end of a long session. We'd given him a book to hold to still his restless hands, but after flubbing a take for the third or fourth time, he exploded—and threw the book on the studio floor and swore at himself. Shocked silence: we called it a wrap for the day and set a time to reconvene the next morning.

At nine a.m. Russell walked in and asked if I could assemble the studio crew.

Of course.

He spoke briefly and utterly honestly: "You all work very hard. My outburst was unprofessional and a waste of your time, and I owe you an apology. It won't happen again. Let's go to work."

Applause.

As the years went by, we couldn't afford a host anymore. In 2004 Russell stopped coming to Boston, but we've remained friends. We've gotten together in Key West, in New York, at David Halberstam's house in Nantucket, and of course in Leesburg, where we have lunch and visit Arthur Godfrey's grave.

# NINE

# Pitching the Pitchers

Working with Alistair, Vincent, and Russell was wonderful and, as it turned out, the easiest part of my job. When I started as executive producer of *Masterpiece Theatre* in 1985, the year after the megahit *The Jewel in the Crown* aired, I'd thought that screening programs and choosing the next hit would be the easy part. Up until then PBS had had a more or less noncompetitive ride through the landscapes of documentaries, political programs, and high-end dramas. Even when the networks dove into miniseries like crazy, they were very different from what we were co-producing with the British. In 1989, for example, CBS aired Larry McMurtry's *Lonesome Dove*.

Though PBS was organized completely differently than NBC, CBS, and ABC, it was basically America's fourth network. Its ratings were good, and *Masterpiece Theatre*'s were among the highest. *NOVA* was well established, and Carl Sagan's *Cosmos* (1980) had been a blockbuster, as had *Brideshead Revisited*.

Then in 1986, with the advent of commercial cable, the whole

game changed. Discovery, A&E, and CNN all exploded, creating multiple channels. HBO remained dormant, airing previously released movies and live boxing matches until *The Sopranos* in 1999. Almost overnight, not only did PBS face huge competition for viewers but it also had rival co-producers looking for content, for original programming. Suddenly there were new program buyers in London, giving all of us at PBS a run for our modest money. After years of enjoying a comfortable monopoly, suddenly we found we had competition at both ends of the pipeline.

The budgets at cable channels exploded almost as quickly as the channels themselves, whereas my budget at *Masterpiece* remained more or less the same. We still had a few cards to play: we could virtually guarantee that an assured segment of the viewing public, the educated and affluent, would watch our programs—*Masterpiece* lent prestige to any project. But attracting an audience like ours had also become the mandate of the new A&E network, and bidding wars ensued.

With the proliferation of cable channels, viewers had a lot more choice in what they could watch. People started to have multiple TVs in their houses, not just the one in the family room. The competition heated up not only for eyeballs but also for people's basic attention. "Appointment television," organizing your evenings around a show, became a negative.

Some of our audience fell away, because people felt they couldn't commit the time to *Masterpiece*. They'd be afraid to get into something on a Sunday night, because they knew it was likely they wouldn't be able to be there for the next three or four or five Sunday nights. VCRs were slowly working their way into common use, but not everyone was comfortable time-shifting via tape.

People would say, "I love *Masterpiece Theatre*, but I can't do it anymore. There's too much else going on."

This was true both here and in the U.K.: it was becoming harder and harder for people to stay with long-running series. So fewer of them got made. Our signature format had been long-running adaptations of good British books and long-running costume dramas, but not very many of them were being made anymore. The Brits had swung away from long-form period adaptations; they began to favor "one-offs" and much edgier, more contemporary—and more British—subject matter. They were exploring their own contemporary culture rather than looking back to the nineteenth century.

I remember *Tumbledown* (1988) about the Falklands War, starring Colin Firth, and *Oranges Are Not the Only Fruit* (1989), Jeanette Winterson's story about growing up gay in 1950s England, which aired periodically on A&E.

By then I'd learned that these shifts in taste followed patterns. The commissioners of drama in the U.K. change about every five years, and they are the tastemakers, the deciders. When a new drama tsar comes in at the BBC, ITV, or Channel 4, he or she wants to make a mark by doing something different from what's come before. It's no different here in American television.

Historically, despite regime change, one thing had been stable: the BBC had always done period drama. But now that, too, was changing. Younger people coming into television were interested in forging new paths, and Dickens wasn't on their route.

This made it harder than ever to find material for the *Masterpiece* audience.

Henry Becton remembers my telling him a few years after I took the job of executive producer: "The cupboard is bare. I don't think we're going to be able to construct a series."

In those first years as executive producer, I remember feeling a quiet panic: where was the next *Jewel in the Crown* or *Upstairs, Downstairs*? In 1986 we had aired John Mortimer's *Paradise Postponed*,

eleven episodes about postwar England, and it hadn't worked for our viewers. It was oddly too English. It was too domestic. And we worked again with John Hawkesworth, who had produced *Upstairs, Downstairs*, but his twenty-episode English Civil War drama *By the Sword Divided* (1983–85) failed to cut it with our audience.

In addition, my job began to change as a result of another, economic necessity: the growing financial pressures on producers in the U.K. The British system no longer had enough money to make these high-ticket dramas on their own, not at the BBC or ITV or Channel 4. They needed partners up front, and ones with real money, not just postproduction license fees. I realized that I was going to have to change from a show picker into a real co-producer and take risks on programs in the idea stage, long before the proof was in the pudding. Lots of the British producers and broadcasters would have preferred to go it alone, but they needed our money; and in so many ways, our co-productions became forced marriages. Life got more complicated.

My semiannual shopping trips to London became harder, both professionally and personally. As much as I loved staying in lovely London hotels and talking drama with my British colleagues, I hated to leave Katherine for those long weeks. Like all working parents, I was exhausted by that familiar and lethal combination: work-stress, nasty childhood germs, and lack of sleep. Paul and I had chosen not to have a nanny, so the moment I walked in the door in the evening, he officially went off duty: another version of the children's hour.

It was not so much the scene of a perfect child being presented, briefly, in the drawing room at cocktail time. It was more like me, pouring myself a large glass of wine, trying to be the perfect mother, cooking dinner (even if it was hot dogs and cucumbers), extracting details of their days from a tired Paul and Katherine, and returning long-overdue phone calls to friends. Paul and I both had pneumonia twice. Katherine thrived.

But the classic drama pipeline was down to a trickle, and I was very worried. I realized I should step in and try to do something about it. So I decided to try it with a book I loved.

I had read *Middlemarch* in my midtwenties and had been completely taken with Dorothea Brooke, George Eliot's complicated heroine. The novel had all the elements of a classic *Masterpiece Theatre* series. It was set in the 1830s among the landed gentry of rural England on a beautiful estate, just as their world begins to change with industrialization and reform. It has love stories. I decided that I'd use *Middlemarch* to try to convince my British colleagues to do more costume drama.

During *Masterpiece Theatre*'s first three decades, I calculated that we (well, Mobil Corporation) had poured over $250 million into some two hundred British dramas and done American publicity for them. Up until then, it hadn't been part of my job to make the tide flow the other way, from Britain to the United States. But our audience was starving for the kinds of program the Brits weren't interested in making anymore, so I knew I'd have to try to persuade them to make them. Wasn't it high time for the British to spend money on *our* ideas rather than the other way around?

*Middlemarch* had never been produced, as far as I could remember. At least we hadn't had it on *Masterpiece Theatre*. So I went over to London and proposed it to the BBC.

I was met with interested smiles: "Yeah, great."

Absolutely nothing happened.

On the next trip, I proposed it again and got the same reaction. I tried for two or three years over many expensive lunches, dinners, and evenings at the theater. Painfully slowly, I learned a simple, and rather obvious, tenet of program pitching: a good idea by itself is not enough. Even if it's a great book, or a great story, or a "dead cert" that it's going to be good, none of this is enough to get broadcasters to open their

wallets and finance a project. You need at least one additional glittery bauble in the package: an actor, a writer, or a pile of co-production money. And meanwhile, of course, the British producers were busy pitching me *their* favorite projects. Would we co-produce a new *Jeeves and Wooster* series with Hugh Laurie and Stephen Fry?

Yes.

Would we co-produce a major mini on British police corruption called *GBH*, as in grievous bodily harm?

No.

It's very hard to get a project going from over three thousand miles away when you're distracted by the day job of keeping a weekly show on the air. Even though the titles that the British were offering us weren't bell-ringers, we still had to present new programs every Sunday and Thursday night. Dropping in now and then to talk to potential broadcasters about a new initiative was never going to work. I realized that I needed a good producer on the ground in London. I went to Brian Eastman at Carnival Films. I'd worked with him on *Jeeves and Wooster* and *Agatha Christie's Poirot*, as well as *Traffik*. I knew he was an excellent producer and that his stock with the broadcasters was very high. I also really liked him.

When I approached him with the idea of making *Middlemarch*, he said, "This is very interesting, and I think I have an idea of just who should write it."

Brilliant: nothing in television gets a drama commissioner's attention faster than a hot writer already attached to a project. Brian proposed Andrew Davies, who at that point was a warm-becoming-hot writer—not yet the go-to guy for period drama.

Andrew loved the idea of adapting a book about a beautiful, principled young woman, a genre that would eventually become his specialty in *Pride and Prejudice*, *Sense and Sensibility*, *Bleak House*, and *Little Dorrit*. Once he said yes, we had some traction.

Eventually the BBC decided to come on board, although they weren't ready to green-light the project for production. This was fine with Brian Eastman, who felt he'd made his contribution. I told the BBC we were prepared to co-produce *Middlemarch*. I set aside some money in my annual budget to pay for it, then waited for the BBC to push the button.

But then we ran into trouble. As much as the BBC wanted to make *Middlemarch*, there was alarm when Andrew's first full draft came in. The producer who was working with him at that early point freaked out: "Oh, this is no good; we need to get another writer." They had fundamental disagreements over the structure and pace of the story lines.

But I still thought Andrew was the man for the job. In his draft he had chosen all the right scenes from the book, and I remembered the fantastic scripts he had created for *House of Cards* and *Mother Love*. A more seasoned BBC producer, a lovely, scholarly man named Louis Marks, knew Andrew and seemed to have the patience to get the scripts right. Andrew agreed to the collaboration, and off they went. Andrew fashioned *Middlemarch*'s heroic doctor, Lydgate, as (in his own words) "a western hero, as in 'a man rides into town . . .'" In the end, Andrew's masterful adaptation showcased his unique ability to take nineteenth-century characters and recast them for a modern audience.

Once Andrew had finished several drafts, the BBC had regained its costume drama appetite enough to green-light the project for production. Budgets were set. The series would be six hours long, and it would have the legendary impeccable BBC period drama treatment. Anthony Page, a theater director who rarely did television, came on board, and he cast Juliet Aubrey as Dorothea, the idealistic heroine. Then he took a chance on a relative unknown to play the romantic lead, Will Ladislaw: Rufus Sewell, in his first major TV role.

*Rufus who?* I thought. *Why can't we have a bigger star?* Then I saw him in the love scenes.

The production went smoothly enough, except perhaps for the day when Juliet, heavily corseted, was asked to shoot a scene over and over again next to a fireplace in an airless room. Eventually she keeled over and sort of bounced her head on the stone floor. With a tight shooting schedule to adhere to, Anthony got her up, dusted her off, and did another take.

I actually didn't hear this story until much later, a pattern I soon discovered was typical of the cone of silence that descends over the sets of our co-productions. Even though we were investing relatively little money in these dramas, I was still a distant studio executive, someone to be managed by the creative team in London—they had no need to share *everything* with me. I understood: that's what I was doing with Henry, Mobil, and PBS.

My favorite example is something that happened in 1997, on the set of Daphne du Maurier's *Rebecca*. The production starred our own Diana Rigg as the scary housekeeper Mrs. Danvers (Diana won an Emmy for that performance) and Faye Dunaway as Mrs. Van Hopper, the wealthy, gossipy American for whom our innocent heroine, who will become the second Mrs. de Winter, is a companion in Monte Carlo.

Apparently Faye Dunaway's acting style and general . . . eccentricity proved too much for the first director, who, after a difficult session, said he needed a smoke and walked off into the woods—and in very short order left the production.

Or so I was told when I first learned about the appointment of a new director—several weeks later. That was probably just as well. I woulds have panicked. The program was brilliant in the end.

Tight corsets notwithstanding, *Middlemarch* did get made, and when it aired in the U.K., the British audience loved it; the viewing numbers were very high. The BBC commissioners began to think

there might be a new audience for dramatic adaptations of great books. The BBC's last attempts at big nineteenth-century novels had been *David Copperfield* in 1988 and *Bleak House* in 1985, nearly ten years before; but there really had been nothing similar since then. Could one project like *Middlemarch* turn the tide?

It was, as they say, all in the timing. Enough time had passed that after a few years of the gritty contemporary stuff, the British audience found long-form period drama rather refreshing. The ratings for *Middlemarch*, when it was aired in 1994, were high, and the drama executives saw the possibility of a trend. (Interestingly, it's exactly what would happen with *Downton Abbey* nearly twenty years later: a stretch with no costume dramas, then a costume drama hit, and then several years of costume dramas.)

Henry Becton remembers, quite generously: "At the end of the miniseries our heroine Dorothea Brooke, who has been trying to save the world with big gestures, discovers that actually it's a whole succession of little kindnesses that add up. It struck me as appropriate to the fact that Rebecca had to keep a whole succession of little steps in progress to get this show to happen."

*Middlemarch* was equally successful in the United States. The Museum of Broadcasting even put together a big event with a rather eccentric panel of interesting women: the nonagenarian socialite Brooke Astor; Tina Brown, then the editor of *The New Yorker*; and Sister Souljah, the rapper. They all talked about their love for *Middlemarch*; it was quite an evening. These were smart women responding to nineteenth-century literature with strong heroines. When we broadcast the program, the viewer and press response was just as positive, and I thought I felt a pulse: if audiences here *and* in the U.K. liked this kind of programming, why not propose another project?

Emboldened by the success of our efforts to jump-start *Middlemarch*, I thought the moment had come to suggest that the BBC

consider an *American* classic. A good place to start might be with American writers who were culturally situated somewhere in the middle of the Atlantic Ocean: Henry James or Edith Wharton. We'd done Henry a few times; he can be quite a cool customer for television drama, not prone to tales of *expressed* passionate love. Our 1972 production of his novel *The Golden Bowl* had been really successful, but still . . .

At the time, our production secretary Nathan Hasson was studying Edith Wharton at Harvard. He championed a couple of Edith projects, including her unfinished novel, *The Buccaneers*. I'd never heard of it. Nathan gave me the book and said, "This would be perfect."

He was very right. *The Buccaneers*, when viewed in a certain light, is the progenitor of *Downton Abbey*. It's the story of the dollar duchesses, the daughters of nouveaux riches American tycoons at the end of the nineteenth century who had had lots of new money but no "class." They felt they needed British titles for their girls.

In *The Buccaneers*, three young American women and their mothers go to England to meet titled but financially strapped young men who are all too eager to marry them. The most famous real dollar duchess was Consuelo Vanderbilt, who married a title and became the ninth Duchess of Marlborough and eventually the chatelaine of Blenheim Palace, where Winston Churchill, the son of another American beauty, was born prematurely in the cloakroom.

It's a perfect novel for television, with multiple strong plotlines and beautiful young people falling in and out of love. And it was unfinished! A do-it-yourself project.

We acquired the rights to the book (or was it in the public domain? I can't remember) and, lesson learned, I proceeded to get help in making a pitch to the BBC. Mary Silverman, the American at the BBC's New York office who'd helped us out during the fuss over *Portrait of a Marriage*, once again became our operative within the company.

My father, Paul Eaton,
at MIT in the 1920s.

With my mother and brother, 1947.

My brother and me.

In California with my mother.

It was the '50s . . .

It was the '60s . . .

The house in Maine.

With my parents, brother Jerry, sister-in-law Karen, and nephews Timothy and Jeremy.

On location with John Updike and the giant WGBH mobile unit.

*The First Churchills*—first show, many wigs. Alan Rowe as King William III (*left*) and John Neville as John Churchill, Earl of Marlborough.

With Alistair Cooke and Henry Becton (*right*), president of WGBH, 1992.

Photoshopping with Alistair Cooke.

With Katherine, 1986.

With Katherine, Paul, and Vincent Price on the *Mystery!* set at WGBH.

Paul and Katherine Cooper.

*Masterpiece Theatre*'s twentieth anniversary celebration.

With Diana Rigg on the *Mystery!* set for *Heat of the Sun.*

With Russell Baker on the *Masterpiece Theatre* set at WGBH.

Helen Mirren at the 1997 Emmys, surrounded by *Prime Suspect* hardware.

Alistair Cookie, host of *Monsterpiece Theatre,* "home of classy drama."

With Tony Hillerman and Robert Redford, *Skinwalkers,* 2003.

Derek Jacobi looking closely at the Huntington Gardens in Pasadena.

With Men of *Mystery!* (*left to right*): Jeremy Brett (Sherlock Holmes), John Thaw (Inspector Morse), me, Peter Davison (Lord Campion), and David Suchet (Hercule Poirot), 1990.

Daniel Radcliffe, Maggie Smith, and Ian McNeice in *David Copperfield*.

Director Simon Curtis, Judi Dench, and Jim Carter on the set of *Cranford*.

Judi Dench taking a break during the *Cranford* shoot.

Filming *Cranford* in Lacock, Wiltshire, England.

An important character in *Cranford*.

Sherlock Holmes (Benedict Cumberbatch) and Dr. Watson
(Martin Freeman) pursued by cameraman (Steve Lawes).

Benedict Cumberbatch (*right*) as Sherlock Holmes.

With Annie Leibovitz during the *Vanity Fair* shoot in England.

With Benedict
Cumberbatch at a
*Sherlock* fan event
in New York City.

With *Upstairs, Downstairs* creators Jean Marsh (*left*) and Eileen Atkins, 2011.

Screenwriter Andrew Davies at ITV in London.

Our production team with *Mystery!* host Alan Cumming.

Maggie Smith,
between scenes.

Production of
*Downton Abbey* at
Highclere Castle.

Lord Grantham (Hugh Bonneville) at breakfast, with guests.

*Downton Abbey* creator Julian Fellowes (*right*) on set with Shirley MacLaine, Jim Carter (*center*), and director Brian Percival.

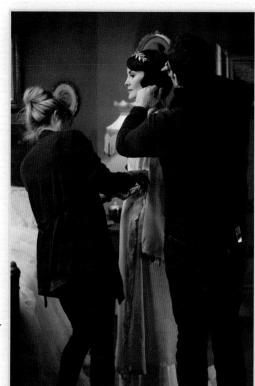

Michelle Dockery as Lady Mary.

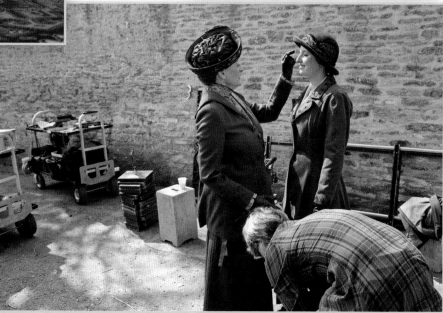

Violet, the Dowager Countess (Maggie Smith), and Lady Edith (Laura Carmichael).

Katherine Emery Eaton,
c. 1933.

Katherine Emery Cooper,
2009.

She identified an accomplished BBC producer, Phillippa Giles, who also loved the book, and once the project was positioned on this inside track, we got the BBC to commission the script. It was a pretty easy pitch, because even though the story is partly American, it combines period drama, romance, and a little bit of social history—*Middlemarch*, but with more frosting.

The first of what became three episodes takes place in America; and miracle of miracles, the British agreed to shoot it here. In those days, they tried to find British locations that resemble foreign settings—it's cheaper. In the book, the early scenes, which show the girls, their English tutor, and the mothers planning their matrimonial siege of the British aristocracy, take place in Saratoga, where the Gilded Age American rich went to relax and play the ponies. But shooting in this upstate New York town proved impossible, so we relocated to an even grander watering hole: Newport, Rhode Island, where even richer families summered and—more important for us— where the great mansions are still intact and are available at considerable expense for use as production locations. It was the most spectacular shoot: the flower budget alone probably would have paid for a couple of episodes of *Prime Suspect*. The BBC was investing big money in *The Buccaneers* because of the success of *Middlemarch*, and we had no competition from American broadcasters because we had initiated it with the BBC. It was all pretty clear sailing.

The BBC brought over an entire entourage of camera people, lens guys, makeup artists, designers, and costumers to shoot in Rhode Island—a mere former colony, after all. They did eventually hire some American crew members, but it looked a little bit like a nineteenth-century British expedition to the Dark Continent. The Brits nervously brought with them everything they were familiar with, or thought they might remotely need, from tea biscuits to hair spray.

Among the beautiful young American women in the cast were

Mira Sorvino and Carla Gugino, both of whom would go on to be big stars in the United States. Though the novel focuses on what happened to all the young women, Carla's character, Nan St. George, is the one Edith Wharton seemed most interested in. But she hadn't managed to complete *The Buccaneers* before she died in 1937.

Our writer, Maggie Wadey, finished it for her and wrote an ending that caused some trouble with the Edith Wharton "police." Maggie's version has Carla's character unhappily married to a young man played by James Frain. She falls in love with someone else. And when she discovers her husband in bed with another man, she runs off with her lover—and who wouldn't? He's played by the delicious Greg Wise, now *really* married to Emma Thompson.

We had angry letters from Wharton scholars who accused us of sensationalizing Edith's book and sexing it up.

Once the mothers and daughters sail for England, the rest of the story is set there; so sadly, our American part in the production was over. But as usual the British cast was brilliant, especially Michael Kitchen, who in 2002 would go on to play the enigmatic Christopher Foyle in the wonderful mystery series *Foyle's War*.

When we broadcast it in 1995, *The Buccaneers* was one of the most successful shows we'd ever done: it set a ratings record for *Masterpiece Theatre* that wasn't broken until *Downton Abbey*. I was very proud that we'd introduced some American culture into a project and hoped this would be just the camel's nose under the tent. Well, it was; but apparently the nose went under the wrong tent.

Just as *The Buccaneers* was being completed, I had lunch in London with Greg Dyke, who was head of the commercial broadcaster ITV. (He would eventually become director general of the BBC, a job he would leave after a dust-up with Tony Blair's government over an allegedly "sexed-up" memo supporting the case for war in Iraq. But 1995 was still palmy days, long before all that.)

Greg is a smart, warm, and ebullient man, and our lunches often centered on war stories about our children. Eventually, over coffee that day, we got around to talking about television drama. He said he'd been pitched a miniseries adaptation of Jane Austen's *Pride and Prejudice*. The producer, Sue Birtwistle, was excellent, and oh yes, the writer was Andrew Davies. We stroked our beards and wisely, quickly—and fatally—decided that even though Daniel Day-Lewis was a friend of Sue's and a very remote possibility to play Mr. Darcy, the BBC and *Masterpiece Theatre* had done *Pride and Prejudice* before, in 1980, and the world didn't need another adaptation of it.

"Let's find something new to do together. Let's have another cup of coffee."

A few weeks later I woke up and realized that I'd made a huge mistake. The project was now at the BBC. I flew back to London and had tea with Sue Birtwistle at the Hyde Park Hotel. Though I threw virtual bags of money at her, she remained unmoved. She was close to a deal with A&E as the American partner. My bags of money couldn't match her scruples. I could only go home and hope the production would turn out badly—which, of course, it didn't.

*Pride and Prejudice* made Colin Firth a big star, and it made A&E a boatload of money. Because of it I learned two critical and useful lessons: One—Jane Austen is bulletproof, review-proof, and a total audience magnet. Two—given that new television viewers come along every ten or fifteen years, the cycle for fresh adaptations of classic works of literature is very short.

As I think back on it, I realize the *Pride and Prejudice* episode taught me another show-biz lesson: how to spin a bad decision into a seemingly rational choice. Because I had to answer endless questions from the press and from the confused *Masterpiece Theatre* audience— "Why isn't *Masterpiece Theatre* airing *Pride and Prejudice*? Why is it on A&E?"—I learned to say, convincingly and as if I completely

believed it, "*Masterpiece Theatre* co-produced a brilliant version of *Pride and Prejudice* in 1980, and we're now choosing to invest our money in adaptations of books that haven't been done before."

I hated saying it, particularly to the press, because I'd begun to pride myself on being a "candid interview," giving honest answers and not mincing about with careful corporate-speak. I wanted to answer the reporters' questions truthfully and say I'd made a stupid mistake and regretted it. But speaking-truth-to-press is a high-wire act, because you're always at risk of saying too much and creating an even bigger story. It seems to be a high wire that I continue to climb up on and continue to fall off of.

For years I berated myself about the *Pride and Prejudice* decision, until I realized that, even though it had been a lost financial opportunity for PBS, it didn't matter. The general public came to think that *Pride and Prejudice* had aired on *Masterpiece Theatre* and was one of its finest moments. Thirteen years later we actually did get the rights and aired it.

# TEN

# Dark Days

The 1990s were a complicated time for *Masterpiece Theatre*, at least from my point of view. That perception is certainly clouded by events in my own life. Between 1990 and 1994, Paul and I lost five babies in four miscarriages. There had been a pair of identical twin boys. The babies were all lost fairly early in the pregnancies but not early enough that we hadn't chosen names for each of them and had begun to imagine who these new people might be. I suspect that most women who have lost a baby will say that this child is still real to her and occupies a very deep and private place in her heart.

The physical roller coaster of these miscarriages was as trying as the emotional one. Because we were getting older and I felt we had to hurry, I didn't take much of a break between pregnancy tries; my hormone levels were going up and down like a yo-yo. The demands of raising a small child at home while producing an ongoing weekly prime-time show at work were pretty wearing. I remember being exhausted, and possibly not thinking straight, for years.

As I look at the list of programs we broadcast on *Masterpiece Theatre* and *Mystery!* between 1990 and 2000, I'm struck by how many there were, and how few of them were breakout hits. There was *Prime Suspect*, of course, and Ian Richardson in the *House of Cards* trilogy (1990), and *Middlemarch* and *The Buccaneers*; but in its very early days, *Masterpiece Theatre* might have presented four or five big, long miniseries per year. Now there were many one-offs, made-for-TV movies; they came and went, making barely a ripple.

Even though it starred Alec Guinness, who remembers *A Foreign Field* (1993) or Emma Thompson in *The Blue Boy* (1994)? And even I couldn't tell you the plot of *Heavy Weather* (1995) or *The Wingless Bird* (1997).

During this period, I really worried that *Masterpiece Theatre*'s time as a cultural icon might be up, and that I really would be the captain on whose watch the ship might go down. We were really scrambling for programs. Every year or two there would be a gem: the adulterous rom-com *Reckless* (1997), with Robson Green, Francesca Annis, and Michael Kitchen, is still one of my very favorite programs. But even the presence of the juicy Colin Firth in an adaptation of Joseph Conrad's South American novel *Nostromo* (1998) couldn't move the needle.

It became harder and harder for people to stay with long-running series, hence fewer of them were getting made. The move to ever-shorter series was also dictated by the fierce competition in the U.K. between ITV and the BBC. If the first hours of a thirteen-part series tanked, it meant that the network would be crushed in the ratings for the next ten weeks. Eventually the same episode shrinkage happened to documentaries too.

The *Mystery!* pipeline was in better shape, with its beloved "detectives with legs"—returning whodunits with strong central characters: Jeremy Brett's Sherlock Holmes, David Suchet's Hercule Poirot, and John Thaw's Inspector Morse. They had never gone out of style in the

United States or the U.K., so the productions kept rolling along, and we had little trouble buying them.

In U.S. television in the mid- to late-1990s, the competition was heating up as more viewers hooked into cable, attracted by original programming like *The Larry Sanders Show* (1992–98) on HBO, followed by the seminal 1999 broadcast of *The Sopranos*. A&E commissioned pieces like *Dash and Lilly* (1999), about the relationship between Dashiell Hammett and Lillian Hellman, which garnered nine Emmy nominations.

It certainly was a rich and memorable time to be producing at WGBH. Henry Becton, who'd become the station's president in 1984, had been slowly building it into the programming powerhouse that would generate more hours for PBS than any other station in the system. He created a children's department, including my friend Kate Taylor's work, that would rival even the Children's Television Workshop (the makers of *Sesame Street*); and very early on he began adding staff and resources to explore the new technologies that would change the television landscape in the coming decades.

But perhaps his single smartest move was to appoint Peter McGhee—the man who'd encouraged me to apply for the *Masterpiece Theatre* job in the first place—as vice president for national production. Peter was a graduate of the Columbia School of Journalism and a producer of the public affairs show *The Advocates*. He's a handsome, enigmatic man whose commitment to the original mission of PBS—to explore, to tell the truth, to populate the "vast wasteland" with new ideas—is unparalleled.

He set about hiring a team of producers and creating a development roster of new series that would eventually make WGBH an international center for nonfiction programming. The science series *NOVA* was already up and running very well when Peter took over, but he appointed Paula Apsell as its executive producer, and she took

it to new heights. He brought in David Fanning to create *Frontline*, the current affairs documentary series (David was the producer of the controversial *Death of a Princess*), and Judy Crichton and Margaret Drain from CBS to create *The American Experience*, the history documentary series. Peter personally championed the U.S. version of *Antiques Roadshow*, a weekly BBC program exploring the provenance and (possible) value of the treasures in your attic.

And those were just the ongoing series. Taking major financial risks, Peter green-lit groundbreaking limited series, such as *Vietnam: A Television History* (1983), *War and Peace in the Nuclear Age* (1989), *Columbus and the Age of Discovery* (1992), and *Rock & Roll* (1995). My friend Elizabeth Deane produced quite a few of the episodes in these series and was the executive producer of *Rock & Roll*. The British were partners in many of these projects, too, and Peter came to learn the intricate minuet of negotiating editorial and creative differences with our colleagues across the pond. The accolades, awards, and grant money started flowing into Peter's department and gradually became a gusher.

Meanwhile, over in another corner of WGBH (in virtually another country) I was producing a completely different kind of series—drama—and reporting to Henry, not to Peter. This arrangement was a kind of historical artifact, and eventually it didn't necessarily serve either of us well. *Masterpiece* had always been under Henry's aegis, largely, I think, because he loved it. He loved reading scripts, screening programs, and swapping stories about the eccentric comings and goings of British actors and television executives. He was also aware, of course, that *Masterpiece*'s underwriter, Mobil Corporation, was the largest funder in the history of PBS, and he wanted to continue to be actively involved with them himself.

I liked my relationship with Henry. He and I worked well together, although I never felt I was doing well enough from his point of view.

He's a man of great equanimity, but I wanted raves—another symptom, perhaps, of having been bitten by the show-business bug.

My closest friends were my colleagues on the children's and non-fiction side of WGBH; our mutual affection and support was solid. In the years before I was married, they had been my family; and later, when we all had kids, we cheered one another on as we ran the marathon of work and child rearing. But over the years, as the documentary colossus grew, I began to feel that *Masterpiece Theatre* was perceived variously as anodyne, a stepchild, and an easy job, because it was an acquisitions series and didn't involve *real* production. The other producers at WGBH were actually *making* programs themselves: imagining, pitching, financing, shooting, editing, and publicizing them. I felt an unspoken judgment: producing *Masterpiece* was merely an importing group; they were creative.

Part of me agreed with this description of my job. I wasn't really making anything myself, and what I was making was just entertainment. This had been my doubt even when I'd taken the job. I also sensed a perception among my colleagues that the executives at Mobil might be pushing their own ideas on *Masterpiece Theatre*. This was quite complicated.

The crowd at Mobil, initially Herb Schmertz and Frank Marshall, were certainly influential, but they were corralled within editorial bounds. It took vigilance, because these guys loved the programs and perhaps fancied themselves as minimoguls—and they were *Masterpiece Theatre*'s sole funders. After the tense moments over *The Bretts*, which Mobil had fostered and which we curtailed, they were less proactive in developing ideas; and after *A Very British Coup*, they never came close to standing in the way of a program we wanted to broadcast. But they did regularly come with us to London to meet with producers and broadcasters, who then, of course, sent proposals directly to them. They had on occasion funded programs on other U.S. networks and

even elsewhere on PBS, so this was legitimate, but it brought them very close to editorial content.

In the 1980s PBS had been known to some as the Petroleum Broadcasting System, a phrase coined by a journalist because Texaco, Chevron, Gulf, Exxon, and ARCO had been pouring money into PBS programming. There had always been the question of whether they had too much influence. Even though *Masterpiece* was not a news or public affairs show, Mobil still needed constant managing, partly because they were doing their own advertising and promotion for the series.

Pete Spina, the executive who succeeded Herb Schmertz in 1988, had put a woman named Fran Michaelman in place to oversee the details of the relationship with *Masterpiece Theatre*. He wanted her to be quite involved, and she was eager to have an editorial voice. It was a potentially dangerous construction.

Henry was the president of WGBH, and while I still reported to him, he had a very full plate. Looking back, I can see that I had very little insulation: I was a producer dealing directly with a powerful and demanding underwriter.

We were coming up on the twentieth anniversary of *Masterpiece* in 1991, and in honor of the occasion, we decided to make a celebratory documentary and hired an independent company to make it, with Mobil footing the bill. Fran began making editorial suggestions, something she shouldn't have done. Ironically, this wasn't a hard-hitting documentary; it was entertainment—clips and interviews. But she had ideas. She was quite persistent.

Three days after I'd had a miscarriage and lost the twins, I went to New York to screen the latest cut of the show. When I got there, Fran called, pushing for her suggestions.

"I've looked at what you suggested," I said, "and I don't think it'll work."

She said that she didn't believe me and that she thought I was lying to her. I hung up.

I'd just hung up on a representative of Mobil Corporation, public television's largest underwriter and the second largest company in the world. Right away I checked in with Fran's boss, Pete Spina, to let him know what had happened, but he had already heard.

Pete was furious. He said he would call Henry and tell him to get rid of me.

I sat in my hotel room in New York, stunned. Women who are three days postmiscarriage are truly not themselves. Though I had to get to LaGuardia to fly home, I could barely get myself up off the bed. Since I couldn't reach Paul, I called Jan Egleson, the director I'd worked with on *The Little Sister* for *American Playhouse*. He was a good friend, a husband and father. And as a director, he knew how to handle emotional people who'd lost it; he was right there with me.

"Okay," he said, "here's what you're going to do. First, you're going to get up and pack your suitcase. Then call me back."

I did. When I called him again, he said, "Good. Now you're going to go downstairs and get in a taxi."

I think he understood that I could take things only one step at a time. Then I rang him from the airport: "I'm here."

"Great! Now get on the plane. By the time you get there, Paul will be home."

And he was.

When the taxi pulled up in front of our house, Paul and Katherine were standing in the doorway. Katherine was about four years old. Paul gathered me up, and Katherine grabbed my hand and took me into the living room and sat me down on the couch. Then she sat her little self as close as she could possibly get to me.

I was crying, and she was very concerned. It was about three in the

afternoon. She watched me, then leaped into action: "I know what, Mummy! Let's go upstairs and get into our nighties and get in bed."

So we went upstairs. Then she snuggled up next to me. That's all she knew how to do—to get physically close.

I was overwhelmed again; but how could it not make me feel better to see that this little four-year-old had compassion? Instead of acting out or being frightened, she was thinking, *How can I make this better?*

I loved her for her generous spirit. Then she bounced off to play.

I went into the office the next day and told Henry what had happened. He hadn't yet talked to Pete.

Later Henry called me. "Rebecca, this is really bad," he said. "You've poisoned the well."

"I've been trying to hold the line with these people," I told him.

He listened, but Pete was so mad that Henry felt it might threaten our funding.

Henry's perspective: "I had a funder with a new relationship telling me I had to fire an executive producer. Of course, this was WGBH's decision, not Mobil's.

"Given that I thought future funding for *Masterpiece Theatre* might be in jeopardy, I had to take this very seriously and figure out a solution that would preserve Rebecca and also preserve the Mobil funding. I decided to engage another person to be the relationship manager with Mobil."

Besides bringing in a corporate "buffer person," Henry felt he had to conduct due diligence on how I was managing other aspects of my job. If I had alienated Mobil, how was I managing my staff? How was I perceived by them? He called each of them into his office for a thorough debriefing, promising them confidentiality, although clearly I knew what was going on. This went on for several months, at the same time that Mobil was being reassured and calmed down. I doubted myself at every turn.

Eventually, Henry put me on notice. My "people management" skills had to be improved within five months or there would be "a personnel change."

Henry talked Pete down. Mobil, through Fran, continued to push its ideas, but within proper editorial boundaries.

This tricky time, in which I had to do the essential work of finding enough good programs for *Masterpiece*, also became a terrible time of crisis of confidence: Mobil's confidence in *Masterpiece Theatre*, Henry's confidence in me, and my confidence in myself. Even though Henry, too, was fully vigilant about maintaining our editorial standards, I felt he'd thrown the book at me. And I suspected that I'd lost the loyalty and confidence of my staff. It was a terribly lonely time.

Paul remembers: "Rebecca was always worried she was going to be dumped. . . . It was long and it was drawn out. It took a lot out of her. That's where her energy went, not to the family."

My husband and daughter were wonderfully supportive. They decided to throw me a "party."

As Katherine recalls, "The party consisted of getting balloons and ribbons and putting them around the bedroom. The idea was to surprise her when she came home. We wanted her to know that we were there for her.

"I had made a sign that said, 'Good job at WGBH!' I think we also made a cake. In my four-year-old mind, it was a real party. I knew it was very hard when she lost the twins. The older I get, the more I think about that."

As chilly as the atmosphere became, there was, I felt, a moment of quiet triumph in those dark days. On August 25, 1991, *Masterpiece Theatre* won three Primetime Emmys: Andrew Davies for his script for *House of Cards*; Sir John Gielgud for his performance in John Mortimer's *Summer's Lease*; and *Masterpiece Theatre* received the prestigious Governors Award, honoring its twenty years of glorious program-

ming. It was accepted by Henry Becton . . . and Pete Spina of Mobil Corporation.

Over the next five years, Mobil's relationship with *Masterpiece Theatre* remained relatively calm, but the giant multinational was undergoing a cultural change. Ever since Herb Schmertz left in 1988, *Masterpiece Theatre* had been nobody's baby; it had become an artifact of an earlier time, when arts philanthropy had dovetailed nicely with corporate branding. Now we were more or less just a "corporate account," costing Mobil a mere (for them) $20 million a year.

Pete Spina died in 1993, Fran Michaelman left, and we were passed from executive to executive, some of whom got more involved than others. Their involvement was sporadic and not particularly intrusive, although I remember one rather dramatic episode.

In 1996 we'd co-produced *The Fortunes and Misfortunes of Moll Flanders*—based on Daniel Defoe's eighteenth-century novel about the many rises and falls of a beautiful woman born in prison. Determined to improve her lot, Moll becomes a petty criminal and marries as many men as she can, including, unwittingly, her own brother, with whom she has several children. The novel is a wonderfully comic and racy classic, like *Tom Jones*.

Alex Kingston played Moll, and a future James Bond (Daniel Craig) played her true love, the highwayman Jemmy. Andrew Davies, naturally, wrote the script, and there was much romping, disrobing, and rolling around, all within the decency boundaries of PBS.

But on the Friday morning before *Moll*'s Sunday-night broadcast, I walked into my office, where the phones were ringing crazily, and my secretary was sweating bullets. Apparently our current executive at Mobil had just screened the advance press copy, was shocked at *Moll*'s prurience, and was demanding that we pull the show.

That he would even imagine that Mobil had the authority to do this indicates how distant the relationship had become, or perhaps

how out of touch this particular guy was. *Moll* aired to great reviews and ratings. But again more Mobil fence mending was needed. Henry called the man, heard him out, and reaffirmed our editorial policy.

Over the years, *Masterpiece Theatre* did have several champions within Mobil, and none fought for us more fiercely than Molly Meloy, Mobil's global brand director, an ebullient farmer's daughter from Iowa who, at our first meeting, introduced herself by saying that she grew up wanting to *be* Alistair Cooke. She loved the program and truly believed it was in Mobil's corporate interest to support it, but even she couldn't prevent Mobil from doing what the company eventually decided to do.

In 1994 Mobil discontinued funding *Mystery!*, citing an internal lack of support for spending big money on us. Mobil no longer needed the brand burnishing it had wanted so badly in 1971. It agreed to continue financing *Masterpiece Theatre*, with the understanding that the program would now be called *Mobil Masterpiece Theatre*, something it had wanted for years.

As a parting gift and in an attempt to prevent or at least delay Mobil's complete withdrawal, we moved *Prime Suspect*, the jewel in *Mystery!*'s crown, over to *Masterpiece Theatre*. PBS, which for twenty-five years had been able to air *Masterpiece Theatre* and then *Mystery!* in its prime-time schedule at no cost, stepped in and agreed to fund the Thursday-night broadcast of *Mystery!* itself.

Mobil's withdrawal of the *Mystery!* money was a sign of the times and of times to come. The idea that funding public broadcasting should be part of a corporation's civic duty was starting to evaporate, even as corporate profits rose. It became harder and harder for producers to raise the money to get their shows made.

I was troubled by the loss of the Mobil support for *Mystery!*, but I thought we were secure with PBS. Still, the handwriting was on the wall. Six years later, in 2000, Pat Mitchell came in as president of

PBS, the first woman in that position, full of enthusiasm and energy. I'd known her slightly when she was at a local Boston television station. But it soon became clear that she felt there was too much British drama on PBS; she wanted to develop more American material, both documentaries and dramas.

*Masterpiece* is a show that critics love to hate now and then because, they say, it's just "British imports." I think it's a natural instinct that the president of American public television would want more American material. But right off the bat, Pat Mitchell decided that *Mystery!*, on Thursday nights at nine, should be canceled. The headline in *U.S. News & World Report* read "Good-bye Miss Marple; Hello, Miss Mitchell." She needed the money for other projects.

Of course, Henry and I thought taking *Mystery!* out of the schedule was a completely wrong-headed decision. The series had a substantial audience, distinct from that of *Masterpiece Theatre*, and it drew many contributions to local PBS stations. I didn't think that Pat appreciated that these contributions were the very bone structure, the skeleton, of PBS funding.

*Mystery!*'s last Thursday-night broadcast was April 5, 2001. British drama on PBS had been reduced by 50 percent.

I continued to talk about the issue whenever I was interviewed. We didn't have an aggressive campaign to contact people to get out the story of *Mystery!*'s demise, but I discussed it publicly whenever I visited local PBS stations. It turned out that the stations felt the same way; they knew *Mystery!*'s demographic and economic assets, and Pat began to get pushback from station executives, funders, viewers, and the media.

Around this time, Henry Becton organized a meeting in Boston for all the WGBH executive producers to meet with Pat to talk about our programs. It was not specifically a *Mystery!* meeting. There were probably fifty people sitting around a big conference table, and each

of us was asked to speak about what was happening with our series. It was outwardly friendly but tense; everyone knew that the funding for their series was largely in Pat's hands. Quite publicly I made it clear that I disagreed with Pat's decision to eliminate *Mystery!*, that I thought it missed the point of how important the show was to local stations. Then I had to jump on a train and go to New York for my nephew Tim's graduation from journalism school.

When I arrived at the hotel, I had a phone call from Henry: "Pat's pretty upset about what you said; you have some fences to mend here."

His perspective was that "because Rebecca believes in honesty, she is sometimes more honest than is diplomatic for the interpersonal moment."

Again.

From then on my relationship with Pat Mitchell was not good. Publicly she would be very friendly and embracing, but I felt that I had lost her support. When Henry asked me to mend fences, I wasn't sure who should actually be getting out the hammer and nails. Had I been wrong to publicly defend a program I believed in? Was she right to have been upset? Had either of us broken some kind of professional code?

I wasn't sure what would happen next.

As Henry sees it, I was "sheltered for many years from the typical pressures on an executive producer, because we had one funder who by and large let Rebecca do what she wanted, despite some tension and difficulty. Almost every other executive producer had to worry about securing corporate sponsors, or going after foundation funding, or getting PBS money. It only was when Mobil pulled out that Rebecca had to pay attention to PBS and learn the hard way."

I suppose many mentors and mentees, if that's a real word, reach a similar tipping point—a moment of separation when the student realizes that he or she will pursue goals in a manner entirely different

from that of the teacher, no matter how much he or she admires him (or her). I saw a clear picture of Henry—thorough, temperate, prudent, consensus seeking, a good leader—and realized I wasn't like him. I would always be more righteous, narrowly focused, and probably impolitic because I was a producer—and producers are obsessive, and, to a fault, concerned only with the good of their own programs.

But as it turned out, *Mystery!* was like Tinker Bell in *Peter Pan*. Remember Tink, as Peter calls her, the irascible fairy played on stage not by an actor but by a moving light and a tinkle of bells? Remember the scene where she drinks the poison intended for Peter, and her light starts to fade and go out? When Peter exhorts the audience to save Tink's life, to clap if they believe in fairies, they always do, and her light grows brighter, and she lives on.

I think the same thing happened to *Mystery!* Its audience, the press, and the brass at local PBS stations clapped, spoke up, protested its incipient demise, and convinced Pat Mitchell to keep it alive. She modified her decision, and we created "Summer of *Mystery!*" airing in the *Masterpiece Theatre* slot, Sundays at nine p.m. Miss Marple and Inspector Morse continued to show off their ratiocination skills in American living rooms for years to come.

# ELEVEN

# Made in America

So what *about* presenting American drama on *Masterpiece Theatre*? This question, whether posed as a criticism of an all-British series dominating the PBS schedule, or asked innocently and longingly by viewers who love great American novels, biographies, and history, is perpetual: why don't we do more of our own stories? And the answer, of course, is money.

Drama, particularly costume drama, is about the most expensive television you can make: well done, it can cost $3 million to $5 million an hour to produce. The entire annual *Masterpiece* budget has hovered around $10 million for the past forty years. But it has seemed to me—and to many other red-white-and-blue American producers—that this shouldn't stop us from doing our patriotic duty to crack the problem.

There was an interesting precedent that I thought could be useful. In the 1980s, Lindsay Law had produced a PBS series of all kinds of American drama, from Tennessee Williams to Tony Kushner to

independent films: *American Playhouse*. PBS money wasn't nearly enough, so he concocted a clever combination of PBS financing and theatrical deals—the films could be seen in movie theaters as well as on television. But these deals were extremely complicated, and required constant hustling and pitching to make sure the cash kept flowing. Eventually Lindsay went off to run the boutique film company Fox Searchlight, and with *The Full Monty* (1997) he made a lot of money for them, and eventually for himself—lucky Lindsay. I didn't think the movie release idea would work for us, but Lindsay's example showed me that I would need to be imaginative and find partners in addition to PBS.

In 1997 we had an opportunity, or at least a small opening. Out of the blue the Corporation for Public Broadcasting created a multi-million-dollar fund and quietly hired a seasoned television producer, Marian Rees, to make five television films for PBS, all adaptations of American books. There had been no call for proposals for this money; and other potential producers were caught off guard—including me.

Originally from Iowa, Marian is a strong woman, well known in Hollywood. She had a career of good work behind her and had fought her corner well in the often sleazy man's world of 1960s and 1970s American television. But still—millions of dollars for drama is a lot of money, and I thought we should have some of it.

The Mobil muscle was extremely helpful in this instance. Its executives felt they owned drama on PBS and were adamant that if there were to be any television adaptations of fiction, they should come under the *Masterpiece Theatre* banner. Although Mobil didn't offer any additional money for that privilege, they were basically right. Launching anything new on television requires a tremendous amount of start-up publicity, just to let the audience know it exists. Putting a new drama under the *Masterpiece Theatre* umbrella, with its prominence in the prime-time schedule and its very high profile, would

automatically elevate any project head and shoulders above the rest. The PBS brass agreed that the five new shows should be presented by *Masterpiece Theatre*.

But it was a shotgun wedding. I wasn't willing to include any new material for *Masterpiece Theatre* without having editorial control over it, and working for me was not what Marian Rees had signed up to do. Months of negotiations ensued. Before production could begin, we had to agree on five projects—five American projects that could be done as two-hour films, representing the diversity of our culture and history (this *was* PBS, after all), and to which the rights would be available and affordable.

Needle in a haystack. Forget *The Great Gatsby*, *The Sun Also Rises*, *The Age of Innocence*, and *Portrait of a Lady*; the rights to many of your favorite classics are still under copyright or are tied up by the movie studios that bought them in the 1930s, '40s, and '50s and which continue to sit on them and even periodically make them. Many of the best-known titles had been produced over and over, or were appropriate only for a miniseries treatment, not a two-hour film, or had costume, location, or casting requirements that made them simply too expensive to produce well. Finally we came up with a mutually agreeable short-list of ideas . . . then set out to make the shows.

Marian and I agreed that she and her team would produce Willa Cather's *Song of the Lark*, Eudora Welty's *The Ponder Heart*, Langston Hughes's *Cora Unashamed*, and Esmeralda Santiago's twentieth-century memoir, *Almost a Woman*. Somewhat reluctantly Marian also agreed to tackle one of my favorite American books, James Agee's *A Death in the Family*. We wanted books by known American writers that would showcase diversity; good regional representation; dramatic, filmable stories; and available rights. But it was a pretty academic, schematic approach.

We struggled over scripts and cuts of each of these films. It turned

out that Marian and I had real differences in taste—in aesthetics, if you will—about the type of dialogue, lighting, shooting, acting, and editing that each of us preferred. Marian's sensibilities had been formed by her years producing successful commercial dramas for *Hallmark Hall of Fame*—and they had been very popular. In 1986 she'd won an Emmy for *Love Is Never Silent*.

By contrast, many of the British television writers, producers, directors, and actors I'd worked with came from theater backgrounds. Many of the cinematographers came from documentaries. And nearly all of them had worked occasionally in feature films. I felt that their work had great understatement and subtlety—perhaps a kind of British restraint. They conveyed feelings with unspoken reaction shots, less with on-the-nose dialogue. They photographed scenes in available light. They used costumes that were delicate and authentic. And of course they used fabulously real locations, not sets.

The fact is that British producers, at the BBC in particular, have a long history of making costume dramas about their culture. They've efficiently cranked them out like fabulous doughnuts for years. American producers make them rarely, having to reinvent the wheel each time, which results often in a certain stiffness, an artificial feeling.

American television used to be good at period drama, back in the golden age of the miniseries when shows like *Roots* (1977), *Shōgun* (1980), *The Winds of War* (1983), and *Lonesome Dove* (1989) were produced. And now they're back in business again with historical dramas on cable like *Boardwalk Empire* and *Hatfields & McCoys*; but there was a long period of drought in between. They became too expensive to make, and with the infrequency of production, the creative people seemed to lose the knack. The calculus is pretty simple: costume drama is expensive to produce, and it goes in and out of fashion with viewers, thereby limiting its appeal to an American commercial broadcaster that needs good ratings to attract advertising money.

Or maybe it's something else entirely.

Julian Fellowes, the creator of *Downton Abbey*, has something to say about this: "It isn't only that the British have a sense of their history, but also that a lot of our rituals are still essentially period. The way we conduct social events is very similar to the nineteenth century in many instances. In Britain, you still get into black tie or a smoking jacket, even for an office bash. We still have a monarchy. We still have all these things that take us back into history. It's just part of who we are.

"It's hard for Americans to see modern customs as such, and there is a desire to make period characters essentially modern in order to make them sympathetic. So you'll get scripts written [in the United States] where the heroine is essentially a completely modern character.

"I think American actors lead the way in terms of film; they have an instinctive grasp of it. English actors are better on stage—it's something they've been fed pretty early. Americans are better at musicals than we are, but probably in straight theater, again, we have the edge. In period probably the English have the edge."

There are lots of interesting historical, cultural, and even political reasons that more period drama isn't made for American television, even on PBS; and that, when it does show up, it is costly to produce and looks a little phony. First, the writing: successful English television writers are cosseted and indulged, in contrast to their American counterparts, who often have to submit to endless decisions by review committees and endless layers of interfering producers and directors. Often British writers are even solicited: what do *they* want to write? And once they sign on to a project, they are rarely replaced.

Maybe this is because the English have such a long and deep respect for the written word and the proper use of their native tongue. Accents are, of course, an instant identifier of class and even county of origin: Yorkshire vs. Lancashire, Devon vs. Cornwall, etc. The English also love their books, their history, and their physical landscape with

a passion and poignancy that, who's to say, might come from thousands of years of civilization, or perhaps from watching the spectacle of a great empire on the wane.

And to be an actor in England is to have a reasonable job, compared to the fabled and guaranteed heartbreak of trying to become a star in America. British actors, in my experience, seem willing to work anywhere, not just to focus, laserlike, on making it big, and quickly. It's much more common for big-name film stars like Maggie Smith, Judi Dench, or Kenneth Branagh to take a job acting onstage or on television, and even on radio, than it would be for, say, Robert De Niro or Julia Roberts. Our movie actors eschew TV parts, except for the occasional big, juicy HBO "payday," although things may be changing.

From the perspective of Elizabeth McGovern, American born but long a resident in the U.K.: "There's something about the approach to acting as a craft that you see in the very fiber of an English actor, which you don't see so much in the Hollywood system. Hollywood's much more about the exploitation of a personality and charisma. I was always drawn to this idea of craft, of an actor working on something apart from him- or herself, something that might improve with age and time, and that they could apply to various disciplines.

"I had no interest in exploiting my personality in a way that would leave me used up after a short time. In the U.K. they are very influenced and impressed in many ways by the Hollywood system, but overall the historical, cultural approach to acting and theater, and the way it impacts television and movies, still very much exists in England. There's much more regard for the writer. There's much more regard for an actor who can do all sorts of different things. You're just a person with a job."

Her husband, director Simon Curtis, knows something about this: "I made a film about the differences in acting styles of Marilyn Monroe and Laurence Olivier—*My Week with Marilyn*. Great acting is a mix-

ture of the English external limps and funny tics and so on, and the American tradition of inner life and psychology—Lee Strasberg. But great acting is both, inside and outside. Personally I think there's just good acting or bad acting."

Alistair Cooke, an actor manqué himself, had his own theory about English versus American actors. He was sure that the secret ingredient was the plethora of British acting schools and government-financed regional theaters. He thought British actors were given more opportunity to learn the craft of acting by doing years of repertory work and by playing dozens of characters.

Maybe so: or maybe it's London, and the diminutive size of England compared to the United States. An English writer or actor can live a reasonable life in or near London, with opportunities to work in every medium. Here in the States, a serious or ambitious actor or writer really has to choose between doing movies or television in Hollywood and doing theater in New York.

As Kenneth Branagh sees it, "England is a small island, and different kinds of work are concentrated. We aren't broadly divided, New York to L.A., theater to film, across a much, much larger country. Decisions to focus on one thing or the other aren't as pressurizing in quite the same way. The invitation to do the variety of things in England is probably more naturally in the system here than it is in the States.

"Across my career, the film industry in England hasn't been as strong. We are profoundly grateful to be able to do some theater and some radio and some television and some film. If we are lucky, we regard the interchange in those disciplines as a very healthy, creative thing."

The British never tire of telling their own cultural stories, or celebrating their illustrious history. They preserve their beautiful old buildings, to the point that they are often accused of turning Britain into a theme park or what Andrew Davies refers to as "chocolate box England." Well, maybe; but we in America have a tendency to tear

things down, to make way for newer, bigger, better. Perhaps it's because we're a country looking forward, while England is preoccupied with looking back.

And then there's the BBC, a public broadcaster financed directly by the viewers. Every household in the country with a television set pays about £145 [about $233] annually, £3 billion [just under $5 billion] into the system each year. The viewers get a phenomenal amount for that money.

A nearly $5-billion-a-year public broadcaster is a well-financed operation, one of the legal mandates of which is to address aspects of British culture, past and present. This, of course, often translates into historical drama—biopics, and adaptations of beloved British books. So PBS is a public broadcaster too: why can't we do the same thing?

I wasn't in the business in the late 1960s when PBS was born, and its official birth information is a matter of public record. But the more I've been involved with it in its later growth and evolution, the more I think about the implications of its origins. It seems to me that the two major impediments to funding PBS as adequately as the BBC were Hollywood and politics.

In 1968, network television, comprising only three networks— NBC, ABC, and CBS—was an extremely profitable and competitive business. Its executives and advertisers had very little interest in creating a strong fourth network that could drain viewers away from the big three. But lip service for a fourth network was abundant: who *wouldn't* go on record supporting this educational endeavor, as it was described then? Much of the initial funding had come from the Ford Foundation. But the idea that government money should be spent creating PBS (or any new television network) had little real corporate or congressional support. Although PBS was created during Lyndon Johnson's presidency, he wasn't interested in imposing a dedicated tax to pay for it.

Then Richard Nixon was elected in 1968. Given his long history of bad experiences with the media, he was hardly in favor of financing an editorially independent public broadcaster that might give him more trouble. His antagonistic views on liberal journalists were legendary, and his attack-dog vice president, Spiro Agnew, gave them voice. They were, as he called them, "nattering nabobs of negativism" and "an effete corps of impudent snobs who characterize themselves as intellectuals." Nixon couldn't stop the creation of PBS at that point, but he could sure starve it with a barely sustainable budget.

So public broadcasting was born chronically undernourished and hungry: even now only about 15 percent of its funding comes from the federal government, and the remainder must be laboriously raised from corporations, foundations, individuals, and other sources. Public broadcasting, which could have been mandated to do costume drama representing our social and cultural history, doesn't have the money and never has. Over two decades our federal funding has grown only slightly—and is the recurring target of watchdog political groups. This brings us back to my problem twenty years later, trying to get some American drama on *Masterpiece Theatre*—slowly, slowly, slowly.

As Marian Rees worked on her films, I had the idea that we should approach our British colleagues about some American projects that would work for them, too, much as *The Buccaneers* had. This would get us some additional money. In the late 1990s a new crop of television executives were running things in London; I thought they might be more open to genuine co-productions and American subjects.

At one of my first meetings, I struck gold. Over coffee in the Granada Television cafeteria, Gub Neal, the head of drama there, instantly agreed to develop two of my ideas. One was a biopic of Fanny Kemble, a beautiful British actress who married an American plantation owner in the mid-nineteenth century and wrote an anti-slavery journal that was championed by U.S. abolitionists. Her moral

stand eventually cost Fanny her marriage and access to her children. The other project was *Mark and Livy*, the story of the courtship, love, and marriage of Mark Twain and his gentle wife, Olivia.

The Fanny Kemble project had come to me from an American producer, Nell Cox; and I'd found *Mark and Livy*, a biography by Resa Willis, one fine summer day in the Kennebunkport public library, when I was idly looking for something not British to read on vacation. What attracted me to the story that day in Graves Memorial Library was its portrait of a marriage: the lives of two people—one of whom happened to be Mark Twain—who, through great emotional sacrifice, saved each other's lives.

Samuel Clemens was a hard-living humorist making money performing the nineteenth-century equivalent of stand-up comedy. He might have frittered away his many gifts and eventually self-destructed had he not met Olivia Langdon, a fragile woman whose presumed lot in life was to care for her parents and never marry. Sam fell completely in love with her, and she with him.

Her father sent him packing with the words, "Prove to me that you can make something of yourself."

So Sam went away for a year, sent love letters to Livy, and fabricated glowing testimonials from all kinds of imaginary people, trying to convince her father that he was worthy. It worked: they married and were hugely, passionately, in love. In my view, Sam woke Livy up not just sexually but to life itself. But after their children were born, things began to get darker.

One winter Sam took their son, then two, on a sleigh ride; the child caught a chill and died. Sam's guilt was profound. Livy stabilized him enough so that Sam Clemens, with her help as his first reader and editor, could become Mark Twain, write *Huckleberry Finn* and *Tom Sawyer*, and make a lot of money—which he then lost with a series of ill-fated inventions and investments.

They'd built a beautiful house in Hartford, Connecticut, but couldn't afford to live in it. They had to go back on the lecture circuit and live in Europe, which was cheaper. One of their daughters stayed home; while they were gone, she died. Sam and Livy became very spiritual, even trying séances to contact their lost girl.

Sam Clemens was a larger-than-life personality—maybe even manic-depressive. Even as his energy invigorated Livy, it also cost her dearly. Livy's health eventually gave out, and the doctor's prescription was draconian: Sam must keep away from her. He was too much for her.

They moved to Florence, where Livy lived out the rest of her life as an invalid. Though Sam was living in the same beautiful villa, he wasn't allowed to see her. So he wrote her scores of letters, loving her, amusing her, promising her that she would regain her health and all would be well. He knew it wasn't true. It was his turn to sacrifice himself for her.

Once Granada Television said it was interested in co-producing *Mark and Livy*, we optioned the book. I instantly thought Robin Williams would be perfect for the part of Mark Twain. Wonderfully easily, I found just the right American writer to adapt it. Camille Thomasson and I worked hard together on the script, spending one memorable week in a bed-and-breakfast very near the perfectly preserved, fanciful house where Mark and Livy had lived so happily. It's now a museum, whose director liked our television idea very much and provisionally agreed to let us film there when the time came.

Working so closely with Camille reminded me again what a relatively manageable job I had as executive producer of *Masterpiece Theatre*, a series whose productions were actually made by people on the ground in Britain. Even though I'd done more "hands-on" work on *Middlemarch* and *The Buccaneers*, in this all-American production I was up to my neck in the creative process, spending hours discussing the approach to the story, its dramatic arc, the breakdown of scenes, the relative importance of characters, and so on, with Camille. Then

on receiving her drafts of the script, I was learning how to give her feedback and suggestions in that very specific way that might improve the work, in my opinion, and also create an atmosphere that would motivate her to come up with even *better* ideas.

I found it exhausting. I was new at it; but worse, as a pretty controlling person ("Commander Overdrive," as Katherine would say), I also found it very hard not to insist that my ideas be incorporated. I was impatient and knocked myself out trying not to be. After what must have seemed like tortured creative input from me, Camille came up with four hours of fine work.

Granada loved the scripts, PBS loved the scripts, and eventually we got them directly to Robin Williams without going through his agent, who most likely would have put them at the very bottom of a large pile of possible projects because only short money was involved.

This, by the way, is what so often happens with PBS projects in Hollywood. Writers, actors, directors—everybody—has great initial enthusiasm for the mission of PBS, and even for specific projects. But when the moment of truth arrives and "the talent" has to sign on and take the job, things fall apart. Exceptions abound, of course, but the discrepancy between what PBS pays and what everyone else pays is just too big.

Robin responded wonderfully to the scripts and saw immediately how well the part of Mark Twain suited him. He lived in San Francisco, knew that Sam Clemens had settled there as a journalist in the 1860s, and felt the affinity. I think the project spoke to Robin.

Then Brian Eastman, the producer of *Traffik, Jeeves and Wooster, Agatha Christie's Poirot*, the midwife of *Middlemarch*, and a great friend, got the scripts to Richard Attenborough (*Gandhi, Cry Freedom, A Chorus Line*), who instantly agreed to direct. Robin wanted to meet him, so we all gathered one August afternoon in the empty dining room of the Hyde Park Hotel in London (the scene of my inef-

fectual fruitcake seduction of Michael Palin). It was a love fest, ending with Robin briefly becoming Queen Elizabeth II, for reasons that now escape me.

At that point, everything depended on the money. Brian's preliminary budget, even with Robin's relatively low fee, came to about $16 million. Granada was good for half of it, but I had to raise the other half. Since the project was unlikely to earn money in the international market ("Who is this man, Mark Twain?"), it was not a magnet for investors.

After months of trying, and failing, to construct a reasonable business model, Brian and I approached the cable company Showtime and the producer Robert Halmi, Sr., who had a deal there. Showtime was willing to put up the money in exchange for the U.S. premiere; PBS agreed. Showtime was only twenty years old at that point and just starting to become a player in the original-programming cable market. It was looking to challenge HBO's supremacy.

Robin's agent felt that he should make a big "payday" movie first, so we waited and waited for him. Finally his schedule was clear. Although the exact provenance of Halmi's co-production money was never clear, things seemed solid enough to begin to lock down production dates.

And then came September 11, 2001: after a week or so, as we all attempted to pick up where we'd left off in that time of national grief and bewilderment, we discovered that Halmi's money had evaporated in the face of political events. And Robin felt he needed to take a break and spend some time with his family.

We reduced the budget drastically and cut the project from four one-hour-long episodes to two ninety-minute ones, but the moment was lost. Robin changed agents and engaged someone who couldn't see how *Mark and Livy* could benefit his career. My phone calls went unreturned.

It had been about five years since I'd plucked *Mark and Livy* off

the library shelf and had instantly produced, written, and directed it—in my head.

The sad history of American drama not broadcast on *Masterpiece Theatre* also includes the Fanny Kemble project, which expired for lack of script money, and John Updike's *Rabbit* books. If there is one great American literary classic that hasn't been produced for film or television, I'd argue that it's *Rabbit Run*—and its sequels.

Rabbit Angstrom is a twentieth-century Everyman, a high school basketball star who marries, fathers children, has affairs, runs a Toyota dealership, moves to Florida, and dies after a pick-up basketball game. It's a simple enough American life story but is spectacularly written and woven through with sex, guilt, religion, death, and forgiveness. Some excellent scripts had already been written by Judith Paige Mitchell, but they were deeply entangled in rights issues, and our lawyers had to sort that out.

The good news was that the production money appeared very early in the game. A Canadian company called Alliance Atlantis was eager to do business with us. And once again I thought I'd had a casting brainstorm: the quintessential American Everyman actor, Tom Hanks, should play Rabbit; his wife, Rita Wilson, an actress and a singer, should play Rabbit's wife, Janice; and best of all, Tom's son Colin, who had just starred in a small gem of a movie, *Orange County*, should play Rabbit's son Nelson.

I actually pitched it directly to Tom Hanks. His daughter Elizabeth was a student at Vassar, and the school invited me to come to Poughkeepsie when Tom was scheduled to give a talk there. The whole student body showed up to hear his wonderful presentation. Then a small group of us went back for dinner at the president's house. Colin Hanks was there too.

I did that obnoxious producer thing, pitching to an actor at a party: "I've got this great project."

Tom looked slightly startled; I'm not sure he knew who Rabbit Angstrom was. He said, "Call Gary."

Gary Goetzman is his producing partner at Playtone, their production company.

I did call Gary, sent him the scripts, and went out to L.A. for a meeting. He was polite and very funny, but I could see that he and Tom were fully consumed with a big HBO project they were about to do: *John Adams*.

"Come back later."

Meanwhile, back at WGBH, we couldn't seem to close a deal either with the writer or with Alliance Atlantis. The negotiations went on so long that the company went out of business, and our legal teams got crosswise with each other. The whole thing fell apart.

And then there's the story of *The Glass Menagerie* starring Meryl Streep—which also didn't happen. We optioned the play easily enough, from Tennessee Williams's estate, but only after long negotiations with Paul Newman's lawyer. Paul Newman? It turned out that Paul still held the television rights, having directed a version of the play that was released as a feature film in 1987 and was still available on DVD. He said he loved the performance that his wife Joanne Woodward had given as Amanda, and he wasn't really interested in seeing anyone else's. Eventually he agreed to let us co-produce *Menagerie* with Showtime, who would, once again, have the premiere.

Finally, finally, I got a meeting with Meryl Streep in a café in Greenwich Village. Yes, she wanted to play Amanda; and yes, it would be great if Matt Damon were to be Tom, the narrator, and Ben Affleck, the gentleman caller. Their movie *Good Will Hunting* had just opened, but they still seemed "gettable." Meryl was eager to work with Jonathan Demme as the director. What a fabulous team that would be. . . .

The negotiations began—and went on and on and on. Matt and

Ben won an Oscar and got very hot; Jonathan Demme went on an extended holiday in France; and then Meryl was cast in *Angels in America* for HBO. Eventually our option on the play expired. The only good thing to come out of it all was a memorable phone call I had with Meryl, a fellow Vassar College graduate, when we discovered that we'd shared a boyfriend—sequentially, not simultaneously. We giggled and swapped extremely personal stories about him.

In spite of these disappointments, *Masterpiece* did in fact successfully produce two American dramas in addition to Marian Rees's projects. One was Henry James's *The American* (1998)—good old reliable Henry—starring Matthew Modine and our own Diana Rigg. It was co-produced with the BBC. The other was one of Paul Newman's very last projects: Thornton Wilder's *Our Town* (2003), in which Paul played the Stage Manager.

Joanne Woodward ran a theater company in their hometown in Connecticut, the Westport Country Playhouse, and she had talked Paul into going onstage for the first time in thirty-eight years. The production eventually moved to Broadway for a limited run; and its director, James Naughton, persuaded Paul that it should be memorialized as a television production for PBS and Showtime.

Joanne was a huge fan of *Masterpiece Theatre*, and Paul had once sent *Frontline* a completely unsolicited check for $50,000 to show his appreciation for its work. They were easy and fun to work with. As it happened, Paul's next project was to be Richard Russo's *Empire Falls* for HBO. He told me that he and Joanne were going to be in Kennebunkport for several weeks. I mentioned I had a house there, and in an enthusiastic moment, I asked if they'd like to come over some evening for martinis and lobsters.

Paul Newman actually said, "I'd like nothing better."

But, true confession, it never happened. I panicked at the thought of entertaining *Paul Newman* in my shabby old house. He would be

bored; I would have nothing interesting to say; the porch had holes in the screens. . . . I never called him back.

Paul's performance in *Our Town* earned him a Primetime Emmy nomination, but *Masterpiece Theatre*'s production of *The Lost Prince* beat out his *Empire Falls* on HBO for Outstanding Miniseries. And there's more on that story to come. . . .

*The American Collection* premiered in 2000 with theme music composed by John Williams and played by Yo-Yo Ma and members of the Boston Symphony Orchestra. The title sequence won a Primetime Emmy, and Marian Rees's *Cora Unashamed* became one of the highest-rated *Masterpiece Theatres* ever aired; it won a Peabody Award. But the $24 million for a second series was impossible to raise again from PBS, from CPB, or from our British partners. The prospect of an ongoing American drama series sank below the horizon.

I learned a few lessons from this adventure: (1) don't be afraid of Paul Newman; (2) a good idea is only the beginning of a very long haul; and (3) pouring millions of dollars into British drama creates *no* obligation for the British to pour it back into ours.

Until then I hadn't realized how strongly British broadcasters felt that adaptations of American classics, or dramas about American history, just would not be of interest to their audiences. British executives acquire hundreds of hours of American television drama, but it is already produced. Of course this all works the same way in reverse: it's rare for an American network to adapt a British book or do a non-American period piece. *Masterpiece Theatre* is truly a niche.

I also learned that getting a project made from scratch in this country would be an impossible task for me to accomplish while executive-producing *Masterpiece Theatre*: that kind of producing is more than a full-time job. It's a job for carapaced obsessives who have infinite patience and an appetite for overcoming obstacles. It requires vigilance, creativity, and an absolute refusal to take no for an answer,

because true producing is an unbelievably protracted process of getting other people to see your vision and do things primarily your way.

Even for Steven Spielberg. I recently had a conversation with Doris Kearns Goodwin, who wrote *Team of Rivals*, her biography of Abraham Lincoln and his Civil War cabinet. In the late 1990s, when she'd just started to write the book, she had a call from Spielberg, who told her he'd always wanted to do a film about Lincoln. They talked; he went away; she wrote.

He called her every few months: "How's Mr. Lincoln?"

He optioned her book before she'd even finished it. Eleven long years and innumerable screenplay drafts, many failed financing deals, and several frustrating casting attempts later, Spielberg made a movie based on approximately four pages of Doris's book, *Lincoln*. It was nominated for the 2013 Academy Award for Best Picture, and of course Daniel Day-Lewis won as Best Actor.

Interestingly, our most recent and the most successful venture into American drama was a television movie about Native Americans, and it was for *Mystery!*, not *Masterpiece Theatre*. In 2000, when it became clear that Pat Mitchell was serious about reducing the PBS commitment to British costume drama, we dug in and started researching the work of contemporary American mystery writers. Even for me, a reader impatient with the formulaic construction of whodunits, it was exciting.

There were dozens of mystery writers, each of whom had written dozens of books with strong central characters—colorful protagonists "with legs." And they all had that essential ingredient that I knew our audience would love, a vivid sense of place. James Lee Burke's mysteries set in and around New Orleans; Daniel Woodrell's hard-boiled stories of crime and punishment in the Missouri Ozarks; Margaret Maron's North Carolina–based books featuring a district judge; and Linda Barnes's look at Boston through the private eyes of Carlotta

Carlyle, a former cabbie. How great, and how quintessentially PBS, to be able to create a mystery series that would highlight the fabulous geographical and ethnic diversity of this country, as well as tell good stories. The rights to the books were almost always available; the fans were legion and ready to be turned into viewers; and the mystery genre was a proven winner for television: see *Matlock*, *Columbo*, and *Murder, She Wrote*.

We prepared a presentation for Pat, beginning with Henry Becton's favorite mystery writer, Tony Hillerman. Tony had written eighteen novels set on the Navajo reservation, the Big Rez, featuring two Native American cops, Joe Leaphorn and Jim Chee. The stories moved back and forth between the Navajo and Anglo cultures, they were all set in the stunning Southwest, and they were reliably filled with interesting intrigue and murder. Perfect—except that the rights were owned by Robert Redford.

We decided to pitch them to Pat anyway. We'd barely made it through our introduction of the idea when she practically jumped out of her chair. "I know these books. I know Bob. I know he'd like to see them on PBS."

All of which was true, and after hundreds of hours of lawyers talking to lawyers, we managed to secure the rights and move toward production. Bob's son Jamie Redford had already written a screenplay of Hillerman's *Skinwalkers*; Chris Eyre, a Native American graduate of the NYU film school, wanted to direct; and I hired Craig McNeil, the production executive on *Prime Suspect*, to produce. We cast Adam Beach and Wes Studi as Chee and Leaphorn.

I loved working with Jamie on the script: learning how to weave information into believable dialogue, how to create suspense, and how to wrangle that hardest of scenes, the moment when the goo[d] guy figures out whodunit and has to tell us how, and wh[y] quickly and dramatically—the dreaded denouement.

nearly mathematical plotting that's necessary to keep the audience one small step behind the protagonist.

Meeting Robert Redford and working with him turned out to be two very different things. I had met lots and lots of famous British actors and even members of the royal family, but walking into Bob's office in Santa Monica, I was definitely shaky. Like so many of us, I had been hypnotized by Hollywood stardom (all those movie magazines in Pasadena), and I'd only ever seen Bob when his face was almost thirty feet high, moving in to kiss Barbra Streisand in *The Way We Were*.

I couldn't hear anything he said for the first ten minutes. How many times had he had to wait for his interlocutor to calm down?

Over the months of production, I found him to be very easy to work with. He has a very unusual quality, particularly for a Hollywood guy. Whenever I was explaining something to him, or trying to make a point about the film, he would sit absolutely still and watch me carefully. I could *see* him listening; he never interrupted or rushed things along. That concentration actually gave me confidence to up my game—to express myself better. Perhaps it was his training as an actor, the legendary "being fully in the moment."

It's a quality that's very difficult to replicate. For me, impatience and my "Commander Overdrive" instincts get in the way.

Working in the Native American community was frustrating, inspiring, depressing, and enigmatic all at once. Even though both Bob and Tony Hillerman had earned the community's respect, we were outsiders. To me, the people on the tribal lands seemed guarded and dispirited, and I could feel the years and years of isolation and pain. But it was a great relief to spend time with people who in general talked so much less than the hyperverbal people I was used to; and it was moving to spend time in a culture that still truly valued its connection to its old ways and to the earth.

When it was broadcast in 2002, *Skinwalkers* reached an entirely

different audience than was typical of *Mystery!* For the first time in memory, PBS stations in Phoenix, San Antonio, and Albuquerque had the highest ratings in the system. I'm sure Bob's association was key, but to me, the success of the show was also proof that regional American drama had real possibilities for PBS.

Pat Mitchell and her colleague Coby Atlas commissioned scripts for two more of Hillerman's Chee/Leaphorn books: *Coyote Waits*, written by Lucky Gold, and *A Thief of Time*, written by Alice Arlen. The script work was hard, because we were making single films and reinventing the wheel each time. A more typical Hollywood M.O. would have been to commission and spend money over ten or more episodes, with continuing story arcs for Chee and Leaphorn, and with weekly murders committed and solved. But PBS didn't have that kind of money, so we made an expensive movie-for-television each time. We aired the two films, and again they were very popular.

The moment came to make a fourth film, and it was up to me to raise the $2 million to top up the $3 million that PBS was already putting in. The British weren't interested, unconvinced that their audiences would want to see Native American dramas.

We worked out some deals with Governor Bill Richardson's New Mexico film office to shoot there more cheaply than in Arizona; and we approached Jeff Skoll, formerly of eBay and the founder of Participant Productions, and the Warren Buffett family for financing help. But my heart wasn't in it: it seemed questionable for PBS to put $3 million into a single two-hour film when an entire season of *Mystery!* programs cost only $10 million. As much as I loved working with Jamie and Bob, and as much as I believed in the regional mystery idea, it just seemed wildly uneconomical to continue the series, so we let it drop in 2004. Thus ended this chapter of *Masterpiece Theatre*'s role, and mine, as a producer of American material.

But for me, *Masterpiece Theatre*'s limited foray into original Amer-

ican drama was worth every penny it cost, because it provided a show-biz moment that went right to the top of my list of favorites. It happened on a hot, sticky day in Boston in July 2003. I was simultaneously waiting for a callback from the famously hard-to-reach Robert Redford and packing my car for a trip to Kennebunkport. I carried my cell phone with me everywhere, just in case, and made endless trips out to the car, lugging suitcases, food, and finally the dog.

As I put her in the backseat, avoiding her beseeching brown eyes, my cell phone rang, and it started to rain. I went inside, and Bob began to unload his careful notes on a cut of *Coyote Waits*.

All of a sudden, an almighty clap of thunder seemed to split the house. "Holy shit," I said. "Bob, I've got to get my dog out of the car. She's terrified of thunder."

"Go!" he said.

I put him on hold and ran to the car to get Maggie. Back in the house, with the dog drooling in terror, I resumed with Bob, who carefully started to repeat his notes. Then my landline rang. I couldn't put Bob on hold again, even though I recognized the number: it was Paul Newman calling with his notes on a cut of *Our Town*. Butch was on one line, Sundance on the other.

I told Bob the story a few days later. He laughed briefly. Then, always the competitive actor, he asked suspiciously: "So what did *he* want?"

# TWELVE

# Dusting Off the Jewel

On an afternoon in September 2002, I was sitting in the little *Master-piece Theatre* screening room with some of the team, watching the rough cut of an episode of *Daniel Deronda*. The door opened, the lights blazed on, and John Willis, a terrific British television executive who was then running WGBH's national productions, walked in and said, "ExxonMobil has decided to stop funding *Masterpiece Theatre*."

I thought he was kidding.

He certainly was not.

ExxonMobil had decided that funding the series was no longer in its corporate interest. So after thirty enviable years of sustained sponsorship, *Masterpiece Theatre* was on its own.

I panicked—but only momentarily. I thought that *Masterpiece Theatre* was so iconic and so well loved by its audience that it would be a quick sell to a new underwriter. I was wrong—by about ten years. I didn't realize quite how drastically the world of sponsorship had changed since 1971.

ExxonMobil's withdrawal was gradual, with the final dollars coming in for the 2004 season. PBS once again stepped into the financial breach.

That last year of 2004 turned out to be a crucial, pivotal year for *Masterpiece Theatre*, a real turning point. It was the end of what the series had been and the beginning of what it would become. For me, my friend Alistair Cooke was the exact center point of the pivot. After he'd retired in 1992, I used to visit him often on trips to New York. It was always the same drill: a warm and loving greeting from his wife, Jane; Alistair impatiently fussing around at the drinks table, producing a whopper glass of scotch for me; tasty hors d'oeuvres; and then Alistair's priceless stories about the great and the good of the twentieth century: British and American actors, writers, diplomats, journalists, and politicians.

He'd forgotten nothing. But on one visit, he left the living room and came back, handing me a videotape.

"I'm ninety-four," he said. "When I die, if you do any sort of tribute, this is what I'd like to have broadcast."

The piece had nothing to do with *Masterpiece Theatre* or even Alistair's career in BBC radio. It was his 1974 address to a joint session of the U.S. Congress, on the occasion of the two-hundredth anniversary of the first Continental Congress in Philadelphia. When Alistair spoke to that distinguished group of congressmen, his hero Winston Churchill and the Marquis de Lafayette were the only other non-Americans who had ever had that honor. As he handed me the tape, I realized that he was telling me that even if he was known to the *Masterpiece Theatre* audience as the quintessential Englishman, he was now an American citizen, and as such, this was his proudest moment.

As his daughter, Susie Kittredge, says, "He had been in love with America since he was a small boy. He had made a living and a life

getting to know her whims and fancies, her history and hopes. He both admired and forgave her."

A few years later my home phone rang with a call from Alistair. Skipping any kind of small talk, he told me he'd been diagnosed with inoperable lung cancer and had been given a prognosis of three to six months to live. He was matter-of-fact, but I couldn't breathe. I told him I loved him, and he said the same, for the first time. I hung up and looked at the clock: it was nine o'clock, Sunday night—*Masterpiece Theatre* was on the air.

Alistair died about a month later. Susie and the family scattered his ashes in Central Park while Jane watched from her apartment's fifteenth-floor window.

His memorial in Westminster Abbey was historic: the American flag flew from its turrets for the first time since the Revolutionary War. Luminaries abounded. The head of the BBC read the lesson, and the journalist Peter Jennings, a Canadian and an Alistair Cooke acolyte, delivered the eulogy. Susie and Jane had asked me to read a Bible passage from the Book of Romans. The night before, at a small family dinner, Susie had given each of us one of A.C.'s handkerchiefs, immaculately pressed and folded.

On the day I walked with the family into the chancel I saw rows and rows of famous and ordinary people, all of whom had loved that voice and that perfect, elliptical writing style. There were about 2,200 people crowded into the abbey. Right in the front row of VIPs were two small figures in dark coats and modest hats: Eileen Atkins and Jean Marsh. They each gave me a tiny wave.

As my reading moment approached, the historic nature of where I was, and what I was about to do, overwhelmed me. I got very shaky and felt faint. But I took out Alistair's hanky and had a momentary but vivid sense of him: *Oh, for god's sake, Rebecca, don't be ridiculous. Just get on with it!*

Off I went to the pulpit in my new red hat and read out the sacred text without a hitch.

Later Eileen told me: "I couldn't get over your bravery. My mouth goes dry just at the thought of not playing a part, but of having to stand in front of everybody at something as amazingly dignified and *grand* as that, in Westminster Abbey."

On April 4, 2004, we broadcast Alistair's 1974 address to Congress, just as he had asked. The Alistair Cooke era was over.

In September 2005, I found myself in a little rented Ford Fiesta being driven by my dear friend Ed Mitchell, wedged between giant limos on our way to the Primetime Emmys in Pasadena, my hometown. *The Lost Prince*, our BBC co-production set just before the Great War, which tells the story of the royal family and its fragile, troubled son Prince John, had been nominated for Outstanding Miniseries. Its creator, Stephen Poliakoff, hated to fly, and none of the other British executives were interested in coming to this all-American awards ceremony. I was the pinch hitter drafted to accept the Emmy, in the very unlikely event that it would win. I'd bought a new skirt and talked Eddie into being my date.

When Jimmy Smits called out, "And the winner is . . . *The Lost Prince*," I walked up to the stage and made my acceptance remarks, mostly honoring Stephen, in front of the hundreds of fancy people right there in the Pasadena Civic Auditorium and in front of millions of people watching around the world.

But my mind wandered. I could see myself, age ten, upstairs on the second floor of that very building, wearing white gloves and a party dress, at Miss Gallatz's Dancing School, having a painful crush on a rascal named Jacques Courtois. My own life story tumbled

around in my head, and I felt an odd new appreciation for luck, for my job, for the people who'd helped me get to this moment—and for the amount of work I still had to do.

And the work started that night.

Apparently the executives at HBO, whose *Empire Falls* (with Paul Newman) had lost out to *Masterpiece Theatre*, were annoyed and provoked that our David had beaten their Goliath. Picking up Emmys was essential to HBO's business strategy, both because the attendant publicity attracted new subscribers and because HBO executives got hefty bonuses for their wins.

Mere days after the Emmy festivities, I learned that HBO had made a massive bid for *Elizabeth the Queen*, a proposed British miniseries about the first Elizabeth R, which would star Helen Mirren. Months before I'd heard that the program was in the works, and had been waiting to see scripts. I hadn't felt any urgency about securing it, because at that point we had absolutely no competition in America for period British drama. HBO was doing classy contemporary American drama with American stars—like *Empire Falls*. And A&E hadn't done much since *Pride and Prejudice*. The cable companies were beginning to attract our audience, but not with British programming.

I was stunned and quickly realized it would be a major black eye for *Masterpiece Theatre* and PBS if *our* Helen Mirren from *Prime Suspect* appeared on HBO in *our* signature kind of drama. In 1972 Glenda Jackson, after all, had been an iconic Queen Elizabeth I in our BBC co-production of *Elizabeth R*. But after scrambling around to raise our bid as high as possible, we realized that this *Elizabeth* was going to end up on HBO. They could outspend us by a factor of five because of their huge income from subscribers. In fact, that's why HBO wanted *Elizabeth*—to attract more subscribers.

It woke me up.

I could see clearly that the television landscape was changing and that *Masterpiece Theatre* was being left behind, resting on her many laurels. The evidence was blinding. Our audience was aging; the ratings were the lowest they had been in decades, possibly ever; we'd had no corporate sponsor since ExxonMobil bowed out in 2004, in spite of the efforts of our sponsorship group; and PBS was on record as saying that it wanted less British drama in the prime-time schedule. I knew all this, yet hadn't added up what it meant. We seemed like relics, and we might soon be off the air, and existing only as an exhibit in a broadcasting museum.

Everywhere, I heard the phrase "I used to watch *Masterpiece Theatre*," or worse, "My *parents* used to watch *Masterpiece Theatre*."

I thought of quitting and looking for a job elsewhere: HBO? It crossed my mind, but my 1960s sensibility of doing worthwhile work, and making a contribution that left the world a better place, was so intertwined with my love for my life in Boston, my deep connection to British drama, and my fear of failing in the commercial game that I knew I was inexorably bound to *Masterpiece Theatre*.

At that critical moment, our faithful audience spoke up. The Corporation for Public Broadcasting and PBS had commissioned a study; the surveys revealed that people who donated money to their local TV stations cited *Masterpiece Theatre* more frequently than any other prime-time series as the reason. And even better, it was specifically British drama they wanted to see. Even though our ratings were drooping, they were still higher than those of many other PBS shows. And our audience was consistent. These viewers were loyal, both in their viewing habits and in their donations to their local stations. Because donor support is the very lifeblood of public broadcasting, we got the attention of executives at the network, and the tide slowly began to turn back in our favor.

It was time to do some major rethinking and self-examination,

and that required money. We applied for, and received, a grant from PBS and CPB, specifically to be used to ensure *Masterpiece Theatre*'s health and longevity—and miraculously, we could pretty much spend it as we saw fit. It was wonderfully nondirective. My strongest instinct was, again, not to let the mighty *Masterpiece* go down, but I wasn't at all sure how to prevent that. I didn't think it was just a matter of finding better shows, or more modern shows, though certainly that was part of the solution. Nor was it just outbidding HBO the next time around. We had to do something more far-reaching with our entire approach, including our on-air look. It was time for a *Masterpiece* makeover, one that capitalized on and preserved what we did best but identified and addressed where we were falling short.

It sounded like a terribly good idea; however, I really didn't want to do it. I didn't know how, and I feared weeks of listening to branding gasbags talk about silly, undoable ideas. Reluctantly, I looked around for a "brand doctor," a concept I really disliked, thinking that brand management was all smoke and mirrors: talk, image manipulation, high-priced consultants, and huge amounts of advertising that we'd never be able to afford.

We visited a few big-name branding companies in New York that made slick presentations, and then eventually we came across the guy who would help save *Masterpiece Theatre*'s life.

His name was Bob Knapp. He had formerly been CEO of Harris Interactive, a worldwide market research organization best known for the Harris Polls, but now he was a solo practitioner. He made his presentation to us in a dizzyingly stuffy room at the Yale Club in New York. He was a straight shooter that day, and he still doesn't mince words now. Essentially he told us that *Masterpiece Theatre* was the jewel in PBS's crown, but it was a dusty jewel, and hard to find.

He says, "A colleague of mine had told Rebecca and her crew that

*Masterpiece* was in no condition to pitch to potential sponsors because there didn't seem to be much about the program or franchise that was new, or forward-looking. He advised her to get someone to come in and help define the brand, so that there'd be a story to pitch."

Bob was irritatingly right. One of the biggest mysteries of my career had been the inability of *Masterpiece Theatre* to attract a sponsor after ExxonMobil withdrew its support in 2004. It was one of the most high-profile, most decorated titles on PBS, with an extraordinarily devoted, educated, and affluent (if aging) audience: what company wouldn't want to attach its name and dollars to it?

I could understand that the more sophisticated multinationals might, in the first year or two, fear that ExxonMobil's association with the series had gone on for so long, and was so strong, that a new sponsor's brand would be overshadowed. But after that cooling-off period, I found the lack of interest incomprehensible, as did the press. At every press conference and in every interview I gave, I got the question, "Why doesn't *Masterpiece Theatre* have an underwriter yet?" PBS had to pay the full bill.

We never publicly discussed the dollar figure we were looking for (it was about $10 million a year at that point), but the media and press certainly knew that the cost was a fraction of what commercial advertising would amount to. We were offering a thirty-second sponsor credit at the head and tail of every *Masterpiece* hour for roughly thirty-five weeks a year, at what a nanosecond at the Super Bowl would cost. For two or three years, WGBH tried to drum up interest from companies that they thought would profit from a connection with our audience: financial services, high-end British products, travel, insurance, banks, even DuPont. I would put on a suit and go on sales calls as often as possible, convinced that my personal passion for British drama would win the day. I was sure that if I could get a lunch with Howard Stringer at Sony, or Sandy Weill at Citibank, I

could make lightning strike again for *Masterpiece*, as it had with Herb Schmertz at Mobil back in 1971.

But I couldn't get a lunch date. And for me, the absolute nadir in the search for a munificent, culturally savvy, corporate Medici came when I learned that we might have interest from the company that made Botox.

In fact, the sponsorship game had changed radically, as any PBS viewer will tell you. The days of the single sponsor that would underwrite a program or a series because the company believed in the PBS mission, or because an association with PBS might burnish its corporate image, were over. More and more companies were using advertising agencies, where PBS would be merely a part of a larger media buy. The shift was away from corporate philanthropy and toward product marketing. Mere association wasn't enough; companies needed to sell their soap directly. The contact people at these agencies were often thirty-somethings with no history of, or interest in, *Masterpiece Theatre*. The people doling out the money were exactly the people who were *not* watching us anymore.

I had hired a colleague, Doug Billman, to start the makeover process, and he worked hard to spruce up *Masterpiece Theatre*'s sales potential, because he truly believed that the show was iconic and shouldn't be reduced to a short-money advertising opportunity. Eventually he led us to Bob Knapp.

Bob observes, "Consultants rake the leaves into piles, so to speak, and see if anyone wants to jump in. Rebecca and her staff were in a quandary, because they had seen extraordinary success, lost it, and didn't know how to get it back. When I met them, they had been through the drought of post-Mobil support. And at that time, in some corners of PBS in Washington, *Masterpiece Theatre* and British drama had been left for dead. There was a feeling that there were better ways to spend energy and dollars.

"Rebecca has an extraordinary ability to block out the noise. She was singularly focused on trying to maintain the integrity and the

approach of what *Masterpiece* had always been. But when I entered the former WGBH facility, I saw a run-down building with lots of big theatrical posters of actors I hadn't seen in a while, and mustard-colored rugs that signaled 'nonprofit.'

"To me it felt like a waiting room where you might be waiting for something that never came. Yet when you talked to Rebecca and her associates, it was clear that they were thrilled and alive with the stories they were procuring and airing. At the same time, they seemed to be living in an alternate reality from popular entertainment and couldn't seem to find their way out."

With grant money from PBS and CPB, and with the warm support of the new president of PBS, Paula Kerger, an executive who understood better than anyone the importance of donors/members, we jumped off the rebranding cliff. If I had known how incredibly difficult and potentially risky it is to reinvent successfully an iconic brand like *Masterpiece Theatre*, I never would have done it.

But willfully oblivious or just ignorant, I knew we had to do *something*. *Masterpiece Theatre* was dying on the vine. I remember lecturing Bob Knapp that we couldn't afford massive research, and that whatever he did, he absolutely had to come back to us with specific, actionable, meaningful suggestions that we could realistically adopt to attract more viewers and ultimately a new underwriter—no airy-fairy mission statements or impossible dreams.

We gave him the names of fifty or so *Masterpiece Theatre* stakeholders, some fans, and some foes. They were PBS executives, TV critics, former and potential sponsors, regional TV station managers, and selected viewers. We asked him to interview them personally, with the promise of anonymity, in order to get a realistic if anecdotal picture of how *Masterpiece Theatre* was perceived.

Off he went. When he eventually collated and shared the opinions he'd garnered, we discovered that they were alternately heartwarming

and brutal. But they served as a catalyst. As a team, we began to get our mojo back. His findings reminded us how exceptionally well done and unique these British dramas were, and how much a part of people's lives *Masterpiece Theatre* had always been. We'd been so mired in the money and ratings struggles that we'd lost sight of the wonderful stories at the heart of the work.

I remember meetings when we'd try to bring Bob up to speed on the *Masterpiece* programs he'd missed over the years; we'd interrupt one another to tell him the plots of our favorite shows, and we'd even act out, badly, our favorite scenes. We were allowing ourselves to be fans of and advocates for the material: we were falling in love again, and it was a wonderful feeling.

Eventually Bob came back with some succinct and reasonable observations and advice. His main point: we were getting in our own way. The actual programs in the *Masterpiece Theatre* series were compelling, but we were making it very hard for the audience to find them and, once they'd arrived, to get into them. We were scaring away new, younger viewers in many ways, even with our very title. *Masterpiece Theatre*, especially spelled the British way, with an *re* at the end, which implied sitting in an uncomfortable seat in a dark room and watching something written hundreds of years ago, about which you would be tested later for a degree in English literature.

He observed a basic problem: the audience didn't know what it would be seeing from one Sunday to the next. It's hard to get people to make an appointment for a television series that prides itself on being "appointment television" when they don't know who, or what, they'll be meeting. Our audience was having its head snapped: Jane Austen one week, followed by Jane Tennison the next, followed by Jane Eyre, etc.

Bob said: "Within the series, a war story would be followed by one about romantic love. Forget about branding: what was the nature of the show? There was no continuity."

The necessary but disruptive public television membership drives, thrown into the middle of the prime-time schedule every December, March, and August, didn't help with that problem. Then a special, like a big Ken Burns project, might pop up in our Sunday-night slot for a few weeks' running and preempt us.

Bob gave us a chart with five columns. At one extreme was "do nothing and act like you did," in which we'd make small changes that appeared to be more than they actually were. He explained that he'd worked with many organizations that thought they wanted to make changes but actually didn't: they wanted an illusion of change.

That didn't apply to us.

At the other extreme was the option to kill *Masterpiece* entirely and sell the *Mystery!* franchise on its own to a cable channel. Obviously we discarded that one out of hand.

Bob says, "Then I proposed dividing the programs into the Four Seasons of *Masterpiece*: Romance, Mystery, Modern (for things like *Prime Suspect*, which can't be in the same category as 'I'm in period costume cheating on my lover'), and one we called The Vault, for classics repeats of shows like *Upstairs, Downstairs*."

Ultimately we came up with three subseasons: *Masterpiece Classic*, *Masterpiece Contemporary*, and *Masterpiece Mystery!* all in the same Sunday-night slot. Now viewers could get a better sense of program content and choose accordingly. And from a publicity point of view, we could launch three seasons—three bites of the publicity apple, as it were.

Much as I wanted to rely on instinct and subjectivity and not spend a lot of money on pollsters, in the end we did some audience focus groups at PBS's request.

Bob explains: "Initially there was some reluctance to make changes at *Masterpiece* without doing some research. In four geographically diverse cities, we brought in the DVD covers for the shows that had been on *Masterpiece Theatre* over the previous two years. We asked

people to put them in piles according to the types of shows. It was a very visceral exercise. Everyone divided the DVDs into these three categories with no prompting from us.

"Having three 'seasons' would also allow *Masterpiece* to launch several times a year, which both helps people remember that the show is on and forces you to use an organizing principle."

Essentially, we changed everything about *Masterpiece Theatre* except the programs and its famous Sunday-night-at-nine time slot. And thus, *Masterpiece Theatre* became *Masterpiece*.

All of these decisions were tricky because the last thing we wanted to do was to alienate our longtime and loyal fans—the ones giving money to their local stations—yet we had to attract new viewers and a sponsor. We had to make people feel that *Masterpiece* was cool again.

We called the viewers in our core audience "smart women of a certain age." We knew that they were mostly college educated and upper income. It occurred to everyone simultaneously that we needed to reach out and ensure that we were attractive not only to them but also to those who'd become the next generation of those women.

We found out that women thirty and younger don't watch television on televisions; they watch videos or stream shows on their computers. That's their whole frame of reference, a head-snap for people forty and older. Not unnaturally, these realizations on our part coincided with the emergence and the flowering of things like Facebook and Twitter and the social media world.

We thought hard about other ways to take *Masterpiece* in a direction that would bring us younger viewers. In particular, we identified young women twenty-five and over; we started calling them "smart girls." We figured that if we didn't engage women at that age, they would never grow up to join our base.

We had smart girls right there on our staff. We deployed one of them, Olivia Wong, into a digital "space" that I only half understood.

She explains, "At the time, Facebook was *the* social media site. It seemed like the right place for *Masterpiece* to be if we were going to be in this world at all. Other PBS shows had already established pages there, but we wanted to make sure it was the right fit for *Masterpiece*. It took us a while to figure out what our voice would be."

We decided that a Facebook page should promote broadcasts, provide little reminders of when programs were going to be on, and also remind fans of our Web site. Next we added a Twitter account. I couldn't believe we were doing these things. We joined Twitter so that we could live-tweet at the Emmys in 2009, when *Little Dorrit* was nominated. *Live-tweet??*

I had to force myself to be interested. The solitary bookworm in me just didn't get social media—the constant interconnectedness and the fragments of information. When the technology evolved to the point where viewers could watch a program and simultaneously tweet about it to one another, I despaired. It was so much the opposite of what attracts me to drama and reading: silent, personal, concentrated time-travel and escape. But of course it's the way we live now.

Creating a new on-air look was slightly more familiar to me because once again, the brilliant and patient designer Chris Pullman was holding my hand. He loved *Masterpiece Theatre* as much as any of us, and I knew he wouldn't let us embarrass ourselves. We needed three new opens, three sets of music. Many of Chris's former design students at Yale had gone on to start companies in L.A. and New York, doing feature film trailers and animation for title sequences. We asked three different companies to do designs for us, on spec.

I remember a designer at the production house Imaginary Forces, who showed us some striking storyboards for the opening of a new television show he was working on for AMC. They were black-and-white drawings of a man in a suit, falling, falling, from a tall office building. It was apparently for a show set on Madison Avenue in the

1960s. Brilliant—but we didn't hire him. We went with Kyle Cooper at Prologue, because his idea of a central image of pages from a book spoke to what *Masterpiece* had been about for so many years, yet it still gave us something we could play with.

Our co-conspirators at Prologue in L.A. and the people at Man Made Music in New York, run by Joel Beckerman, were angels in disguise, willing to work with us patiently and at a reasonable cost, to get it right. They also knew they were working on something iconic and wanted to treat it well.

Senior producer Susanne Simpson managed them all with a light touch and a clear voice.

I felt strongly that for the three new musical themes, we should stick to the original much-loved *Masterpiece Theatre* theme, Jean-Joseph Mouret's "Fanfares for the King's Supper," discovered all those years ago at Club Med. I can't carry a tune in a basket, and can barely hum that famous melody; I asked Joel to keep it, but to take it wherever he needed to. I love that you can still hear the original theme in each of the three new opens.

As I write this, it all seems so orderly and succinct, but the truth is that it often felt like a hot mess. The work took months, with false starts, wrong directions, stalls, and endless tense meetings. I would be impatient and indecisive, all at the same time. We had to make countless choices and decisions, and even as I resisted making them, I insisted on being the decider. Nothing seemed good enough, but I couldn't articulate exactly what would make anything better. I cringe to think how frustrating it must have been to work for me during the whole rebranding adventure.

I suppose all this is the discomfort of creating anything new: a process full of endless uncertainty and disorder, until the "creation" finds its shape. Coming up with a vision of what you want to create, altering it when a better idea comes along, but insisting on what you

sense is right, is exhilarating and frightening, especially when you have something important to preserve and honor even as you're dismantling and remodeling it. It reminded me of my days as a film producer, and it was hard.

It was also alarmingly public. We got out ahead of ourselves by making a presentation at the PBS annual meeting, a convention of hundreds of executives, managers, and producers. We trumpeted our intention to give *Masterpiece Theatre* a major facelift. Bob Knapp and Steven Ashley made a slick and witty PowerPoint, and in the spring of 2007, I got up on a stage and promised that a brand-new *Masterpiece*, "not your father's Oldsmobile," would be on the air in January 2008.

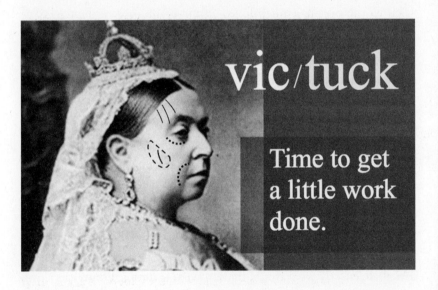

vic/tuck

Time to get a little work done.

The launch was six months away, and our plans were still lying in pieces all over our offices: unacceptable versions of the new themes; imperfect storyboards of the new opens; no staff to design a Web site; and worst of all, no hosts. There had been no hosts at all in the three years since Russell Baker had retired in 2004.

Knowing how much luster and credibility Alistair Cooke and Russell Baker had brought to the series over the years, and knowing that PBS as a network needed more "personalities," we set out to find three new hosts who could represent each new genre: *Masterpiece Classic, Mystery!,* and *Contemporary.* We knew the days of the four-minute Alistair Cooke introductory essays were over, because audiences (and PBS executives) wanted us to get right into the drama. So we were looking for star power, for personalities who would set the tone for the upcoming shows and maybe even bring their own (younger) fan base with them.

*Masterpiece Classic* was scheduled to air in January, so we concentrated on finding its host first. We wasted several months waiting for Kate Winslet to say no and for James McAvoy to say yes and then no. Sigourney Weaver's agent wanted her to do it, but James Cameron wanted her to do *Avatar* more. The list was pretty long.

When I called Hollywood agents, or more accurately their assistants, they would invariably say, "I don't have X at the moment—can he return?" meaning, "I don't know who you are, and he'll probably never call you back."

If I ever did get through to an actual agent, he or she seemed only to hear that I was with PBS, and since PBS equals no money, the conversation would go politely nowhere. Even the lovely Ken Branagh, through his manager, answered with a perplexed, "Didn't you ask me this once before, and didn't I say no?"

The fastest rejection I got was from George Clooney's agent, after I'd spent two days carefully crafting an e-mail offer. Literally five minutes after my finger came off the "send" button, I got a return e-mail saying no.

Then we had a collective brainstorm and remembered Gillian Anderson's deep appreciation for *Masterpiece Theatre.* We'd met when she came to L.A. to help us publicize *Bleak House,* a BBC co-production

written by, of course, Andrew Davies, in which she gives a perfect performance as the beautiful, haunted Lady Dedlock. After years of mixing it up with journalists during her *X-Files* days, she didn't particularly like doing press interviews; but she traveled from London, where she now lives, to L.A., to help us out.

She'd looked right at me and said, "I love *Masterpiece Theatre*. Let me know if there's ever any way I can help."

She's a woman of her word.

Gillian explains: "When I was called about the rebranding campaign, I understood it as a way to build audience and to bridge certain demographics. I said yes right away. My only concern was that a few people said to me, 'Congratulations on your new job.' I was a little worried that they would think that somehow I'd chosen to do this instead of acting per se. But that didn't last very long.

"I appreciated what Rebecca and her crew were doing and wanted to be a part of it. A lot of it was realizing how important *Masterpiece* is to what gets created in the U.K.—and knowing how much PBS relies on the audience for the funding to make it happen. I wanted to help keep these shows coming and to be vocal about them, to encourage other people to acknowledge their appreciation, too, by being generous."

At this point we were seriously behind schedule. Even after Gillian agreed to do it, negotiations went on and on. Her schedule was tricky because she was just coming back from Sri Lanka, where she has a house. It was literally early December before we arrived at a mutually agreeable shooting date in London. The newly minted *Masterpiece Classic* was to go on the air in January.

We didn't have a director, we didn't have a set—we didn't have anything.

Senior producer Susanne Simpson and I had to jump-start the shoot in a freezing-cold warehouse in London. Despite the time we'd

spent on music and imagery, we hadn't been able to focus on the set: should it be an abstract background, or should we construct something like what we'd done for Russell Baker, an interesting-looking office, filled with books?

Susanne remembers, "Because we weren't sure how we wanted it to look, we actually had our producer in London bring in all kinds of props: tables and couches and vases and chandeliers. We tried each of the props: should we go with something simple and abstract, or re-create the whole Alistair Cooke look? There was the constant tension of wanting something new and fresh while at the same time not disappointing the loyal fans of *Masterpiece*.

"It even came down to the clothes Gillian would wear. Did we want her to have an Edwardian look, or a simple modern one?"

We were clear about one thing: after the years of homey, cluttered, eccentric sets for *Masterpiece Theatre* and *Mystery!*, we should go for utter simplicity and elegant lighting. We should focus only on the personality and the words of each host. We should go with a different palette for each genre: white for *Contemporary*, grey for *Mystery!*, and red for *Classic*.

But red for *Classic* presented a problem: Gillian arrived on the set with bright red hair. We'd been picturing diminutive, beautiful Gillian Anderson with her own blond hair. She apologized: she'd just been in Los Angeles for screen tests for the new *X-Files* movie, and they'd dyed her hair exactly the same color as the background of our new opening backdrop. She sort of disappeared into it.

Back in Boston, it was immediately clear that while its components seemed simple to construct, the new three-genre idea for *Masterpiece* put a real strain on our small staff back in Boston. There were only seven of us. The staff had come on board a conventional public television show to do conventional publicity, marketing, and outreach—organize print reviews, set up press junkets and live interviews, sell a few

DVDs, raise some money. Now suddenly they had multimedia responsibilities in media that hadn't existed five years before.

Bob Knapp adds: "I had to remind them that we were selling a product here. After all, their viability with PBS had been questioned."

It became very clear that everything we did had to focus on tune-in—more eyeballs watching the show.

At this point in 2007, we got a lucky break, and someone on our staff knew how to turn it into a programming stroke of genius. For no apparent reason—except, perhaps, ratings competition and an instinct about the rising tide of Austen-mania after Colin Firth emerged ravishing and dripping wet in *Pride and Prejudice*—the BBC *and* ITV simultaneously decided to do new dramatizations of some of Jane Austen's books. The BBC asked us to co-produce *Sense and Sensibility*, and ITV asked us to come in on *Persuasion*, *Northanger Abbey*, and *Mansfield Park*. All of Jane's novels had, of course, previously been produced as feature films or television programs, and we'd aired most of them at one time or another over twenty years.

But Erin Delaney, one of our producers and a "smart girl" who had spent many hours of her early years marinating in Jane Austen, knew perfectly well that Jane had written only six books in her lifetime. Why not put them together on television and, for the very first time, air them all at once?

Why not, indeed? We took Erin's advice and branded those six weeks *The Complete Jane Austen*. We joined up with the Jane Austen Society of North America (JASNA) to get the word out, and a more fervent and messianic group of English majors you've never met. Did you know that JASNA has 4,500 members and a huge database? Neither did we.

We could barely restrain them from throwing Jane Austen parties and otherwise creatively drumming up business, eighteenth-century

style, for our broadcasts. I took a cab once to a screening in New York City, and as I was approaching the venue, I looked out the window to see young women in Regency dresses and elegant bonnets streaming out of the subway and down the sidewalk toward the entrance.

Our announcement about the launch of the new *Masterpiece*, with Gillian as the host of *Masterpiece Classic*, was picked up everywhere, exactly as we'd hoped. Somehow we staggered over the rebranding finish line on January 13, 2008. *Masterpiece Theatre* was coming back to life as *Masterpiece*, and having the Austen six-pack as its opening act was a marketing dream come true.

Reviews were incredibly positive for our "stunt" of airing all the Austens at once. And the Web site numbers exploded, as did audience numbers; the "smart girls" demographic of women eighteen to forty-nine jumped 125 percent. We were also helped by the launch of our Facebook page in late 2007, right before *The Complete Jane Austen* aired in January 2008.

Even though many Austen fans had seen any number of the programs before, they watched all over again. On our new Facebook page, rabid Janeites made connections to actors who'd appeared previously on *Masterpiece*, like Rupert Penry-Jones (*Jane Eyre*, 1997; *Casanova*, 2006), featured in our new version of *Persuasion*.

Olivia Wong adds: "Austen lovers even traced costumes used in previous Jane Austen broadcasts. Many British productions use the same costume houses, so these pieces are recycled. The fans' attention to detail was amazing."

The rebranding helped us focus on attracting new viewers not just on Facebook but also on our Web site, which much to my Luddite surprise was proving to be a key component in our new popularity.

Bruce Kohl, senior producer for interactive media, explains: "People have always been passionate about *Masterpiece*, and yet there was also a sort of moat around it, with the audience gathered lovingly

on the other side. In the digital space we wanted to create more intimacy, playfulness, and move away a bit from an academic approach, as valuable as that is. We wanted to give people new and refreshing ways to connect.

"For the Austen series, we gathered all the leading men into a kind of online dating service. You could read their turn-ons and their turn-offs, and their income, which we correlated to what it would be today. For *Emma*, we did a bachelor quiz that helped you pick a suitor from Emma's cadre of possibilities. Because Emma is intrusive, she would chime in with dating advice at various points."

Almost instantly, journalists and reviewers began to refer to *Masterpiece Theatre* by its streamlined new name, *Masterpiece*. Viewers took a bit longer to adapt; I'm sympathetic to that. I still think of *PBS NewsHour* as *The MacNeil-Lehrer Report*. But gradually we realized we'd done it: we'd actually achieved what we set out to do in the high-wire act of rebranding. But we barely had time to draw a breath.

The team went out for a celebratory dinner, knocked back a few cocktails, and got back to work to find the perfect host for *Mystery!* We had exactly six months before we would air the first Sunday-night *Masterpiece Mystery!—Inspector Lewis*, set in Oxford and the descendant of *Morse*.

My first, last, and best suggestion was to hire my favorite master of ceremonies in show business, Alan Cumming. I'd seen him as the emcee in *Cabaret* on Broadway and was fascinated by his poignancy and charm. He is a classically trained actor, and he'd actually been in a Jane Austen drama, playing the fatuous curate Mr. Elton in the 1996 *Emma*, with Gwyneth Paltrow. To me, he seemed everything I wanted *Mystery!* to be: witty, smart, complicated, dramatic, and stylish.

He said yes right away. I think he was attracted by the idea of being an ambassador for the work of his British colleagues, even though he's passionately Scottish and married to an American, Grant

Shaffer. He also seems to like to work constantly, and this was before he became Eli Gold in *The Good Wife*.

With his impish sense of humor, Alan brings fun into the room. The tapings were easy, and the audience reaction to his version of the *Mystery!* emcee was huge. As he stepped out of cabs in New York, people would come up and say, "You're the host of *Mystery!*" He said he'd never been recognized so often. He'd been a theater actor, speaking to a few hundred people a night. Now he was exposed to five or six million people a week.

The first person to host *Contemporary* was Matthew Goode, a British actor who'd played Charles Ryder in the 2008 film version of *Brideshead Revisited*. In *Brideshead*, Matthew had a full mane of hair. But when he showed up in New York to tape our opens, he'd shaved his head. He's a gorgeous man, so it didn't matter. But we could have done without the surprise factor.

Hair was becoming a significant production issue, between Matthew's lack of it and Gillian's surprising flame-red color; even Alan Cumming's was occasionally shaved on one side and long on the other. We learned to make our hair specs clear long in advance of shoot days.

But hair or no hair, our efforts had paid off.

Bob Knapp says, "The rebranding of *Masterpiece* had it own dramatic momentum. You had protagonists with a noble cause. Then you had seemingly insurmountable odds in terms of money, support, and competition. But they pulled it off."

*Masterpiece* was back in the game. We were all exhausted and a bit stunned. And we were oblivious to the fact that we'd set the stage for some programming that would eventually take *Masterpiece* into an entirely different television orbit.

# THIRTEEN

# But What Does an Executive Producer Do All Day?

That's the question I get all the time, from my eye doctor, from small-talkers at cocktail parties, from high school classmates at reunions, and from the ladies in my Pilates class. I haven't quite perfected the thirty-second elevator response, but it's something like this: "I raise money for *Masterpiece*, choose and work on the programs for it, and oversee the publicizing and broadcasting of these shows in the United States."

I actually try to make my answer as boring as possible in order to avoid follow-up questions. I love my job—to me, it's the best job in American television, and in many ways I think I was born, raised, and educated to do it; but I find it difficult, to the point of excruciating, to make small talk about it. Maybe that's peculiar, but I suspect people in all kinds of professions feel that way too.

My husband, Paul, an artist, says he certainly does, and he's altered his answer accordingly.

"And what do you do, Paul?"

"I'm a tree surgeon."

He got even more tired of answering follow-up questions about *my* job, and so he perfected a conversation-stopper: "Oh, Rebecca makes educational films for Mobil Oil." That response was guaranteed to inspire the interlocutor to excuse himself and head for a refill at the bar.

Explaining what an executive producer does is impossible, because the job varies in every medium and genre and with practically every project. An executive producer in feature films is entirely different from one in television. An executive producer credit can be merely a courtesy to indicate that you got the project off the ground: or it can mean that you thought it up, raised the money, sweated blood, wrote, directed, produced, and starred in it.

The best way to tell you what my version of an executive producer does all day might be to give you the case history, from soup to nuts, of one *Masterpiece* co-production. I think that *Cranford* may be a perfect case study, not only because it was perfectly made but also because the show was perfectly typical in almost every way. Plus it features a cow in a union suit.

*Cranford* is a five-hour miniseries we co-produced with the BBC in 2008, just six months after the Jane Austen marathon launched the *Masterpiece* rebranding. Based on some short stories by Elizabeth Gaskell, *Cranford* is about the lives and loves of a charming group of people in an English town in the mid-nineteenth century. So far as an idea, it's nice, but it just sits there. And that's often where projects begin—as raw material or as a concept, but with no story or organizing principle. Sometimes producers begin with a great novel that has a great single or multithread plot (like *A Tale of Two Cities*), and sometimes they start with a wholly original script (like *Traffik*), but in this case there was a setting, some characters, and an armful of unrelated storylines. Hmmmmm.

*Cranford* came to us in the winter of 2005, when I had a call from Jane Tranter, the legendary head of BBC Drama, whose judgment I'd come to trust after we'd co-produced *Wives and Daughters*, *Daniel Deronda*, and *He Knew He Was Right*.

We laughed and swapped gossip for a while. Then Jane said she was coming to New York with a producer who wanted to do an Elizabeth Gaskell project: would I come down from Boston and have dinner with them?

Yes. That particular executive producer decision was easy, both because Jane had an excellent track record and because I knew the work of Elizabeth Gaskell. She's not on the Austen-Brontë-Dickens nineteenth-century all-star team, but she's a solid player. We'd co-produced her novel *Wives and Daughters*, and I'd read (most of) her other books.

So, good creative relationships and a thorough grounding in the underlying material are obviously essential at the beginning of a project.

I went to New York, and we all met at a cool downtown hotel called 60 Thompson, drank cosmopolitans, raved about La Mer skin products, and laughed some more. That's something I love about working with the British—the wit, the shop talk, the small-world drama gossip. It's fast and sharp and fun—until of course, you're out of the room and the subject of the gossip becomes you.

Whenever I'm pitched a project, my first question is: Who's the producer? Who's going to put his or her life on hold to make it happen? Any television executive can tell a lot about how a show will play—broad, intellectual, comic, tragic, postmodern, traditional— just by knowing who the producer is. He or she will spend years bringing the project to life, assembling the rest of the team, and persuading people to invest in it.

Sue Birtwistle, the prospective *Cranford* producer, was someone I'd known since 1987, when she'd produced Evelyn Waugh's *Scoop*.

And then in 1995, I'd unsuccessfully tried to get her to co-produce *Pride and Prejudice* with us instead of with A&E. I knew Sue was a good producer. She has taste and judgment. She is tenacious, protective of her projects, and incredibly well connected.

The next critical question was "Who's going to write *Cranford*?" It existed only as stories about colorful characters in a town; it desperately needed a dramatic arc and an emotional engine. Sue and Susie Conklin, her script editor, were proposing that Heidi Thomas write it.

I didn't know Heidi personally, but they set her up beautifully for me: "She's practically a nineteenth-century character herself. She's worked as a brassiere fitter in ladies' lingerie; she bakes; she's married to an actor; and she wears old-fashioned high-button shoes. You'll adore her."

But more than that, Heidi had writing chops. She'd written an excellent adaptation of *Madame Bovary*, which we'd aired in 2000, and several British television series that I'd really liked. I did the necessary executive producer due diligence and asked around about her—all good. I knew she could pull together the bits and pieces of Gaskell's stories and make a warm and dramatic two-hanky miniseries. But as good as Heidi was and is (she's gone on to write the new *Upstairs, Downstairs* and the wildly successful *Call the Midwife* series), Sue Birtwistle had something—or, more accurately, someone—who sealed the deal for me.

Sue and her husband, the director Richard Eyre, former director of the Royal National Theatre, have a world-famous personal Rolodex and can attract star casting for any project they undertake. They've worked with, have access to, and are friends with practically every first-rate British actor you can think of. In 1989 Richard had directed Daniel Day-Lewis in *Hamlet*, and Sue had cast Colin Firth as Mr. Darcy in *Pride and Prejudice*. And that's just for starters.

So whom had Sue persuaded to star in *Cranford*? Queen Victoria

in *Mrs. Brown* (for which she should have won an Oscar); Queen Elizabeth in *Shakespeare in Love* (for which she *did* win an Oscar); M in the James Bond movies; and a PBS favorite from the Brit-coms *A Fine Romance* and *As Time Goes By*, Dame Judi Dench.

Judi famously doesn't like to read scripts. She works with people she trusts and prefers to have prospective projects simply described to her. Sue offered her the part of sweet, innocent Miss Matty, and Judi was in. The excellent Kate Harwood would executive-produce for the BBC. That was good enough for me. We would do *Cranford*.

My next task was to do the actual deal. As the executive producer of *Masterpiece*, it is my job to negotiate all the financial and legal agreements with our British producers or their distributors. Henry Becton taught me how in the best New England skinflint tradition, something I was already familiar with, having had a Yankee father. Back in the days of *Cranford*, PBS was *Masterpiece's* sole funder. Every year it was my responsibility to convince the PBS executives that every dollar requested for *Masterpiece* was essential. Once the money was secured, we were good to go.

Then suddenly, with *Cranford*, everything slammed to a stop. Judi had to go play M again in a new Bond movie, and she wouldn't be available till the following year. The BBC begged us to keep the money on hold—"ring-fenced," as they called it—and to wait for her. It took some contorting with PBS, but we did it—because Judi is worth waiting for. So we earmarked the money for future spending and filled the slot with *Bleak House*, a stunning BBC production in its own right.

By the time the production started up again, the BBC's tune had changed. *Cranford* was going to be really expensive, they said, and they needed more than a million dollars from a U.S. partner. Regrettably, if we couldn't come up with it, they said, they'd just have to go to HBO.

HBO? This wasn't HBO's type of programming. HBO was doing *Deadwood* and *Entourage*. I smelled a rat. HBO had never done *Cranford*-type period miniseries before: why would they start now, even with Judi Dench?

In fact, there *was* a problem, if not a rat. Apparently another BBC/ HBO project had fallen through at the last minute, and the BBC, which really *did* need more money for *Cranford*, was trying to sell the miniseries to deep-pocket HBO as a "make-good." Even though I'd put money on the table and we'd had a telephone handshake, they were trying to get the project back.

For a while, it looked as if the whole *Cranford* idea would be abandoned, without HBO *or* PBS. The three-dimensional moving puzzle—the Rubik's Cube of production schedules and financing— just wouldn't fit together, as so often happens in movies and big-budget television. But at the last minute, the pieces of the cube clicked together, the schedules freed up, and either the BBC decided to con- summate our original deal or HBO's interest evaporated. We signed the contract with the BBC. Sue Birtwistle remembers thinking that for her, getting news of our production money was like suddenly hearing that the U.S. cavalry had ridden into town, coming to her rescue.

Heidi went off to write the scripts. Eventually I was sent first drafts, as were Jane Tranter and her team. The BBC and Sue were contractually required to give my notes "meaningful consideration," legalese that meant that they didn't actually have to do anything about them. So I knew that, as usual, my best course of action was to be as persuasive and convincing as I could and hope to be heard. I flew to London for script meetings and casting conversations at Sue's house. As a long-distance producer, I found the going pretty uphill. I was a minority partner, and thus outside the core creative team.

But my job was to voice ideas that I honestly believed would improve the scripts, no matter what resistance I encountered. It's

much easier to insist when you have the contractual authority to do so, but the creative act of writing a script is so delicate that in my experience, executives (the British ones, at least) rarely "big-foot" writers. My suggestions were not so much ideas representing the American point of view as they might have been in a documentary; they were more notes about plot clarity, dialogue tweaks, and character development. In so many of our co-productions, including *Cranford*, I like to think that my script notes can be helpful *because* I'm at a distance from the project. Since I'm not in the day-to-day, hand-to-hand combat of writing, shooting, and editing, I might be able to offer a fresh perspective. I suppose I'm one of the first members of a program's eventual audience.

If feature films are a director's medium, television is a producer's—that's where the control is. So once Kate, Sue, and Heidi came up with relatively strong scripts for *Cranford*, the production went director shopping. With Judi Dench on board, they were "spoilt for choice," as the British expression goes. Once again *Masterpiece* was a minority partner, with consultation, not approval, rights; and once again something major threatened the whole thing.

I discovered that the production had hired a director whom we'd never discussed and whom I'd never heard of. There was much explaining and backfilling, and I was sent an example of his directing work to reassure me: a dark drama about immigrant smuggling in the North Sea, in which a fair number of refugees were fatally trapped in the pungent hold of a fishing vessel.

Interesting—but about as far from charming, sunlit *Cranford* as you could get.

I flew to London and met the director, who, unlike his film, seemed warm and jolly. Everyone got along fine, but I still had doubts about his suitability for *Cranford*. I voiced my concern but then, as always, had to step back and let the team get on with things.

Sue Birtwistle was able to attract the very best heads of department in drama production: a production designer; costume, hair, and makeup people; a first-rate cinematographer; and sound and picture editors. You can barely read these people's names as they fly by in minuscule type at the end of a TV show, but they are the ones who truly make it possible for you to suspend your disbelief and time-travel to another time and place. You don't even know it, but the hours they spend adjusting the ribbon on a bonnet, or emphasizing the sound of silverware clinking on china, or perfecting the flicker of candlelight on an actress's face, are what hypnotize you and make you leave your living room and alight in the town of Cranford, or in the dining room of Downton Abbey, or out in the garden of Bleak House.

Judi Dench in the lead was a magnet attracting additional starry talent: Eileen Atkins, Imelda Staunton, Michael Gambon, and Francesca Annis quickly signed up. And dozens of agents and talent managers beseeched Sue to cast their lesser-known clients. The story was going to center on two spinster sisters, played by Judi and Eileen; a fragile and ghostly aristocrat, Francesca; and a group of kindly, bossy, interfering, and helpful Women of a Certain Age. There would be birth, death, marriage, and betrayal. All the storylines would weave back and forth to create a narrative of a strong and loving community. It attracted stars, character actors, and young up-and-comers.

Eileen Atkins remembers it this way: "The minute I heard Judi was in it, and I'd read the first episode, I knew it was going to be huge fun. And it was—it didn't disappoint on any count. To have a group of women—I think there were six or seven of us—and they were all good. There wasn't a dud in it. And I can't tell you what a difference that makes. You're not carrying a soul."

Shooting began in May 2007, in freezing-wet weather, with scenes that were supposed to take place during lovely summer. The perfectly reconstructed village of Lacock in Wiltshire became the location for

*Cranford.* The entire village is owned by the National Trust and has been featured in productions ranging from the 1995 *Pride and Prejudice* to several of the Harry Potter movies. It consists of about 284 acres and is filled with restored buildings from the fourteenth, fifteenth, and eighteenth centuries. Real people still live there.

Once again the set magicians went to work, planting temporary trees and bushes, spreading dirt over asphalt, and sprinkling manure where necessary. Lady Ludlow's grand house, Hanbury Court, is in real-life West Wycombe Park, and has figured, at different angles, in many, many *Masterpiece* productions: *The Lost Prince, Daniel Deronda,* and some interiors for *Downton Abbey,* among them.

One week in June when the production was shooting there, I went over to England for a set visit, and that's when I discovered that the *real* acting in this production would never appear on the screen.

I spent the day on the set, watching the crew shoot take after take of Judi and Eileen chatting at a picnic. Sue and the director were hunched over television monitors, watching them work. Extras floated back and forth on the grand lawn in the distance. Between takes, as usual, there was lots of sitting around and much hilarity among the actors as they chatted about ex-husbands, face-lifts, and other mishaps. As usual, the scene had to be shot from all angles, from wide to close-up. A passing cloud would cause the light to change, or an actor would miss a cue, or a dog would bark. So it took forever—also as usual. Finally after maybe eight hours of production, the team finished shooting what would end up as two minutes on screen—pretty typical. The production wrapped for the day, and we all went back to the local inn, where the cast and crew were staying, to have hot baths and a small drinks party.

I thought the production was going swimmingly, although I noticed that Sue, always thin, was looking particularly gaunt and jumpy. Apparently things were not going well with the director—he

of the immigrant-fishing-vessel film. Not at all. And at that party, some award-winning drama was going on behind the scenes.

Here's Eileen's version: "I was having a really hard time with the director. He just didn't stop telling me how bad I was, and how nothing was happening. And I thought, 'Well, he's probably right. Nothing *is* happening, because even *I* don't like my character.'

"But I think in the end, I was this man's only friend on the last day. He came over to me at the party and said, 'They're trying to sack me, I think.'

"I said, 'No, no, you're paranoid.'

"He must have thought I was terribly two-faced.

"I said, 'No, c'mon, sit down with me in the corner and have a drink. No, no, no, of course they're not.'

"But they were. They did it at the end of the party. He was quite right. I never saw him again. I felt rather badly about it."

I drove away the next morning knowing nothing about any of this. Everybody *I'd* talked to had seemed chipper and happy.

Simon Curtis, an old friend of Heidi Thomas, directed *David Copperfield* (produced by Kate Harwood), and has since done the movie *My Week with Marilyn*. He can fill you in on what happened next:

"Suddenly I got a call saying, 'Could you come in?'

"When I asked, 'When do I start?' they said, 'In the morning.'

"They delivered the scripts that night, and I started reading them. Often on other scripts based on a novel, I would go to Wikipedia and find a synopsis to help me, but this was essentially a new piece of writing. The list of actors in that cast was amazing, young and old. I basically turned up the next morning without having read the story, because there had been no time. I'd never read one word of Elizabeth Gaskell.

"As soon as you go on the set as a director, you get bombarded with questions. They said, 'What are you going to do about the death of Walter?' I had no idea if Walter was a child, a cow, or Michael Gambon.

I just alternated yes or no to every question I was asked, and I got away with it.

"But it taught me a lot about directing. Directing is about preparation, but it's also about instinct. It struck me that there were so many brilliant actors there who knew what they were doing. They'd been rattled: it was my job to unrattle them and give them a level of comfort.

"There were two Dames in the cast, Eileen Atkins and Judi Dench. I'd worked with another leading lady of this stature, and the agent's tip on how to work with her was 'Don't let her smell your fear,' which is a terrifying thing to be told. I position myself as a friend of actors. I wasn't scared."

Eileen seems to agree: "Simon gave good notes, and he took over a very rocky ship. Suddenly it was wonderful. The ballast was right, and he captained the ship."

So back on course under Simon's command, HMS *Cranford* sailed on for three more months in Lacock and then at Shepperton Studios, and a good time was had by *almost* all. Apparently someone momentarily forgot the oldest saw in show business (credited to W. C. Fields, who would have known): never work with children or animals.

Simon Curtis elaborates: "These sets are like microcosms of families because you have generations together. On *Cranford*, there was a baby in the story that drove us crazy. In fact, there were twins playing a baby, and they were just allergic to being on set. Whenever they arrived, they would scream.

"I said, 'Let's get rid of that one, and bring in the other one.' Then that one would scream even louder. We needed just one shot of a smiling baby. Everyone jumped in to try to help, but the babies just loathed being there. We had to send one of the assistant camera guys off to spend a whole day with that baby and all those toys behind the camera, just to get one little shot that we could cut in later."

Bawling babies aside, on *Cranford*, Judi Dench set the tone. Appar-

ently, she often does. This is one reason that, in addition to the privilege of sharing a stage or a scene, everyone wants to work with her.

Simon says, "For Judi, as for Derek Jacobi, being part of a company is what they grew up on—the Royal Shakespeare Company has a sense of creative community. For someone like Judi, it's a really important part of it. She's always organizing games on the set."

Eileen continues: "You know, Judi won't have two minutes of gossip. She doesn't like gossip—which is a good idea.

"So we were stuck on a hillside one day, and they brought us newspapers, thinking we would want to sit and read. Well, nobody can read without their glasses, and nobody had got their glasses with them.

"Of course Judi had been to art school, so she can do all kinds of things. I love doing games, but I'm no good at them. So she handed us all these papers and said, 'Now, in this game you fold your newspaper and you tear out silhouettes of things. Then we see which one is the best.'

"She said, 'Now the first one is a boat.'

"So I spent ages. I was holding them all up: 'Eileen, haven't you finished? God, what are you doing?'

"I said, 'Well, it's the sails.'

"Judi said, 'The sails?'

"Yes, I'm trying to do a very pretty sailboat.' Of course it was ghastly, because I can't do things like that. But I was enjoying it entirely. I said, 'Look!' and held it up.

"Judi said, 'I said "a *goat*."'"

Dame Judi, in a bonnet and curls as the innocent Miss Matty, was a sight to behold as she hung around the set during the downtime. I had the good fortune to share an ice cream cone with her; and apparently, on another occasion, she cut quite a figure in contemporary London.

Simon Curtis tells the story: "Judi broke a tooth, and we had to

get her into a dentist in Ealing. The thing is that during lunch breaks you can't take off all those costumes and wigs, because it takes about three hours to get them back on. So Judi decided that she would go to the dentist in her Miss Matty regalia.

"The dentist said, 'Oh, are you going somewhere special tonight?' assuming she was dressing up to go to a party."

Back in Boston, even as *Cranford* was being shot, the daily rushes arrived for our inspection. Watching take after take of the same scene shot from different angles is a kind of torture that only the editor or perhaps the director really needs to submit to. But it's a long-distance way for a producer to confirm that the performances and production values are on track. Eventually rough edits of each episode came in, and I would screen them with whoever on our staff was available. I value the reactions of my staff not only because they are smart and articulate but also because they have no expectations or preconceptions of what they're about to watch; they haven't read the script or seen the rushes. Their reactions—pleasure, boredom, distaste, or confusion—are really worth paying attention to.

I remember sitting in the dark in our airless screening room, smiling with delight, cooing at the baby, and getting choked up when Eileen, as the moralistic Miss Deborah, leaves her sense of convention behind and, in a gesture of true humanity, walks with a grieving neighbor behind her father's coffin as it's pulled on a cart through the middle of Cranford.

I got that unmistakable, wonderful feeling that *Cranford* was exactly the kind of program that *Masterpiece* has always done, and should always do. I sensed that *Cranford* was going to get great reviews, pull in a solid audience, and win awards.

My job at that point, as with every *Masterpiece* program, was to make sure all of these things happened. Publicity, promotion, marketing, and advertising are the less arty but equally critical other half

of the television and movie business. Without the trumpet call of publicity, the most perfectly made program will sink like a stone, seen only by a handful of people and the filmmaker's family.

For a miniseries like *John Adams,* or *Mildred Pierce* with Kate Winslet, HBO often spends as much money on the publicity as it does on the actual production. Of course, PBS doesn't have that kind of money, so we have to be very strategic.

*Masterpiece* does have an advantage over many other PBS shows in that we have an incredibly loyal audience. Every week millions of people tune in at nine o'clock on Sunday night just to see what's on. Often our audience is double PBS's prime-time average.

But this audience is just the starting place for us. Our publicists Ellen Dockser, Olivia Wong, and Heidi Schaeffer, with PMK*BNC in Los Angeles, work all year cultivating TV critics and feature writers with phone calls, DVDs, arm-twisting, and charm to get them to review or write about our shows—free publicity. Erin Delaney makes brilliant on-air trailers, and Bruce Kohl produces behind-the-scenes features for our Web site. Occasionally PBS gives us extra money to buy radio or print advertising, but they have to feed all the hungry mouths at the table—*NOVA, American Experience,* Ken Burns's projects—so we have to wait our turn.

*Cranford* was a typical *Masterpiece* program in that it was a beautifully made show, but it had a title that no one had heard of—not like *Pride and Prejudice* or *A Tale of Two Cities.* It did have Dame Judi Dench, so we worked hard to get reporters to do interviews with her. The BBC flew her and some of the rest of the cast and the producers out to Los Angeles for screenings.

When it aired on May 4, 2008, *Cranford* got wonderful reviews and nice big ratings. In the *New York Daily News,* David Hinckley wrote: "For at least three weeks, *Masterpiece* fans who grumble about seeing fewer of those lushly filmed and brilliantly acted British period

pieces can take a break. Starting tomorrow night, they can positively luxuriate in a gem titled *Cranford*."

The awards season was our next challenge, and in television, of course, it's a Primetime Emmy you want. Eileen got one as Best Supporting Actress, but sadly *Cranford* was skunked in the Outstanding Miniseries category by Tom Hanks's *John Adams*, the publicity for which HBO had spent millions of dollars.

Two years later, the BBC and *Masterpiece* co-produced *Return to Cranford* with the same team, except for Eileen Atkins, whose character, Miss Deborah, had died in the first series. Judi Dench missed Eileen badly as filming for *Return* got underway. So Sue Birtwistle arranged for a life-size cardboard cutout of Eileen in full costume to be positioned just out of camera range, but just in Judi's sightline, for every shot. *Return to Cranford* was just as well done and successful as the original. But after that the team disbanded; everyone moved on to different projects.

Looking back, I wonder what might have happened if, at the beginning, *Cranford* had been designed as *Downton Abbey* was—to be a ten-hour, yearly series. It has the heart and the humor of *Downton*, with a brilliant cast headed by a Dame; it's the story of a community on the cusp of change; and it's filled with jeopardy and tender love stories. Might it too have struck gold and become a historic television event?

Who knows? In this business, so much is all in the timing.

*Cranford*, of course, is just one of the ten or so titles we aired that year. Most of the programs we do follow a similar pattern, and I do similar executive producer things on each of them. It's the script work and the editing process that I love the most, the unique and satisfying feeling you get when you read or screen a scene that has come together just right. The moment when the rickety house falls down in *Little Dorrit*. The moment in *Birdsong* when Eddie Redmayne's character

sees the daughter he didn't know he had. I get frustrated when other necessary parts of my job pull me away from this kind of work. And the other parts of the job often have to do with money.

In public television, funding is at the top of every executive producer's list: find it, spend it properly, and then go find some more. In 2010 we had a breakthrough in our thinking about funding for *Masterpiece*. Most of our funding came then, as it does now, from PBS. We were still on the hunt for a corporate sponsor, but we realized that even if we got lucky, it was impossible that a company would stay with us for thirty years, as Mobil had. I felt a personal responsibility for *Masterpiece's* financial future and talked endlessly with our senior producers Steven Ashley and Susanne Simpson about ways to guarantee it.

Steven kept coming back to the deep attachment our audience feels for *Masterpiece*—for nearly forty years, *Masterpiece* had been the drama of their lives. How could we tap directly into that attachment and use it to fund *Masterpiece*?

Susanne came at things from a different direction. Could we create a group of higher-end patrons who would fund us, advise us, lead us to more higher-end patrons, and receive a credit on the air? It took months to work through the political and logistical challenges that raising money for *Masterpiece* in a new way might cause. Wouldn't a solicitation through our Web site, one that might result in thousands of donations, create confusion with public television stations' fundraising across the country? Might we be seen by stations to be encroaching on their projects and donations?

All of our ideas eventually solidified into the specific notion of the Masterpiece Trust, a way for people to donate a minimum of $25,000 directly to *Masterpiece*. The donors' names are elegantly credited on the air. As simple it sounds, this notion would have gone nowhere without a critical idea proposed by Jon Abbott, now president of

WGBH. Donations to the Masterpiece Trust from members of any station other than WGBH will be shared with that station. Everybody wins. The Masterpiece Trust is up, running, and going into its third year.

So I've now learned the delicate dance of fund-raising, an activity that is completely counterintuitive to me. I was raised by a Yankee gentleman and a Southern lady who taught me never to talk publicly about money, and never, ever to ask anyone for it. But I've found that because my passion for *Masterpiece* is shared by people with financial "capacity" (a fund-raising term of art I've just recently learned) we can meet there. People seem to love hearing *Masterpiece* stories, and I find their deep affection for the programs very energizing. Eventually the money starts to flow.

Meeting potential donors and showing the flag for *Masterpiece* involves visiting public television stations all over the country. It can be exhausting, but is always revelatory: parachuting into Chattanooga, St. Louis, West Palm Beach, Pittsburgh, or Seattle for a day or two, meeting dozens of people, hearing their stories, and then heading back to Boston. There have been many, many chicken dinners, but my very favorite is one that I did with Russell Baker quite awhile ago, years before the Masterpiece Trust was created but worth telling anyway.

Russell was invited to be the featured speaker at a station that will remain nameless, and I was his warm-up act. We were in a vast room with tables elaborately set for dinner—enormous candelabras, flowers, and white linen. A few minutes into my spiel, an elderly man seated at a front table slowly and gently listed to starboard and fell to the floor. The EMTs came and collected him; luckily, he'd only fainted. But in the interim, more wine had been served to the guests. A brief fistfight erupted at a back table, apparently caused by a disagreement between two gentlemen over their relative net worths.

Just as that got settled and I resumed my warm-up, the candelabra on one of the tables toppled over, smashed crystal and china, and started a small napkin fire.

Russell stepped up to the microphone and said, "Ladies and gentlemen, I don't think you need to hear from me tonight. Why don't we all just go home?"

# FOURTEEN

# The Road to *Downton Abbey*

More and more attention was being paid to the new *Masterpiece*. PBS asked us to make branding presentations to groups of producers, marketers, and executives. It increased our funding—not by much, but some. We were nominated for awards and then began winning them. *Masterpiece* had come back to life.

And luckily, we had lots of good programs to offer. In 2008 and 2009 we co-produced with the BBC two miniseries for *Masterpiece Classic* that were as good as anything we'd ever done in *Masterpiece Theatre*'s early years: *Cranford* and *Little Dorrit*. And building on *The Complete Jane Austen* idea, we consolidated four big Charles Dickens titles, including a rerun of *David Copperfield* with Daniel Radcliffe (now turned Harry Potter) and aired them as *The Tales of Charles Dickens*.

Gillian Anderson's intention had always been to introduce *Masterpiece* for only a year, lending us her star power to give the rebranding a boost. After she left, the elegant and brainy Laura Linney came on as our host.

*Masterpiece Mystery!* hit the jackpot as well, with two extremely promotable and well-done projects: Kenneth Branagh in Henning Mankell's *Wallander* (2008) and Benedict Cumberbatch and Martin Freeman in *Sherlock* (2010).

There was never a doubt in my mind that we would do the *Wallander* mysteries. Two words: Kenneth Branagh. I didn't know Henning Mankell's books about a brooding Swedish detective whose personal life is, of course, in shreds—apparently a job requirement for a successful crime fighter. But I did know that it was to be Kenneth Branagh's first-ever television series, and we had to have it.

As much as I'm not a mystery reader, Ken is: "I love a good twist-and-turny plot, whether it's in Agatha Christie or the most up-to-date, modern piece of crime fiction. I like them when they're in grand or obscure styles. I like them when they're absolutely feet-on-the-ground here-and-now. As many as I've read, I never, *never* know who did it until the author or the television director has decided they want to tell me. I have acquired no expertise in it at all: I am the original sucker punter every time and happy to be so. I love the puzzle, even if I'm no closer to solving even the simplest of them. I find them absolutely delicious."

Even after I'd done the deal for *Wallander* with the producers Andy Harries and Francis Hopkinson at Left Bank Pictures, I was afraid Ken would drop out. I couldn't quite understand why he would forgo a big Hollywood movie to work on a smallish television show with a limited budget set in the tiny Swedish town of Ystad. But he didn't drop out, and eventually I found a moment to ask him why in the world he'd done *Wallander* in the first place.

He explained: "I was fascinated by the way Henning Mankell was writing about this man's interior life. At the end of his forties, Henning Mankell seemed to have found a character in the procedural genre, Kurt Wallander, onto whom he could hang a lifetime of expe-

rience in political activism. To be a modern Swede is to be politically active and philosophical and socially engaged.

"That combination was a very interesting way to look at the psychological development of someone as he heads over and across that fifty-year mark. I started reading Mankell's *Wallander* novels when I was forty-six; then I played Kurt across my fiftieth birthday. Many people can see reflections of their own lives in Kurt's relationship with his father, his relationship with his daughter, and his relationship with his work. They all undergo sea changes because of Kurt's own sense of what's happening to him at this point in his life: to the way he feels about what he does, and about his body, the way he starts to register the crumble and decay in ways that haven't happened before.

"It was a really interesting crucible that made me thoughtful about the same kind of issues in my life. And given the success of the books, I felt the show could reach lots of people around the world.

"Playing Wallander requires openness, a vulnerability and a nakedness that paradoxically requires all the technique you may have acquired over thirty years of trying to be an actor, and requires you to put all that technique away, at one and the same time. So both as an artist and as a person, I found that an interesting challenge.

"The character in the books and in the scripts seemed to demand that the actor simply be. You need to get as much artifice out of the way as possible: no detective trademarks, no funny collars up on the coats, no behavioral tics—just a kind of soul in quiet torment, open to the four winds. I think that some of that provides rich rewards for Wallander in the way he experiences life—not always comfortable, but intense and vivid. You could call it a life examined, and a life that is full."

Left Bank Pictures will produce the last of the Kurt Wallander mysteries that Henning Mankell has written, and Ken will slip back into the world of whopper Hollywood films, like *Jack Ryan*, *Thor*, and *Cinderella*.

And there's *another* close call in my personal history of programming missteps. When I first heard that the BBC was planning to do a modern-day version of Arthur Conan Doyle's Sherlock Holmes stories with Hartswood Films, adapted by Steven Moffat, I was underwhelmed. Jeremy Brett's Sherlock was still fresh in my mind. Jeremy had been married to my predecessor at *Masterpiece Theatre*, Joan Wilson, and had been part of the family.

The day after Jeremy died in September 1995, I'd announced his passing at a reception for donors at WGBH. Within hours, I had an e-mail of impeccable logic from Arthur Golden, the author of *Memoirs of a Geisha*: "Sherlock Holmes is dead?? He was married to your predecessor?? Does this mean that *your* husband is the next Sherlock Holmes?"

When I happened to mention the new *Sherlock* project almost as an afterthought at a staff meeting, Erin Delaney, one of our producers, levitated in her chair: "Do you know who Steven Moffat *is*? He does *Doctor Who!!*"

No, I didn't know; believe it or not, I'd never seen the BBC cult favorite *Doctor Who*. But I sat down and read the *Sherlock* scripts— and found them to be the cleverest and most modern work I'd seen in ages. Eventually, the actual productions of them, starring Benedict Cumberbatch as the irascible, brilliant Sherlock, and Martin Freeman as his flatmate Dr. John Watson, newly returned from the Afghan war, took them up even higher.

Steven Moffat says that the idea to update the classic detective stories "came together very quickly—all the details of how Sherlock would fit into the modern world. It was the easiest-ever pitch at the BBC. Mark Gatiss and I barely got it out of our mouths before they said yes."

What distinguishes this *Sherlock* from anything we've done before is its appeal to a younger audience, one that is totally at home with social media. They are *Doctor Who* fans and they follow Steven Moffat's

every professional move—texting, e-mailing, and tweeting all the way. They also follow Benedict Cumberbatch's every personal move. A group of his fans call themselves The Cumberbitches—and then there are the Cumberbunnies. Through Steven and Mark's *Sherlock*, we're attracting a new audience to *Masterpiece*, just as we set out to do with the rebranding.

In Steven Moffat's view, the continuing appeal of the Holmes stories derives from "the same things that always appealed—the friendship and the deductions. When I first read the stories, it wasn't the Victoriana that impressed me, it was the amazing, impossible deductions, and Sherlock's magic trick of knowing everything at a glance. But it was better than a magic trick because he *told* you how it was done (That's what magicians get wrong—you must explain the trick or you have no third act!).

"And over time, I started to adore that warm, unspoken friendship at the heart of the story. All Mark and I did was to move Doyle's impeccable original closer to the modern audience by putting it in their world. All the virtues are the same, but with the dust blown off. Moving Holmes and Watson into the modern world just allowed us to see them again."

Though we realized we were reaching younger viewers with *Sherlock*, we *didn't* realize that we were warming them up for *Downton Abbey*.

For me, the *Downton Abbey* story began in April 2008, and it began with an entirely different program: *Upstairs, Downstairs*. For years after the last episode of the original series aired in 1977, there had been vigorous attempts to resurrect it, first with members of the original cast, and eventually in brand-new incarnation.

*Up/Down*, as we all called it, had truly been a seminal television event, brilliant in the logic and simplicity of its original concept: a

cast of characters representing the upper and lower classes of English society, living happily together under the roof of a beautiful London house at a colorful, volatile time in British history. Throw in love, marriage, deception, money, illness, humor, childbirth, and a war, all beautifully written and winningly performed, and you've struck television gold: a long-running hit series. Or a great movie. Robert Altman, Bob Balaban, and Julian Fellowes all acknowledged *Upstairs, Downstairs* as a progenitor of their *Gosford Park*.

Julian says, "I loved *Upstairs, Downstairs*. I thought it was fantastically well done. One of the most attractive elements of it was that it didn't take the modern position of deciding that all the upstairs people are horrible and all the downstairs people are lovely. They were all just people, and some of them are nicer than others. I would say that that certainly was an influence on me.

"I think there are usually a pretty even mixture of nice people and stupid people and clever people and ugly people in any social group. Everyone is just trying to get on with their lives."

But the stars for a television sequel of *Upstairs, Downstairs* were never properly aligned—until April 2008.

Eileen Atkins and Heidi Thomas flew from London to Los Angeles to do some publicity for *Cranford*, which Heidi had written. They sat together on the flight home.

Here's Eileen version of what happened: "I hope I'm not quite as bad as Heidi, but neither of us ever draws breath—*garrulous* is the word. We talked so much that everybody else [on the plane] hated us. They put the two talkers in a section practically on our own.

"I thought I must be looking very old, because she kept reaching up for things for me, and she tucked me in with one of those pashmina shawls. I found her very, very good company. There had apparently been other requests to redo *Upstairs, Downstairs*, but they hadn't come through me. Heidi found the secret entrance.

Here's how Heidi remembers it. "As a child, I was a devoted fan of *Upstairs, Downstairs*—so devoted, I used to watch it with my mother's dressing table set pinned to my head, pretending to be Rose. I yearned for it to be revised, but it never was. As my own career burgeoned, I started to wonder if I might one day be in a position to do it myself.

"I knew Eileen quite well as she had been in three of my productions: *Madame Bovary, Ballet Shoes*, and of course *Cranford*. About two weeks before we were due to fly out to LA for *Cranford*, I had a call from the BBC to ask if they upgraded me, would I accompany Eileen on the journey? I agreed.

"Eileen genuinely hated flying and I just saw it as my role to try and make sure she was comfortable. I felt that I had essentially been invited along as her lady's maid, but as I come genetically from the servant class and she was used to having dressers in the theater, the system worked a treat. I helped her to work her seat and her television and at one point I lent her my pashmina because it was freezing cold.

"We first discussed *Upstairs, Downstairs* over the afternoon tea on the flight. Eileen was very keen that the show should be revived. By the end of that trip, a plan was in place, but there would be another eighteen months of legal dealings before everything was in place for a revival."

"I never intended to be in it," Eileen says, "but on the plane, Heidi said to me, 'Of course, you'll be in it.' I said, 'Oh, I doubt it, Heidi. I don't like doing series.'

"I did start thinking, 'Well, maybe if they write me a really nice part. . . .' I thought Heidi's writing was terrific for *Cranford*."

The plane landed, various agents and lawyers and producers got involved, and it looked like *Up/Down* was finally going to take off. It was a no-brainer to decide to co-produce the new *Upstairs, Downstairs*. Yes, it was sacred territory, but if ever there was a television

program intertwined with a network, it was *Up/Down* and PBS. It would have been disastrous to lose it to another broadcaster; and with Heidi, Eileen, Jean, and the BBC drama team all working on it, its chances of success looked very good.

So I did the deal. And then came that telephone call, the one I told you about at the start of this story, which I took as I sat on the screen porch in Kennebunkport: Laura Mackie, pitching *Downton Abbey*. It sounded a lot like *Upstairs, Downstairs*, and I turned it down.

*Downton Abbey* at this point had its own dramatic backstory. Julian Fellowes and Gareth Neame told it to me later.

Gareth first: "Julian and I were supposed to have dinner at Drones, a restaurant in Belgravia, near where he lives. It was a rather inauspicious start, because as I got out of the cab, he was hovering around the doorway. The restaurant wasn't open: they had no gas.

"We wandered around, but there aren't very many places to eat around there. We just walked into a place and took a table down in the basement. We were actually debriefing on a couple of other things, because we were trying to do another project together that hadn't happened. I hadn't really planned any of this conversation; we clearly enjoy working together, and thought we should do something.

"I said, 'Could I ever persuade you to revisit the territory of *Gosford Park*, but in a multiepisode television environment, where you can have that whole cast, but week upon week, so that viewers can get to know them and invest in them as characters?'

"I knew this was a good environment for a show. As a British producer, you're looking for something unique, something we can do that the United States cannot. Spy stories are one genre, because of James Bond and Graham Greene; the other one is the country house. We see it in whodunits with Agatha Christie, but we also see it in Jane Austen—this very class-bound, traditional environment.

"There aren't many people who can pull this off. Having worked

with Julian already on a couple of other ideas, I thought he was the one who could write this show. I don't think I fully knew at that point quite how commercial his writing style was. I didn't know him then anything like as well as I know him now. I just had a hunch that he would capture that world brilliantly. He did, and he also managed to write the most brilliant soap opera.

"As we were leaving the restaurant, Julian didn't say, 'No way, I'll never do it,' but nor did he say, 'Eureka, I've been waiting for some-body to ask me.' He said, 'Let me think about it.'

"At the time, of course, I didn't think that meeting was any dif-ferent from other meetings I do day in, day out. I simply thought something might come of it."

Julian's version *mostly* coincides: "After we found our way to this terrible restaurant, Gareth and I talked about this-that-and-the-other. Then he said, 'Have you ever thought of going back into *Gosford Park* territory for television?' I can only suppose that he had already formulated this idea in his head, knowing he'd see me for dinner. I suspect that the question was one of the purposes of the dinner for him, but it wasn't for me—I hadn't thought about it at all.

"What made me nervous was that I was asking for two bites of the same cherry. I'd won the Oscar for *Gosford*; that was one of the big mile-markers of my career, the biggest to date then. And I was somewhat afraid of a sort of creative laziness, of going back into safe territory that had already been successful for me, like some crooner who is always effectively singing the same song.

"But then I started to think about it. It *is* safe territory for me; I know those people. The world they lived in was not so very far away from the world of my childhood, because there were many survivors of that life."

Gareth: "A month or two later, he sent me an e-mail with a short

document in it that said, 'This is the world as I envisage it.' On it were all the principal characters: their names are possibly changed now, and the show certainly wasn't called *Downton Abbey*. But the Robert character was there; and his American wife and their three daughters; and the idea that there was no son—what that would do to the family; and all the principal servants. With no heir in place, the world in this house would be sent into complete chaos—all this, in only three pages.

"It was the first I knew that he was engaging with the idea of it. But it was just a setup; there were no plots. We discussed it further, and at some point we took the idea to Laura Mackie and Sally Haynes at ITV. I remember Laura saying to me before the meeting: 'This is absolutely not what we're looking for.' I think they took the meeting because of Julian. By the end of it, the idea had captured their imaginations. From then on, they were completely brilliant."

The word on the street in London during 2009 was that the BBC and ITV were being foolishly competitive because they had commissioned seemingly identical shows—two upper class–lower class, Great House dramas. People muttered: why bother, when there were so many other stories to tell? But ITV, in commissioning *Downton Abbey*, was actually taking a significant risk. It was a period piece, a costume drama, famously the domain of the BBC. ITV hadn't done anything like it in scope or genre since *The Jewel in the Crown* in 1985. They were, in fact, giving the BBC a run for its money.

Gareth Neame adds: "A lot of people ask, why did I go to ITV when at that time, everyone would have expected the show to be on the BBC? The main reason is that I thought, to send a different signal, to reactivate a brand-new audience for this kind of show. It couldn't go to the BBC, because then everyone would say, 'I love the BBC and this is what we expect of them.' We'd get our guaranteed audience. I don't think *Downton Abbey* would have broken the ground it did if it had been on the network people expected to see it on.

"We didn't know then that the BBC was developing a new *Upstairs, Downstairs*. When one of our publicists called me on a Friday to say that the BBC were about to announce that they were doing *Upstairs, Downstairs*, we were already in preproduction. I thought, 'I can't believe it! Who's ever heard of us? And the BBC is returning with one of the most-loved shows of all time.' I thought this was terrible.

"I was out of London that weekend. I took the train back on Saturday morning and went straight to Julian's house to have a crisis meeting. We were in preproduction, so we just said, 'All right, we're under way.'

"So much of these things are about timing. By that point, we were a couple of months away from shooting, while the BBC weren't anything like that far advanced. We were probably four to six months ahead of them, which gave us a considerable advantage.

"We started shooting in March 2010 and were on the air in September. We had been green-lit the summer of 2009, probably the worst year ever for ITV. We were in the midst of the worst part of the recession, which included an advertising downturn. They made a huge commitment to us."

Julian gives great credit to Peter Fincham of ITV: "His support was very courageous. Happily, the proverb 'Fortune favors the brave' proved to be correct in this instance. I love it when people are rewarded for going out on a limb."

Meanwhile, for *Masterpiece*, the new *Upstairs, Downstairs* seemed like a great "get": a known title, and hugely promotable. PBS committed a significant amount of extra money to advertise it, and our audience was hungry for it. We still couldn't see a place in the schedule for *Downton*. However, all was not sweetness and light at 165 Eaton Place, the fictitious *Upstairs, Downstairs* house, as difficulties in the production began to emerge.

Eileen Atkins: "I'll never forget when the first script came in, on

Simon Curtis's fiftieth birthday. He had nothing to do with *Upstairs*, but he'd directed *Cranford* and was a great friend of Heidi's. I was anxious to see what Heidi had done.

"We were going to Simon's birthday party. I walked in, and the first person I saw was Heidi. She knew I'd got the script that day. She knew I'd looked at it.

"I said: 'I don't like that part. I am offered that kind of part nearly every week, and I don't want to play those women. You'll get somebody else terrific.'

"Then the producers said to me, 'You have to be in it.'

"I said, 'I love the part of the cook. Can I please play the cook? The cook is a very much better part than the woman upstairs.'

"I wasn't going to win on the cook, so I said, 'Can I write myself in some funny lines to loosen up this part and make it amusing?'

"I did what Julian Fellowes does every week very nicely for Maggie Smith—I gave myself a zinger.

"By then I knew that Julian was writing *Downton Abbey*, and I knew he'd got Maggie. When I had lunch with Maggie, she said, 'Oh, don't let them do that to it. If we both play the grande dame, every week they're going to make comparisons.'

"And the first time around [when *Upstairs, Downstairs* and *Downton Abbey* aired in 2010], indeed they did. I did very nicely the first time around [series one]. Now she's sailing high."

It was probably inevitable that this editorial struggle would emerge. Jean and Eileen had created *Upstairs, Downstairs*; they'd cooked it up in Jean's kitchen. And they were both actors with professional track records nearly twice as long as the other team members'.

Heidi Thomas says: "It was exhausting, but really just terribly sad—we'd done so many shows together, and Eileen had never previously asked me to change a single word. The biggest practical problem was Eileen's insistence that her character, Maud, should have a pet

monkey called Solomon. I adored the idea and wrote it into the script, but she soon wanted Solomon in every single scene. Quite apart from anything else, the monkey cost a fortune, charging more than any actor besides Eileen. It had to be licensed every time it appeared, it threw a brush at the director, and it bit Art Malik. It wasn't even keen on Eileen, and once jumped on her head when we were trying to film a breakfast scene."

However difficult the process may have been, eventually both Heidi and Eileen were nominated for Primetime Emmys, one for Outstanding Writing and one for Best Supporting Actress.

Meanwhile, over in the *Downton Abbey* camp, things seemed to be flowing along nicely. Julian Fellowes had begun the process that would allow him to write every word of forty hours, and counting, of *Downton Abbey*. He created an entire world very quickly, populated it with twenty interesting characters, and dreamed up interconnected storylines of love, intrigue, money, and British social history. He chose a visually and historically rich period, beginning with the sinking of the *Titanic* in 1912, and set his story in a fabulous house in the English countryside.

I think it's fascinating to hear how Julian initially thought about the project.

"I had never devised a series before. After dinner with Gareth, I started to think about it, and then I started to put something down. Coincidentally, when Gareth and I met, I was reading a book called *To Marry an English Lord*. I started to think about how these American girls [the dollar duchesses, as in *The Buccaneers*] have become a sort of cultural phenomenon in our history. We think of them coming down the gangplank from their liners and marrying their viscounts and marquises and either making a success of it or not. But we don't really think of them thirty years after that, sitting in Staffordshire and still trying to get decent plumbing.

"By then, their younger sisters, for the most part, had married

Americans and gone to live on Long Island. The fashion for becoming a European countess didn't really survive the First War. Of course some of it continues to this day. But earlier, there were something like three hundred of these girls who married into the upper classes. I thought some of these women were trapped, though ironically, many of them outlived the way of life they'd been brought in to save. They were still alive in the Second World War, and in the fifties.

"I thought it would be fun to make one of the characters an ex-Buccaneer twenty years later. In a way, I had started to imagine Cora. And then I thought, 'But what is the situation?' In fact, we had stayed with a friend of ours who was a distant heir. The young man lived outside England, and he was brought home to live on the estate and be trained up.

"That, of course, was the germ of the story of Matthew, because what Matthew Crawley gave me was the opportunity to have a kind of respectable intellectual middle-class set of values operating alongside aristocratic values. The working class is represented in the staff.

"I knew many families desperate to have a son. I remember one family that had six daughters in pursuit of a son. I know one with seven daughters and no son. So I could see the advantage of the outside heir coming in. There was no heir in my story, but I didn't want to make the family childless. If you give them a line of daughters, they're less sad, and there's more tension. If you have children who have to be disinherited because of these arcane laws, then everything is tenser.

"With drama, all the time, you're trying to think of tension. I always say that one of the hardest things to dramatize is happiness. That's why, in the old days, Hollywood films ended with the marriage and the kiss—because the drama was over.

"The outside heir and the daughters gave me a situation where everyone had a reason to get involved, and to either be angry or not angry. I felt that the counterimpulses of Cora and Violet feeling

indignant that Mary is being passed over were totally believable and understandable and sympathetic.

"Constructing *Downton*, I was consciously thinking in terms of those American structures. I had liked *E.R.* There was something called *Chicago Hope* that I liked very much, and *Thirtysomething*, with all these stories going at once.

"One story per episode isn't the right rhythm for now. Probably it's because we've got attention deficit disorder or whatever. You need to be engrossed. I absolutely loved *Jewel in the Crown*. But in fact, when you're watching it, you could go and make a ham sandwich and a cup of coffee and ring your mother and come back, and you could pick it up within about two seconds, because it was *so* slow. I think that's gone for now.

"The philosophical spirit of *Upstairs, Downstairs* was an inspiration for me, but not its narrative structure. Also, that [series] was quite deliberately set in London, and I wanted to explore the business of being a mini-king, where you have a great estate in the village and everyone expected you to be the kind of social dynamo of the area. That seemed interesting to me, as did the rather longer relationship you had with servants in the country. In London, there was a tremendous turnover. The average time for a footman to stay was eighteen months. If you read letters at the time, they were absolutely *filled* with the search for servants—people looking for a silver maid and a lady's maid, and a second footman, and so on. I knew we'd have turnover: apart from anything else, actors want to leave. But I wanted that stability of the country society.

"In the country, we've only got one famous person coming to the house. But that's rare for us. Normally the Crawley family is on the edge of events, talking about them and reading the newspaper. Everyone can connect to that. The queen is not permanently coming to dinner, as she might be in a London setting."

The king was *supposed to* be coming for dinner in the new *Upstairs, Downstairs* (actually Baron von Ribbentrop came instead). I was preoccupied with that series for much of the winter of 2010 and not thinking about *Downton Abbey* at all. I vaguely knew they were still looking for an American broadcaster, and that the series was scheduled to air in the U.K. in September 2010. Then two things happened: Gareth Neame, the producer, told me that Maggie Smith had been cast as Lady Violet, the dowager duchess; and my friend the director Simon Curtis, Elizabeth McGovern's husband, called and told me that Elizabeth was going to play Lady Cora, the American buccaneer.

Maggie Smith has been one of my favorite British actresses from the moment I first saw her on stage in London in 1970 and particularly because of her performance in *The Prime of Miss Jean Brodie*, which, interestingly, Gareth Neame's grandfather, Ronald Neame, had directed in 1969. But Maggie gave a performance I'll never forget in a fairly obscure television monologue by Alan Bennett called *A Bed Among the Lentils*. She plays a lonely, alcoholic vicar's wife who looks right into the camera lens and tells us the story of her passionate liaison with a young Indian grocer. She tells it with such restraint, poignancy, and humor that you cannot take yours eyes off her. We aired it on *Masterpiece* in 1989. Maggie rarely works in television—though she was in *David Copperfield*—and here she was again in *Downton Abbey*.

Then Simon Curtis reported that even in the early days of shooting, Elizabeth felt that *Downton Abbey* was going to be something very special. She herself has been very special to American audiences ever since the 1980 film *Ordinary People*.

Elizabeth: "I knew that I very much wanted to be involved with the project, because I had loved Julian's writing for so many years. I loved *Gosford Park*. I knew he was somebody I wanted to be in business with. I wrote him a letter, and I fought very much to get the part. I had to audition for it a couple of times."

In fact, Elizabeth McGovern and Hugh Bonneville (Lord Grantham) had played husband and wife before and knew just how to be "married." In the short-lived BBC sitcom *Freezing* (2007–8), Elizabeth had played an American actress and Hugh, her British book-publisher husband.

She says, "Hugh and I have always slipped right into a very, very easy acting relationship. We feel safe in that anything we need to say can be said, and it's absolutely okay. There's a mutual trust and respect.

"When you're casting a series, you have to take into account the kind of personality that can endure the rigors of a series like *Downton Abbey*; there are some absolutely brilliant actors for whom it just wouldn't work, because it's a different sort of challenge. The hours are so long. Much of the time, you have to have absolutely no ego about standing in the background. Then you have to take back focus and be the lead. You have to be capable of both forms of art. There are different sorts of talents that have to be considered in casting.

"I'll never forget the day of our first read-through. We had this huge table, where there were literally forty-five actors all sitting around reading. It absolutely took off in a way that was not even apparent on the page. I thought it was a good script, but something else happened in that room, because of the way the stories bounced against each other.

"Everybody suited their part, hand in glove, and also knocked off each other, black and white, colorful, muted, in a way that was just orchestrated. Everyone felt it. But we didn't know the show was going to be a big hit; this was just an enjoyable two hours of reading.

"I've done this for many years, and I feel you cannot ever deny that a big part of this business is luck and timing."

Jumping way ahead in time for a moment, to January 2013— *Downton Abbey* won a particular award that I think speaks to the true magic of the series. In a glittering ballroom in Hollywood, the actor

Alfred Molina opened the envelope and proclaimed, "And the Screen Actors Guild Award for Best Ensemble Cast goes to . . . *Downton Abbey*."

It wasn't Julian Fellowes who tripped up to the stage to accept it; it was Mrs. Hughes, the doughty housekeeper played by Phyllis Logan, accompanied by a democratic cross-section of the Downton Abbey household: Tom Branson (Allen Leech), the chauffeur who married Lady Sybil; the luminous Lady Mary (Michelle Dockery); Ethel (Amy Nuttall), the housemaid who became a prostitute; and Daisy (Sophie McShera), the plucky kitchen maid.

It was an upset victory, defeating the big boys, *Breaking Bad* and *Mad Men*. "Shut the French windows!" said Mrs. Hughes, instantly popularizing an expression of amazement, meaning, "Oh, my God."

The award institutionalized one of the great strengths of *Downton Abbey*: the casting and the cast chemistry. Casting, the dark art of drama, is a true mixture of inspiration and timing. We all do it, every day. You read a book or hear a news story that would make a great movie, and you cast it in your mind: Meryl would be perfect as Hillary Clinton; Allison Williams should play the crazy wife in *Gone Girl*; Denzel would have been a great Obama, but maybe he's too old; Julianne Moore could be Scarlett, if they redid *Gone with the Wind*, etc.

That's the easy part. The challenge is to identify the unknown actors who *will* be famous one day and to give them a chance to prove it; and then, equally tricky, to wrangle agents to get famous actors to find time in their schedules to do the project and accept the money you're offering. Producers, writers, and directors all have passionate feelings about casting, and the person who has to manage all this creativity, and know everything about every actor, famous or not, is the casting director.

I think this is where *Downton Abbey* began to show its uniqueness, even before filming began. Julian had worked with Maggie Smith on

*Gosford Park*, so the task there was to persuade her to join a potentially long, ongoing television series, forgoing more lucrative movie work. Then, once a star like Maggie is attached to a project, she becomes a magnet for other well-known, established actors.

Gareth Neame remembers the process: "The casting was done by me, Julian, and Liz Trubridge [*Downton*'s producer], with our brilliant casting director, Jill Trevellick. I can't ever remember discussing anyone else other than Hugh Bonneville for the part of Lord Grantham. In the case of Bates [the valet], Julian had written that part for Brendan Coyle. In the case of the younger actors, they were all auditioned."

Back to 2010: after I learned the news of Maggie being cast, and heard of Elizabeth's enthusiasm, I suddenly realized that my reasoning about two up/down stories being one too many was very wrong indeed. I quickly called Gareth to see if he'd found an American co-producer. Miraculously, he had not: HBO had passed, as had all the commercial networks, including even NBCUniversal, which owned Gareth's production company, Carnival Film and Television.

He explains: "At that time, my production company had recently been acquired by NBCUniversal. I remember having meetings with its domestic sales team. I was looking for a production partner or a broadcaster in the United States for two projects, William Boyd's *Any Human Heart* and *Downton Abbey*.

"I don't remember going very far with any other broadcaster. We must have raised both these ideas with HBO, and I spoke to somebody at the History Channel and got no real interest there at all. *Masterpiece* was the obvious place for it. Now there'd be lots of other places to go; but back then, *Downton Abbey* was just another British costume piece. If *Masterpiece* wasn't going to do it, I didn't think there were many other options."

Julian remembers: "When they made the deal with *Masterpiece*, I knew it was because they had not been able to sell it to a network. But *Masterpiece* has been good for us. I think it worked out well. I think it's been a pretty happy relationship."

So in very short order, Gareth and I did the deal in which *Masterpiece* became the American co-producer of *Downton Abbey*. It was to become the most-watched drama in PBS history.

With the contract locked down and shooting well under way, I pretty much forgot about *Downton Abbey*—and that's not unusual. My strong feeling about our British co-productions is that we're in business with some of the best drama producers in the world, and what they need most is to be left alone to do their work. Plenty of British network executives are watching them nervously, people who have an even bigger stake in the project, at least financially, than we do; and except for a few key casting, script, and editing moments, the last thing these producers need is noise from an executive who is three thousand miles from the set.

Because our contribution to the production is relatively modest, I'm realistic that my job is to inject money at the outset, then give the program the best and biggest possible exposure in this country when it airs. Essentially, my work largely begins once the program is finished.

So while *Downton* was being filmed and edited over the summer of 2010, I was concentrating on other shows like *Wallander* and *Sherlock*, which were about to air. I was reading draft scripts, discussing casting with the producers, and preparing our publicity campaign. I also remember lots of conversations with the *Upstairs, Downstairs* producers in those months, and celebrations about the casting of the *Mystery!* series *Zen*—Rufus Sewell from *Middlemarch* was *back*!

People now ask me, as I'm sure they ask Julian, Gareth, and everyone associated with *Downton Abbey*: "When did you first know it was going to be such a huge deal?"

How nice it would be to say, "I knew the moment I read the first scene in Julian's first draft of the first episode."

However, I still didn't sense *Downton's* extraordinary future, even as Julian hit his stride, the scripts got more and more compelling, and the rough cuts of the episodes showed real promise. In fact, things might have been going along *too* smoothly. There's an old chestnut about a production jinx that says, if it's a happy, conflict-free set, then the show will be mediocre. I think Gareth might have sensed this.

"Making the first series of *Downton* went swimmingly. We had a wonderful director with Brian Percival. The scripts were great. The actors loved doing it. It was probably the most seamless thing I ever worked on in my life. Of course, you think, *Whoops, this is too easy— it clearly won't work because it's such a pleasure.* Everything went more smoothly than anything I can remember, before or since."

I do remember screening a cut of the first episode and calling Gareth to say, "I'm not sure what else is going to happen to this show, but I can guarantee you that Maggie Smith and Susannah Buxton, the costume designer, will win Emmys."

(And they did. In addition, *Downton Abbey*, Season One, also won for best miniseries, and for writing, directing, and cinematography, six in total—a real haul.)

Sunday, September 26, 2010, at nine p.m. was *Downton Abbey's* premier broadcast on ITV in England. As usual, the next morning I went to the office curious to hear what the press reaction and audience figures had been. They were stunning: the first episode of *Downton Abbey* had a total audience of more than 11.6 million viewers, a 32 percent audience share. That's nearly the equivalent of a Super Bowl audience in this country.

The critics who were writing about the show (the reviews always come out *after* the broadcast in the U.K.) were falling all over themselves. High ratings and reviews are one thing; but once in a blue

moon, a television program enters the mainstream of the culture and becomes an iconic reference point. In *Masterpiece Theatre*'s history, the first *Upstairs, Downstairs* was that program—and it was beginning to happen with *Downton* in Britain.

Gareth remembers: "I first realized that something different was going on with the show after the first episode went out on a Sunday night. The following Saturday morning I was standing in the shower, and listening on the radio to Rachel Johnson, a journalist. She was being interviewed about something completely unrelated, and suddenly she said, 'And I don't mean that in a *Downton Abbey* sort of way.'

"I thought that was weird; there'd been one episode, and already it was being used as a cultural talking point.' That was very unusual.

"The next day the second episode went out. On Monday morning, I was flying to Cannes. By complete coincidence, Julian was on the same flight. When we landed at Nice, I switched on my cell phone, and there was a message from Laura Mackie at ITV: 'Have you seen the ratings? They're astonishing. We've gone up two million or something.'

"Shows do *not* go up between episodes one and two. Wherever you start, you can assume at best a 20 percent drop-off by two, and then hopefully you'll stabilize. To go up by two million was amazing. I'd never seen anything like it. That's when I thought, *This is an extraordinary hit.*

"As the remaining episodes played out in the fall of 2010 in the U.K., we realized it was a cultural phenomenon. It was all over the newspapers. It was being talked about everywhere. People were writing double-page features in papers, asking, 'What's going on with this show?'"

Julian sensed *Downton*'s entry into the mainstream a little differently: "The first moment where I realized it had sort of burst its banks and gone into what they now call the 'national conversation' was when I opened the *Times*, and there was a huge picture of the three

Crawley daughters. The headline was 'George Osborne [chancellor of the exchequer] belongs in the cast of *Downton Abbey*,' and it was an attack on a financial measure that the chancellor was putting together, saying it belonged in the nineteenth century. It wasn't about *Downton* at all; it was about George Osborne. I realized then that we'd moved out of just being part of our own shell. We were becoming an adjective."

Meanwhile, back at the ranch in Boston, we started scrambling to prepare for *Downton*'s broadcast in this country; it was weeks away. Our challenge, as usual, was to get the word out about the show. It looked like we might have a hit if we could marshal our modest resources—and they were modest indeed—fast enough to let people know it was coming. In terms of advertising and promotion money, PBS had already backed another horse, the broadcast of the new *Upstairs, Downstairs*, leaving us with basically enough money for a press release, some DVDs for the TV reviewers, and an e-mail blast to tout *Downton*.

We were also in the middle of the publicity run-up to another tent-pole title for *Masterpiece: Sherlock*. Our small publicity team was busy coaxing every TV critic in the country to review it, because without advertising dollars, reviews were our best publicity. We depended on the kindness of strangers. Talking up *Downton Abbey* was really starting at ground zero.

"*Downtown* what?" was the common response.

We weren't getting much traction; but out of the gloom emerged a fairy godfather. Graydon Carter, the editor of *Vanity Fair*, is a journalist of taste and judgment and a tsar of high-end popular culture. He's also married to an Englishwoman, Anna. He was in London when *Downton* aired and heard firsthand the talk of the town.

When he saw it, he fell in love with it, and with Elizabeth McGovern. Overnight he ordered a photo shoot of her for *Vanity Fair*. The

deadline was literally days away. His people rang Elizabeth and asked her, "Can you try on some dresses we'll bring over, get your hair done, and sit in your back garden for a picture, in, say, twenty minutes?"

The piece meant that *Downton* was going to have huge U.S. visibility in *Vanity Fair*, just weeks before our broadcast. A magazine feature like that for an upcoming TV show is more precious than rubies. Producers are constantly pitching features about projects and actors; it's free coverage.

In that same issue, Graydon even talked about *Downton* in his "Letter from the Editor." He told his readers: "I think you'll love it. It's got all the sort of luxury options Americans expect in their U.K. television imports: the *Upstairs, Downstairs* aspect of life on a gorgeous English country estate, lords and ladies, champagne and pearls, class struggle, suffragettes, motorcars the size of Mercer Street lofts—and all of it dancing in the shadow of the coming war, the war when Britain went from color to black and white."

The *Vanity Fair* coverage launched us into a new orbit of media visibility. A large segment of its readership overlaps with our audience, and even better, they skew a little younger.

Graydon Carter was a friend in the right high place, as was Joy Behar on *The View*, who did all she could to mention *Downton*. It was a remarkable phenomenon: a few high-profile cheerleaders, and the fix was in. And with the increasingly fluid online conversation between British viewers and critics and American Anglophiles, it looked like we were headed for a decent, solid launch. But we'd been badly fooled before, so we just weren't sure.

*Downton* had finished its run in the U.K. and was a huge hit there. But would it travel? Or would it sink like . . . the *Titanic*?

## FIFTEEN

# *Downton Abbey*

Finally, on January 9, 2011, at nine p.m., Episode One hit the American airwaves. And hours later, as soon as the audience numbers came in, it was clear that *Downton Abbey* was going to be a success here too. The ratings for the first episode were the highest for a *Masterpiece* episode in fourteen years, stretching back to the two-part adaptation of *Rebecca* in April 1997. Since *Rebecca* had been aired before the vast increase of cable channels and digital viewing options, *Downton* did exponentially better: it performed more than 150 percent above the PBS prime-time average.

And the audience stayed loyal for subsequent episodes. Very few deserted it even for the Golden Globe Awards, which were broadcast on its second Sunday night. *Downton* peaked in audience size for the *final* episode. It took a while for us to realize how big it might get.

Even as we were celebrating here in the United States, production was about to start on *Downton Abbey* season two in the U.K. *Downton* had originally been commissioned as a one-shot miniseries, not

as a returning series; but Julian definitely had many future story ideas up his sleeve.

In fact, the conclusion to season one left viewers hanging rather perilously off a cliff. Several of the characters' stories were resolved: there would be no male heir for Lord and Lady Grantham; Thomas had joined the Army Medical Corps; and Mrs. Patmore's cataract surgery was successful. But many stories were not settled—most crucially, whether Matthew and Mary would or wouldn't find true love.

In the very last scene of season one, an exquisite set piece of a garden party filmed in the late-afternoon English light on the lawn at Highclere Castle, Lord Grantham considerably ups the ante for future *Downtons* by announcing with great portent, "Ladies and gentlemen, I regret to tell you that we are at war with Germany."

As the credits for the rough cut of this episode rolled in our Boston screening room, production assistant Lisa Lokshin—who, as it turns out, is the perfect demographic of the smart young women who would become obsessed with *Downton*—spoke up in disbelief: "What? Wait a minute—that's the end?!

"That's really annoying," she said. "That makes me mad. We're going to hear about that."

And we did. "Wait, wait, what happened to Miss O'Brien after she put the soap under Lady Grantham's tub? Will Matthew and Mary ever get together? What's going on???"

It was a good problem to have. The blogosphere and Twitterland were talking about *Downton*, and that was just what we needed—an appetite had been created.

Production on Season Two began at Highclere Castle in February 2011, just as our broadcast ended. There was no question that we would be on board. Julian had finished perhaps half the scripts when principal photography began, and he continued writing right through the summer. Can you imagine the pressure? He now had an inter-

national audience: *Downton Abbey* had been sold in two hundred territories.

I find it fascinating to hear him describe his process: "When I get a job, any job, my first imperative is to find among the producers someone who wants to make the show that I want to make. Then having found him or her, I try and get them to be a channel of the notes so that I'm not getting notes from sixteen different people, which is often very contradictory and counterproductive. The notes that are complete nonsense are thrown out and never get to me. The ones that do are either the ones that my friendly producer [in this instance, Gareth] agrees with, or ones where he doesn't necessarily agree, but he's not sure that they mightn't be worth paying attention to. That is my filter.

"I am left completely on my own to write the first draft. After I send it in, I get some general notes: 'This story isn't completed . . . we need to see this one more time . . .'

"I bake away, and then get more detailed notes. The final draft, the fourth one essentially, is the one that goes to the read-through. The basic storylines are mine. The ones we discuss involve the fundamental direction the show is going in; we don't ever really talk about the lesser stories—whether Daisy is in love with Alfred, for instance. That's left to me.

"One of the goals of my writing, in as many cases as possible, is to give all the protagonists a defensible position, so as not to completely show the viewer whose side to be on. And they fluctuate. That is quite deliberate on my part. I think it's more interesting.

"I think a lot in bed at night. When I wake up, I never try to get back to sleep; I try to work out the stories of *Downton*. In the morning, I might have maybe half an hour before I get up to sort out stories and plots and things. I do it when I'm driving, too. When I sit down in front of the computer, I know what the stories are. I might

write a page of indications of stories: 'Mrs. Patmore buys a new hat.' Then I tell the stories, plaiting them.

"I like to avoid putting two upstairs scenes next door to each other, unless it's the same story. If you've got Mary's story and Robert's story, I like to have Mrs. Hughes's story in between, so that it's all woven, and you have the sense of everything happening simultaneously. At the end, I check for, say, a story for Edith, and this one, and that one. I work out if there are any huge thirty-page gaps; then I might move a scene or two.

"The trickiest element is to keep so many characters up in the air. All the actors, I think, with one or two exceptions, are fairly reconciled to the fact that they have a good story maybe three times in the series, and then they will have some smaller stories, or they will be part of other people's stories; that's the only way I can keep them all going. If everyone had a leading role in a significant story every week, every episode would be about twelve hours long. If I lose a character, I think, *I've got to put them back.* Then I think of a story where they can be a witness-participant and drop it in.

"As the actors develop the characters, writing for them becomes easier, because you can hear their voices. A character is created by a combination of the writing and the acting.

"For instance, at the beginning, Mrs. Hughes was quite a standard character, the housekeeper. She's operating as a successful woman within a system, but she doesn't particularly worship it, and you know that when the system comes to the end, she's not going to spend the rest of her life pasting pictures into a book and crying. She'll take her skills somewhere. And that is just as much a creation of [the actress] Phyllis Logan as it is of me.

"I enjoy that. When the actors help you and take you in a direction that clearly is going to work, that's very rewarding. There are some

characters with whom you probably have a slightly greater facility, because the emotional situation they're in is easier to write for.

"I think actors have a very good sense of what is sayable and what is not. When an actor comes up to a director and says, 'This speech isn't quite right,' their solution may not be the solution, but they're almost invariably correct that something's off. I think directors who ignore actors are shooting themselves in the foot.

"When I write dialogue, I say it out loud, to pick up my own repeats. Reading silently, you may not notice that you've used the word *portion* three times in one paragraph. The moment you read it aloud, you hear it immediately.

"I started my writing career largely when I was working as an actor on a series called *Monarch of the Glen.* I had to write in a hotel room or in some horrible dressing room. I could take my computer, plug it in, and start working: I couldn't do all that *Oh, so I've got to be facing the sun at this angle.*

"I work partly in London and in Dorset; I work in the House of Lords—they've given me a little office. I am something of a workaholic, which I can only say is just as well. I feel guilty when I'm not working.

"I don't have time for writer's block; I just have to get on, because I've made so many commitments. Sometimes you write stuff, and it doesn't seem any good, and you chuck it out; but you have to keep churning it out. If you want to be a writer for your living, and you're not just working on your book in the attic, you have to be grown up about it and not wait until you're in the mood. You can't afford that. Usually, if you go for a walk, you can come back with an idea of where you go next.

"One thing I do—it doesn't always work, but it's pretty helpful— is finish work for the day knowing what the next bit is. I don't usually

stand up from my desk until I know what I will write as soon as I sit down the next day. I put in the heading of the scene: 'Robert is standing in the library with Mary.' Once you sit down and you can work immediately, to a certain extent you've got forward motion.

"I'm not a big fan of going back over what I've done. I like to write the episode and put 'The End.' In many ways, that's when the work starts—changing the structure and altering the thing and taking that story out and putting this one in. Somehow modeling an episode that already exists is miles easier than the trudge of making it come into existence."

The most permanent of Julian's characters is the real Downton Abbey, Highclere Castle in Hampshire. It has become iconic. It is featured in the program's logo and in the very first shot of the opening sequence, along with the swaying hindquarters of Lord Grantham's dog, Isis. Highclere was always Julian Fellowes's first choice to be the home of the Crawley family, but he and Gareth and the production team scouted the length and breadth of England to make sure there was nothing better.

Highclere has its own interesting history. The Carnarvon family has lived there since 1679, on an estate of one thousand acres. The current castle stands on the site of a palace owned for eight hundred years by the bishops of Winchester. The distinctive wedding cake exterior (actually a Renaissance Revival style) was added in 1838 by the architect Sir Charles Barry, later responsible for the Houses of Parliament.

Maybe that's what appealed to Julian. He was made a member of the House of Lords in 2011; and his wife, Lady Fellowes, née Emma Kitchener, is a lady-in-waiting to Princess Michael of Kent.

The present Lord and Lady Carnarvon still live at Highclere. An interesting piece of television magic is that only about half of *Downton Abbey* is actually shot at the castle. The stately library with its red

velvet couches and priceless books; the drawing room; the grand hall-way and staircase; and the dining room, with its enormous van Dyck painting, are all really in Highclere, as is one bedroom. The cast and crew take extraordinary care not to stain, scrape, ding, rip, or in any way alter *anything* in the castle. No food, except for prop food, is allowed.

All day, every day, as on any set, large lights, cameras, and scores of people move through the rooms. Outside, it looks like a small village or a military operation: lighting and equipment trucks are every-where, as well as multiple trailers for the cast, producers, and ward-robe and makeup people.

Lunchtime is a wonderful visual treat: how do you feed a decent hot meal to seventy-five people out in the middle of nowhere? You bring in a caterer with a portable kitchen—all drama productions do. But where do you seat seventy-five people if the weather is inclement, or even if it's not? In a converted red double-decker bus.

It's quite a sight to watch Mr. Carson in tails standing in line chatting with Lady Edith, dressed in full costume—but covered by a parka and a protective hair net—next to Thomas, with clips in his hair. Everybody tucks into salads, sandwiches, or "meat, two veg, and a pudding." Then they're all back on set—more or less. The speed of drama production is roughly that of grass growing or paint drying; it's extremely slow. Setting up the proper lighting takes hours, and every scene must be shot multiple times, from many angles. It's like an army maneuver—hurry up and wait. The hours are long, and over the length of the six-month shoot, the weather goes from wet and chilly February to full-blown, un-air-conditioned summer.

It's not the glamorous part of show business. Passing the time requires a different kind of creativity, as described by Elizabeth McGovern.

"On the set there are running gags. The kids gang together and

have a different kind of dynamic than the ones who are older. There's a group that tweets back and forth with each other and laughs uproariously. Certain lines become favorites. One was Penelope's [Mrs. Crawley], which we used to say over and over and make ourselves laugh: 'Much cattle, much care.' It was supposed to mean that inviting a lot of people to the house puts more strain on everyone.

"I float between different groups. I bonded with Michelle Dockery over music, because she and I often sing songs in my trailer. I'll be on the guitar, and she'll sing the harmonies. All this shifts because if you have a lot of scenes to do with somebody, you're thrown together more. You might have a bit of an intimate period with them, and then you find that the story goes in a different way, and you don't see them that much.

"Maggie Smith makes us laugh. What she does on that show is absolutely incredible. It's incredible for anybody if you really understand the hours that it entails—the physical demands of it. She and her character Violet both have a dry wit—it's nothing you can fake. And she tells it like it is. I think the reason she connects so well in that part is because it connects to a lot of who she really is."

Hugh Bonneville adds, "If you're doing dining room scenes that take two days, of course there can be lulls of tedium. I can genuinely say that I've never worked with a cast that gets along as well as this one. When you're working on material that isn't making you tear your hair out because it's weak, when you're working with a crew that is evidently working to the highest standard that it can, and with directors who are prepared and conscientious, and in a setting like that, it all comes together.

"There's a genuine ensemble nature to the show. No one's got room to throw any toys out of the pram even if they want to. The pressure is incredibly tight because the schedule is heavy."

The first time I visited the set, in the spring of 2011, I was star-

struck. I couldn't find the entrance at first, which was mildly embarrassing; I was terrified that I'd walk around a corner of the castle and find myself in a scene with Lady Violet. I did round a corner and was warmly welcomed by Dan Stevens, sitting in the middle of a parking lot impeccably dressed in white tie and tails at nine in the morning, waiting to shoot a formal dinner and trying to keep warm in the sun.

A few hours later the excitement wore off as I stood for hours behind the camera in the dining room, during the endless shooting of that formal dinner party, watching the cast do a crossword puzzle between takes.

And the Highclere scenes are less than half of the location story. Because the original kitchen area, in the basement of Highclere, is now a gift shop and the repository of the fifth earl's collection of artifacts—he was an amateur Egyptologist and funded the excavations of King Tut's tomb—the downstairs *Downton* scenes are filmed over an hour away in London, at the famous Ealing Studios. Ealing is where wonderful postwar British comedies like *Kind Hearts and Coronets* with Alec Guinness were filmed, as was, more recently, an entirely different kind of comedy, *Shaun of the Dead*.

Mrs. Patmore's kitchen, Mrs. Hughes's cozy office, and the upstairs bedrooms and service quarters, are all purpose-built sets that are in use for six months a year, then taken down and packed away until production on the next *Downton* begins.

Recently the British charity Comic Relief made a wonderful *Downton* spoof that involved Lady Cora asking Carson to fetch her a cup of tea. He set off on the sixty-mile journey to the kitchen and arrived back several hours later.

It's a peculiarity of *Downton* that because of this physical separation, half the cast hardly ever sees or interacts with the other half. Mr. Carson, the butler, and Anna, Lady Mary's maid, are upstairs at Highclere with the family often, but Mrs. Patmore and Daisy rarely

are. It's a big event if any of the family actually comes down to the kitchen. Sophie McShera, who plays Daisy, recently said rather wistfully that she'd never had a scene alone with Lady Violet, Maggie Smith, and wished Julian would write her one. Everyone wants a turn at *that*.

Every now and then the whole *Downton* cast will have a scene together: maybe a Christmas party, or perhaps standing at attention outside, anticipating the arrival of a dignitary or a mother-in-law from America. Watch for these moments—they're very rare.

From my office in Boston, I don't presume to know the deep undercurrents in cast relations on the *Downton* set over three thousand miles away, but a few things really strike me when I see these actors together. Hugh Bonneville and Jim Carter, either by virtue of their roles or by their long years of working in the business, are the patresfamilias, one for upstairs, one for downstairs. They are both very solid and reassuring presences who can set a mood or speak for the group. It helps that Jim can juggle and do magic tricks, and that Hugh has done comedy programs in the off-season.

Elizabeth McGovern plays a part, Lady Grantham, that is arguably close to her own life. She grew up in America, married an Englishman, and moved to London, where she is raising two teenage daughters. "In playing Cora," she says, "I draw from my experience as someone who has lived in England, has indoctrinated herself into an English family, and is raising daughters who talk back to her in an accent that isn't her own. It's a different sort of experience. Your daughters have a different cultural frame of reference than you do.

"At times, I'd feel I was approaching a scene in a way the director wouldn't understand. Sometimes I felt they'd give me directions based on their idea of how an English woman running that household would behave. I would have to say to them, 'But you don't understand. I'm American—it would be different for me.'

"Authority with servants was something that used to come up. I think an American has more of a guilt feeling about having servants than an English person does. It's not something that comes naturally to Americans, so they don't have an imperial air with serving people. I think it's the same with children: the American approach to child rearing blurs the lines more between the authority and the child—good in some ways, maybe bad in others."

The younger cast members are—or were—the least known to the public, and arguably their lives have been changed the most by *Downton Abbey*. Dan Stevens and Jessica Brown Findlay were the first to seize the opportunity that *Downton* fame presented and go out on their own. But before they left, it was lovely to see the connections they made with other people in the cast.

Dan and Michelle, who play the beautiful young couple Matthew and Mary, for whom the course of true love never does run smooth, seemed to me to be solid, comfortable friends, watching each other's backs and enjoying the ride. I remember a publicity junket with them in the States: early flights; endless interviews, smile, smile, smile; and they had a ball. Michelle had never been in a limo (*that's* changed). They mugged, laughed, and took pictures. And at one event, while they were waiting backstage to go before an audience of rabid fans, they boogied like crazy to Petula Clark's "Downtown," the soundtrack to the warm-up clip the audience was watching.

Jessica Brown Findlay and Elizabeth McGovern became very close, and when Jessica's character Sybil dies in childbirth, Elizabeth's performance is almost too real to watch.

Thomas, the evil footman everyone loves to hate, is played by an actor who is entirely unlike him. Rob James-Collier is a model-handsome, charming man with a happy family and a quick joke always at the ready. He seems to be a tension-relieving person, instinctively smoothing things over or laughing difficulties away. He, Sophie

McShera, and Joanne Froggatt really are from the north of England, where *Downton* is supposed to be set, and where plain speaking and hard work are, perhaps apocryphally, bred in the bone.

And then, of course, there are Penelope Wilton and Maggie Smith, the grand, and even grander, of the grandes dames. Penny, who plays Isobel Crawley, the earnest, forward-looking mother of *Downton*'s heir apparent, has been appearing in *Masterpiece Theatre* productions all the way back to 1972 (*Country Matters*), working her way through Elizabeth Gaskell's *Wives and Daughters* and appearing nearly forty years later in *Downton Abbey* and *South Riding*.

She's a warm and gentle person whose marital history reveals, at least to me, the incredibly small world of British thespians. For a time Penny was married to Daniel Massey, the son of the actor Raymond Massey. Daniel, an actor too, is the brother of the actress Anna Massey, who was married to Jeremy Brett (Sherlock Holmes) before *he* married Joan Wilson, the second executive producer of *Masterpiece Theatre*. Got it?

Maggie Smith. Arguably, she is first among equals in *Downton*'s solid-gold cast. She and Julian Fellowes share a creative channel or frequency—it's hard to know what to call it—that only seems to get better with each season of *Downton*. She is, hands down, the crowd pleaser in the cast, and the actor who has had the most nominations and has won the most awards for her work on the show. Yet she never, ever goes to awards ceremonies, and says she has never, ever watched a single episode of *Downton Abbey*. The cast and crew, of course, are mindful of her celebrity, and on the set she is treated carefully and respectfully. When Maggie shows up to work, she works—no nonsense.

In talking with her on the set on my first visit, I was so bedazzled by her that I blathered on and on about how much I admired her performance in *A Bed Among the Lentils*. She instantly changed the subject from herself to the hotel where we were both staying, and

warned me about the expense: "It has a wine list that will make your eyes water."

You can hear the voice.

Maggie has won two Primetime Emmys and two Golden Globes for her work on the series. In fact, *Downton Abbey* has cleaned up in America, thus far winning nine Primetime Emmys, two Golden Globes, and a SAG Award. But in the U.K., the series has had a very peculiar relationship with awards—it has been noticeably overlooked. The viewership increases every year, but the awards hardware remains elusive; the cast and creators seem to get *Downton* love much more in the United States than in Britain.

The people who give awards in the U.K. tend to go for hard-hitting, gritty, contemporary programs. In 2012, for example, the highest British honor for a TV miniseries went to a piece called *This Is England '88*, about a group of friends during the mod revival era who are looking for love as well as employment, and whose heroine killed her father when he tried to rape her. The series is a follow-up to *This Is England '86*, set in skinhead culture. *Downton* went home empty-handed.

*Downton*'s popular success may be held against it in award circles. This snootiness on the part of the critics and award-givers, from what my colleagues tell me, is very British. Anyone who gets his head above the parapet and achieves big success in England is at risk for a take-down. In America we worship and celebrate success, something the cast of *Downton* has noticed and commented on frequently when they come over here. The royals may be the only true stars in England; in this country, actors are our monarchs.

As Julian says, "The hardest thing is British hatred of success; that has been the downside. The U.K. is a much more schizophrenic culture politically than the United States. It is a capitalist country, but the media is essentially informed by the Left. An extraordinary intolerance

pervades our artistic and media community in a way that I think has no equivalent in America.

"The British told themselves that period drama was dead, and that there was no more traditional support for this kind of thing—and that to represent a landed family with inherited status as being sympathetic was a kind of crime against nature. For the public to *want* that, to enjoy it and to support it, is a hideous revelation of the fact that many of their suppositions about the public are wrong.

"I am a public supporter of the Conservative Party, not a private one, and now, worse, I am a Conservative peer. So I am a sort of exemplar of the kind of devilry that has held England down, under oppression, for hundreds of years. All of this stuff has plagued me within the industry, but it does to a much lesser degree now."

Hugh Bonneville sees things somewhat differently: "I think middle England loves the show as much as middle America does; but in America, people have a much closer association with entertainment. I feel that in America a TV show or a movie is part of your world, and in Britain it's not. We don't have that same complete connection with it. We don't live and breathe it.

"While I was leaving the Emmys, I noticed Michelle Dockery being screamed at by fans in the streets in L.A. I don't think she gets shouted at in the street in the same way here, even though people will recognize her. The American attitude is 'We're part of this, and we love it, and we love it with no restriction,' whereas the British may be more reserved. People might come up to you, but I don't think you get swarms calling out your name here."

The joyride of success in America is indeed a great one, and it's hard not to get swept up in it when it comes your way.

There have been many peak moments in the *Downton* success story, but I have a personal favorite. In January 2012, in the ballroom of the Beverly Hilton, Rob Lowe and Julianne Moore announced

*Downton Abbey* as the winner of the Golden Globe for Best Mini-Series. It was the first Golden Globe for *Masterpiece* since *Jewel in the Crown* in 1986. The Hollywood crowd was thrilled, and cheered as we walked up to the stage—Julian, Gareth, Elizabeth, Hugh, the director Brian Percival, and me, representing *Masterpiece.*

But it wasn't the clapping and genuine affection of the Hollywood glitterati that touched me. It was what I saw, as I stood on the stage, listening to Julian's acceptance remarks: the smiling faces of three women I knew a little bit, and whose work and integrity I'd admired for years: Laura Linney, Helen Mirren, and Meryl Streep—my royalty.

However, for each *Downton* "high," there oddly seems to be a "low" for *Masterpiece.* Four months earlier, when Julian had accepted the Primetime Emmy for Outstanding Miniseries, his surprise and delight apparently jumbled up his prepared remarks, and he thanked NBC but not PBS. My heart sank. Yes, NBCUniversal owns the production company, Carnival Film and Television, that makes *Downton.* But a shout-out to PBS in front of a television audience of twelve million people would have been something money just can't buy.

Runaway-global-hitdom brought up unexpected issues.

Gareth Neame explains: "In the next two years, all the realities of managing a huge worldwide hit started coming in. Everything we were doing got a bit more complicated. Everyone started to know their price. It was totally different from working on most original dramas, where you're creating new things and you spend your whole life trying to get anyone to show any interest in what you're doing, because nobody gives a damn. You're just another show.

"Now there was a reverse problem, which is that we were trying to manage so much interest in the show that it was getting in the way of everything. Twenty relatively unknown British actors were now worldwide stars, Julian was one of the hottest writers on the planet, and Highclere Castle was now the most famous stately home in the world.

"The ball was so knocked out of the court—everything we were doing was different from the norm and was complex to manage. But hey, it's a nice problem to have."

Then the problem of branding—who would get credit for the series in the United States?—entered a kind of feeding frenzy, and why wouldn't it? A hit like *Downton Abbey* comes along only once in a generation. NBCUniversal, which put up some of the money and was newly owned by Comcast, wanted credit. Understandably, Carnival Film and Television, the U.K. producers, wanted recognition for having actually *made Downton Abbey*; PBS and WGBH, the producing station that created *Masterpiece*, wanted their involvement to be recognized. All these entities felt strongly about getting proper credit.

Nothing succeeds like success, but nothing, apparently, causes more trouble; disagreement and misunderstanding over each of the entities' needs mushroomed daily. The behind-the-scenes drama rivaled what was happening in front of the camera at Highclere Castle. One might assume that the show had gained enough recognition and acclaim to satisfy everyone, but it somehow didn't work out that way.

Our Susanne Simpson, one of *Downton*'s greatest advocates, once again smoothly handled all of us.

And yet for every tense exchange, there would be a nice surprise, a lagniappe, a blessing. I had a wonderful *Downton* moment one day as I was driving along the Massachusetts Turnpike and got a call from our publicist, Ellen Dockser: "What's the best thing you can imagine happening for you, because of *Downton*?"

"An invitation to visit Barack Obama at the White House."

"No."

I had temporarily forgotten that Ellen is a publicist.

"*Vanity Fair* wants to do a feature on you, with Annie Leibovitz taking the picture!"

Good news, bad news: I love Annie Leibovitz. Her work and her life fascinate me, and I love the fact that Graydon Carter, *Vanity Fair*'s editor, remains *Masterpiece*'s champion. But I hate having my picture taken on any occasion, and I was really afraid that Annie, famous for improvising, might ask me to soak in a tub of milk or climb over a fence naked or something. My biggest fear of all was that in spite of the cut-glass PR that a *Vanity Fair* feature would give to *Masterpiece*, it would also confirm the suspicions of our British partners: that I personally was claiming undue credit for *Downton Abbey* and other co-productions.

For twenty-five years, I'd heard and seen the gossip and impressive character assassination that the Brits can come up with for their colleagues—friends or foes. The drama genre is a perfect petri dish for this particular strain of human nature. For all the warm embraces and boozy lunches I'd had with British producers who were pitching their ideas and asking for production money, I'd also had plenty of evidence of their backstage opinions that *Masterpiece* was (no, correction, that *I* was) a credit hog investing only modest money and showing up only at awards ceremonies or media events.

I wasn't imagining the gossip: Andrew Davies had heard it too. He observes, "I suppose they might say, 'Well, I actually did produce this. What's Rebecca doing up here getting a producer credit? Because I didn't see her on the set at six a.m. on all those days.'"

It stung: I only *had* short money to invest, and I'd always made a point of leaving producers and directors alone as much as possible during productions. Showing up at awards ceremonies and doing interviews can be fun, but it's also one of the few ways to demonstrate that *Masterpiece* and PBS are true entertainment "players," both in Hollywood and to the vast audiences watching on television—and most significant, that the quality work seen on *Masterpiece* is worth public support. And simply put, our British co-productions wouldn't

be eligible for prime-time Emmys and other U.S. awards without our involvement.

But back to Annie. The calculation ended up, of course, being simple: yes, there would be gossip, but that's the cost of doing business in show business.

Annie did have a concept: she wanted to photograph me in the English countryside, all green and woodsy, with my "shock of white hair," as she put it, blowing in the breeze, and Downton Abbey— Highclere Castle—in the background.

Maybe not. The answer came back speedily: no Downton Abbey—too distracting for the cast who were filming inside.

So while I waited in a charming country hotel in Hampshire, *Vanity Fair* spent thousands of dollars hiring a producer to find a suitable hillside somewhere in the south of England. It also hired a stylist to buy or rent thousands of dollars' worth of designer coats, sweaters, ball gowns, and shoes, from which Annie could choose items to decorate me.

While Annie was still in New York, I asked her intermediary if I could talk to her on the phone. I could feel myself starting to "produce" the shoot, and I had ideas I wanted to share with her. Could there be an Alistair Cooke armchair out there in the field? What about books? *Masterpiece* is all about books. The intermediary told me charmingly but unequivocally that Annie wasn't too good on the phone and that we'd meet on the morning of the shoot—which finally arrived. Early that morning, I heard cars crunching to a stop on the long gravel drive. Looking out, I saw three sinister-looking black Range Rovers and a giant Winnebago. Ten people got out, including Annie, at six feet the tallest of them all. She came to my room, and we sat down on a couch making small talk about her overnight flight from New York and her shoot the next day in Switzerland with Sophia Loren. But she looked really uncomfortable on the couch

and finally got up and moved over to sit on the end of the bed, facing me. I chattered away.

I realized she wasn't just making small talk; she was working, "reading" me, figuring out who I was and how to shoot me in a way that would best represent what she saw. We talked about children: the daughter she'd borne at fifty, and her twin girls carried by a surrogate. I talked about Katherine. I felt an incredible urge to tell her everything, to help her know me so she could do her job; I sort of fell in love with her right there.

We went through the wardrobe choices in about ten minutes: yes, no, no, no, yes. She took off in one of the Range Rovers, and someone did my makeup. My hair would just be my hair. Then they piled me into another Range Rover and we sped away, tearing around Hampshire, scattering pheasants, trying to find the hillside where Annie and her crew had set up. It started to rain. We got lost and went to the wrong hillside—no cell service. The producer in me started to panic: *How do I fix this? Wait—not my problem.*

Finally we spotted the Winnebago on a far distant hill and headed for it. Annie was there as well as Lady Astor—I think that's who she was—who owned that particular hill. We tried some poses: sitting in the Alistair Cooke chair and, for a few uncomfortable moments, me in a yoga position on the soggy ground. Then some walking and talking, with the wind blowing fiercely, and me wandering through a herd of sheep, poop all over the Jimmy Choo boots. Nobody ever went into the Winnebago; I guess it was there for a bathroom emergency.

Then Annie had a new idea: "Let's go back down to that hotel. I like the chairs in the lounge."

Down we went, the whole fleet of ominous Range Rovers plowing along farm lanes. The lounge was full of gentle guests sipping tea. The producer paid them to leave. One couple demurred and continued to sit and chat quietly, impervious to the six-person camera crew.

Suddenly Annie looked despondent. She said, "Rebecca, I'm really sorry—I don't have it yet. Will you excuse me if I go away and think about this for a few minutes?"

It was utterly fascinating to me: here was Annie Leibovitz, one of the best portrait photographers in the world, struggling in the act of creation. She was under a lot of pressure; I had to leave for Heathrow in less than an hour. She was visibly pushing herself to make a better picture.

Eventually she came back into the lounge and said almost apologetically, "The light is perfect now. Would you be willing to go back up on that hill?"

Of course! Off we went. At the top, she jumped out of the car. There was a huge, perfect rainbow, and everyone, including me, started taking pictures—except I was taking pictures of Annie taking pictures of the rainbow. We were all giddy. She asked me to climb over a fence. Snap, snap—it was done.

She gave me the Max Mara coat and cashmere sweater to keep. We hugged and agreed we loved each other.

Then she stunned me by saying, "Whenever you're in New York with your daughter next, let me know. I'll take your picture together. Your face changes completely when you talk about her."

Annie Leibovitz had done what she does. She'd looked at me carefully for a little while, and then she'd figured out who I am.

# SIXTEEN

# The *Downton* Effect

*Downton Abbey* has been a game changer for so many people, in so many ways. In addition to revitalizing interest in *Masterpiece* and PBS, establishing young actors like Michelle Dockery, Dan Stevens, and Jessica Brown Findlay as bankable stars, and making a lot of money, I expect it will figure prominently in future histories of television. At the moment, we're all still riding the tiger, with at least one more season to be produced and broadcast, and it's too soon to evaluate fully *Downton*'s effect. But it's undeniable that in both Britain and the United States, it has rejuvenated the genre that has been *Masterpiece*'s meat and drink for forty years: high-end period drama.

With *Masterpiece* as a co-producer for many of them, British broadcasters are now investing heavily in costume dramas, such as *Mr. Selfridge* and *The Paradise*, both, as it happens, about department stores. There are projects in the works about the War of the Roses, the last days of the Raj in India, and even a remake of *Poldark*. In this country, the History Channel has had great success with an American period

drama, *Hatfields & McCoys*, and the ultimate costume drama, *The Bible*. Julian Fellowes has been commissioned to write a pilot about the American Gilded Age. Dozens more series are in development all over Hollywood and London. We'll see how long this particular cycle lasts.

In the short term, *Downton* has catapulted *Masterpiece* into a whole new orbit of publicity, visibility, and popularity.

One of the very best unintended consequences has been the end of our ten-year sponsorship drought. We never lost our focus on finding a new sponsor for *Masterpiece*. In the early summer of 2011, we got an inquiry from Richard Marnell, head of U.S. marketing for Viking River Cruises, the world's leading river cruise company. He'd reached us through our Web site. Viking had asked its customers (a database of millions) which television programs they watched. Among the top five were both *Masterpiece* and *Downton*. Viking's prototypical customer matches almost perfectly with *Masterpiece*'s prototypical viewer—a marketing marriage made in heaven. Richard and his colleague Mark Brogger worked with our sponsorship team, sold the idea internally at Viking, and a deal was signed in two weeks.

About a year later, it happened again. We received another inquiry, this one from an executive at Ralph Lauren. Someone had given the *Downton Abbey* DVDs to Ralph Lauren himself, and he'd watched them over a holiday at his home in Jamaica. Another perfect match. A few months later, we had our second sponsor.

All this is good news, but the learning curve has proven to be remarkably steep and treacherous. The attention paid to a hit television show may be what you wish for, but in the world of the blogosphere, "attention" can turn toxic in the short time it takes for a journalist to file an incorrect story, a "pap" to snap an unauthorized picture, or an annoyed fan to tweet.

Heightened attention and fan fervor has on several occasions bitten us badly on the bum. I felt it in the spring of 2012, when I was speaking

to a small group in Florida of maybe fifty *Masterpiece* fans and potential donors. They begged for intel about the upcoming Season Three.

I said (blandly, I thought), "I can't tell you anything specific. You'll have to watch the show. But you saw Matthew and Mary get engaged at the end of last season. They will be married, someone will be born, and someone will die. It's going to be the best season ever."

Well, I was certainly an innocent—everybody's got access to mass media now. Practically before I got back to my hotel, my remarks had been posted in a blog and been picked up by the British press. The British producers were furious; they'd guarded the scripts and plotlines like nuclear weapons plans, and they felt I'd revealed too much. They'd already been fending off paparazzi coming over the walls at Highclere Castle, snapping pictures that might reveal plot elements. Rumors were everywhere about which characters were leaving or dying. I learned the hard way that one of the British papers had instructed its editors to have a breaking news story about *Downton Abbey* every week, corroborated or not.

We wandered into the tall grass on another occasion, when social networking and the U.K. tabloid press piled onto the most unlikely of targets and created an inaccurate story that got out of the box faster than any of Pandora's evils.

We had aired *Downton Abbey* Season One over four weeks instead of nine, combining various episodes and trimming the material very slightly—only minutes—to fit into our time slots. This happens all the time: almost all the shows we do are trimmed or formatted differently from the U.K. versions. Broadcasters all over the world do it. The small cuts don't change the program in any substantial way, and they are made in England by the original editor, producer, or director. We don't editorialize from this end, although of course we discuss the process with them.

As *Downton* was being reformatted for us in London, I suggested

that one place where we might save time was in the endless discussions about the entail. What's an entail? That's the problem—it's complicated and hard to make dramatic. It's an aspect of property inheritance that's important in British law, and important to the Crawley family when they think they might lose Downton—but it's really hard for characters to talk about it in a riveting way.

One day after our broadcast, a *Downton Abbey* fan posted, "Wait a minute—I saw this show in England. It looks different in the United States. That scene was longer when I saw it in London. What's going on?"

The story mushroomed and metamorphosed. Interviewed by Chris Hastings from the *Daily Mail* in London, I explained the necessity of creating new versions of most of our co-productions. But the paper took the story and turned it around, writing that we had shortened the show by *two hours* to make it more intelligible for an American audience, who were too dim to understand the British version, particularly the part about the entail. The American press picked up the story, and it took weeks of interviews and statements to correct it and convince fans that they weren't being robbed.

And then there's the business of spoilers and piracy: once again, it's a good problem to have, and possibly a cultural phenomenon greatly magnified by *Downton Abbey. Masterpiece* found itself right in the middle of it all for a number of reasons. *Downton* is a soap opera with a big cast whose lives are tossed and turned weekly by dramatic life events. Viewers want to know what will happen next and to whom, as soon as possible.

The show is aired in Britain four months before its U.S. broadcast, partly so that the cast can help us with publicity over here. Moving our broadcast earlier, closer to the U.K.'s, would be fraught with problems, not the least of which is that we would have limited access to the cast—they'd still be busy in Britain publicizing the U.K. broad-

cast. But the delay in our broadcast leaves us open to piracy—illegal Internet downloading. As it turns out, *Downton* appeals both to an audience that likes to watch in the old-fashioned way, weekly, on Sunday nights at nine p.m., and to a younger audience that likes to devour it at one sitting, watching as many episodes as possible on their computers, legally or not. All of these elements make *Downton* ripe for piracy, spoilers, and binge viewing.

We've debated long and hard about airing the series closer to the U.K. broadcast, in September. As it turns out, although the critics of our delay are vocal, the audience numbers indicate that we're not losing viewers. In fact, the audience is growing exponentially each year. We don't seem to be suffering from the loss of viewers who've illegally pirated the shows or who've heard all the spoilers and lost interest in watching the broadcast. January and February, when PBS traditionally airs *Downton*, is a sweet spot, a heavy viewing time of year when most people are inside and watching television.

But the pirates are troubling for *Masterpiece*, and not just because the people who illegally download programs are potential lost viewers. The pirates are particularly troubling because they are generally young people, a coveted audience for *Masterpiece*, our next generation. People grabbing individual programs down off the cloud whenever they want to are not developing an affinity for or an attachment to PBS, let alone to *Masterpiece*. And this means that as they grow up—when they have disposable income greater than the cost of a nonfat macchiato—they might not become public television donors, whose contributions are our single largest source of funding.

I came face to face with the pirates in the winter of 2012, when PBS held a screening of a brand-new episode of *Sherlock* in New York City. Although it had just gone out in the U.K., the program wasn't scheduled to air on *Masterpiece* for four months.

In an effort to make it a fun fan-event, PBS had booked Steven

Moffat, *Sherlock*'s co-creator (currently the show runner for *Doctor Who*), Sue Vertue, the executive producer (and Steven Moffat's wife), and Benedict Cumberbatch, Sherlock himself, to be onstage for a panel after the screening. PBS had made free tickets available in a lottery on the Internet. A few tickets were on offer at the box office on the day of the screening. The blogosphere and Twitterland went wild, and people started lining up at seven a.m. for the seven p.m. event. They'd come from all over the country, they were mostly young women, and they were screaming with excitement by the time the episode started. When Benedict, Steven, and Sue came out on stage afterward, they went as nuts as their mothers had for the Beatles, or their grannies for Frank Sinatra.

I was thrilled—until the Q and A started. Not only had these young pirates previously seen this particular episode of *Sherlock*; they'd illegally seen the other two episodes multiple times on their computers. They had only a vague awareness of *Masterpiece*, and it's possible that there wasn't a television set owner among them.

But considering the spectacular resurgence of *Masterpiece* in the past few years, these are all good problems to have. After the rebranding, the series got a second wind—and then *Downton Abbey* came along and turbocharged it into a new orbit. Anybody who's had anything to do with *Downton* is asked again and again: "What do you think makes this particular series so monumentally appealing to so many people, all over the world?"

We all have our theories, and if any of us knew for sure, we would probably tell absolutely no one and instantly set to work to make the next hit show. It's like capturing lightning in a bottle or, as Julian tells it, like making the perfect chocolate éclair. He remembers that when he and his siblings were young, his mother would occasionally turn

the kitchen over to them. One time small Julian tried his hand at a batch of éclairs. They were perfect, and his mother begged him to tell her how he'd done it. He didn't know; he'd just followed the recipe, and something magical had happened—never to be replicated.

I personally have two theories about the *Downton* phenomenon, each based on absolutely no empirical evidence. The first and simplest is Julian: if ever there was a fictional world and a real man born to create it, it's the community of *Downton Abbey* and Julian Fellowes. To spend any time with Julian—perfectly tailored, with a friendly round face—to listen to him talk in vivid, informed, witty, impeccably spoken full paragraphs, is to spend time with a character right out of *Downton*.

I love to listen to him. As his wife, Emma, says, Julian could talk for England; he's world-class. Anytime I have ever seen him, even when he was absolutely exhausted, in pain, or jet-lagged, he could still talk for England. And when you hear him talk about *Downton* and the characters, you can tell they are alive in his head.

Deep down I think Julian might choose to live in *that* house and at *that* time. For him, writing this series is not just a job; it comes from some impossibly deep part of his imagination. I think of him as still having the ability to summon the magic that children do when they lose themselves in play—a little girl in front of a dollhouse, or a little boy with his tin soldiers, making a world. And I say this with the greatest respect.

He strikes me as a man from another time, a nineteenth-century gentleman. He has a courtliness, a formality, and a manner of speaking that are "period." But I don't think of him as solely a creature of antiquity. He's very savvy about modern media. He's done television. He's done plays. He's done movies. He adapted *Mary Poppins* for the theater and won an Oscar for Best Original Screenplay for *Gosford Park*. He wrote a four-part television miniseries about the *Titanic*. But even in the twenty-first century, I would say the nineteenth century is very present to him.

Listen to how he describes himself: "I got interested in history when I was very young. From quite a young age, I woke up to the fact that in earlier periods, different rules had obtained, and different kinds of lives were lived. As a seven-year-old I read a book about Mary, Queen of Scots.

"I think history became a kind of safe haven for me, because I could go into this ordered world. You can enjoy the so-called ordered society, but you don't have to get up at four in the morning and clean out the grates or, if you're in the family, change your clothes six times a day. I think that's one of the big appeals of these shows: people can go into the world of *Downton* and get lost in it. They're not sitting there in a corset they can hardly breathe in.

"I also liked novels, and I took to the nineteenth-century novel like a duck to water, starting with Jane Austen, and then boiling up through the Brontës, and ending up with Proust. I was reading Dickens when I was fourteen.

"A lot of my great-aunts and their cousins were still alive and still perfectly coherent. My oldest great-aunt, Isie, who is always cited as a sort of model of Violet Grantham, was born in 1880 and presented in 1898. She only died when I was twenty-one, so I knew her perfectly well.

"Alongside that, I had this enjoyment of drama and the movies—never the theater. I went to the theater and sometimes enjoyed it, but it didn't speak to me as film and television did. The first result of the interest in history and drama was trashy historical novels I wrote when I was twenty-one. And I enjoyed acting in period stuff, which I did pretty well from the start.

"There is something of the escapologist in every actor—a part of you that loves the idea of being someone else for a bit. And in Europe particularly, you are absolutely surrounded by history. If you couple that with the desire to be an actor, an escape into the past became a feature of my life."

If Julian is an escapologist, then so are we all. Why else would we

allow ourselves to be beguiled by the ups and downs of a bunch of well-off Edwardians trying not to lose their house? If ever there was a television series about the 1 percent, right up there with *Dallas*, it's *Downton Abbey*. Of course people watch television drama to be entertained and to escape, and of course *Downton* is especially well done escapism, but clearly other factors are turbocharging it along.

Lots of theories about *Downton* posit that the show appeals to so many of us because times are tough; when times are tough, we're drawn to dramas about people who wear elegant clothes, who live in beautiful surroundings, and who talk about love. My personal theory about *Downton*'s huge attraction starts there but then veers off a little. Maybe we're drawn to it because, unlike almost any other big, popular drama series currently airing in America, it's a show about a community of people who are all, in straightforward and old-fashioned ways, trying to do the right thing. It has morality at its core.

Although my theory heaps a lot of lofty intentions on an entertaining TV show, I don't know whether or not this "goodness" is purposeful on Julian's part. I've never asked him. But as I look around at almost all the other big American series—*Breaking Bad*, *Boardwalk Empire*, *Sons of Anarchy*, *House of Cards*, even *Mad Men*—I see how dark they are. Their "heroes" are deeply compromised and morally ambiguous, and the stories are often about corruption.

*Downton* is essentially warmhearted. Nearly every one of its characters is trying to make something "right": Robert and Matthew are trying to keep the estate vital and protect those who live there; Anna is trying to prove her husband's innocence; and Isobel Crawley is trying to help everyone she comes across. Downstairs, in addition to the noble and virtuous Mrs. Hughes and Mr. Carson, there's Daisy, trying to do the right thing not just by getting herself some well-deserved kitchen cred but also by marrying William, whom she doesn't love, in order to give him some peace and comfort at the end of his life.

The only real baddie is the late and awful Mrs. Bates. Thomas and O'Brien? No, they're not really bad; they certainly do horrible things rather often, but sooner or later they both see the light and redeem themselves. In terms of good-guy drama, *Downton Abbey* may be unique. We may be drawn to the idea of a community that actually works well, that supports, comforts, and protects everyone who lives in it. So many of our own communities do not.

Ironically, even watching *Downton Abbey* seems to create community in our splintered, everyone-plugged-into-his-own-electronic-device culture. People have the usual day-after-broadcast conversations—what we used to call "water-cooler TV conversations"—when they call their friends to discuss how awful Thomas is or how lovely Anna is. But there's been tremendous *Downton* bonding via Twitter and in other social media. Young people, in particular, tweet and text each other constantly even while watching the show, and when something especially dramatic happens—as when Sybil or Matthew dies—the online chatter goes nuts.

Our social media presence for *Downton* Season Three created the highest-ever Twitter buzz for a PBS program. On the night of the premiere, *Downton* clocked in nearly one hundred thousand tweets—"ten times as much conversation as around the only two higher-rated shows, *The Good Wife* and *The Mentalist*, reported *The New York Times*.

More than 100 (112 to be exact) public television stations around the country held preview screenings for *Downton*, and we had reports of hundreds of private screening parties, with fans gathering together, occasionally in costume, to watch the show.

Phones went unanswered on Sunday nights at 9:00. Dinner parties were postponed. Children were put to bed early. The television magic that has happened with *Masterpiece Theatre* all those years ago had come full circle—it was happening again.

# Afterword

It's now almost a year since I started writing this book in that old house in Maine. Ironically, as hard as it was to begin to write it, it's harder to stop. I worry: will anyone read it? Have I said too much, or too little? Have I done justice to the *Masterpiece Theatre* story? Probably; probably; hard to say.

I've been back to that house only once since last fall because my husband, Paul, lives there now. We'll be divorced soon. Even though it was the Maine house that somehow got me started, I've written most of this book in the sunny living room of an apartment in Cambridge. But it, too, turns out to have been an evocative setting.

This place is only blocks away from the little attic apartment where I lived during those early years at WGBH, the years when I was wrangling the Balkan dance troupe for local television, following Patrick Ewing around with a film crew, mourning my mother and father, and watching *Upstairs, Downstairs* and Alistair Cooke from my orange corduroy couch. I'm also just a few blocks away from

another apartment where Paul and Katherine and I lived—the place where she took her first steps while I was at work.

When I decided to write this *Masterpiece* memoir, I rationalized it by telling myself, "Write it and retire." My plan was to remember, say what I could, and then beat a hasty retreat. Producing *Masterpiece Theatre* for twenty-eight years should certainly be long enough for me and for its audience—maybe it's time for new blood. There are many, many more things I want to do before I can't do them anymore. Tap dancing is unfortunately now off the list, but learning to make a piecrust from scratch and living in Europe for a year are still physically possible.

However, in the process of sifting through the programs, the war stories, and the memories, and in the process of going to London to have thoughtful, funny, and revealing conversations with fine people like Eileen Atkins and Julian Fellowes and Kenneth Branagh, I find myself back in the soup, simultaneously getting nostalgic for the old days and fired up for the new ones.

Perhaps it's the perspective of being out of the daily grind of the office. I can now see the *Masterpiece* forest distinct from the obscuring trees. I've fallen in love with *Masterpiece* again, both as a viewer and as a worker. I see the hours and hours of spectacular drama, the millions of devoted viewers, and my clever, imaginative British colleagues, and I don't want to do anything else. All I want is to continue to produce *Masterpiece*, and perhaps write another book about it.

I've heard about this phenomenon: writers being constitutionally unable to hand their work over for publication; actors longing for one more week of performances; unsatisfied painters, overpainting just a little. As I've written about the work of actors like Maggie Smith and Helen Mirren, and writers like Andrew Davies and Julian Fellowes, I've envied their mysterious gift of creativity, whatever it is that allows them to leave this world for a little while, to live temporarily, for our

benefit, in another one, where life seems more vivid and more deeply felt. And for as long as I can remember, I've envied that same elusive gift in my mother.

As I finish this book, I wonder if I've just taken this same magic trip. The book is not a novel, and it certainly stands on the shoulders of others, but it was created out of nothing nonetheless. To write it has been uncomfortable, exhilarating, and revealing. In doing it I've had a glimmer of understanding into why my mother was the way she was. This particular experience—what I suppose is creativity—is addictive. And my mother gave it up. Maybe she did it because then, as now, there weren't many good parts for older women; maybe she did it because she thought she should be a homemaker for my brother and me. But definitely she left her life in drama before she was creatively finished. She must have missed it deeply in all kinds of ways.

And maybe, in order to stay connected to it, or to ease her sense of loss, she opened a window for my brother and for me into the life she'd left, and she showed us as much of it as she could: theater, movies, books, and show-business people in New York and Los Angeles. I loved it all, and idolized her, in thrall to her stories and even to her moods. And then, although it seems almost accidental to me, I wandered into the same field.

It doesn't seem to stop there. I named my daughter Katherine Emery after her grandmother; and in the wake of a childhood of set visits, famous people, trips to London, awards ceremonies, and Broadway shows seen from a seat on the sixth-row aisle, this Katherine, too, is drawn to drama, particularly the deep satisfaction of forming a community and creating something new.

Is it presumptuous to say that my story is a family saga and has a dramatic arc, just like my favorite programs? Is it possible that most of our stories do?

This book is of course *Masterpiece Theatre*'s memoir above all. I

think hard about what I've learned about it from trawling through its life story: I wonder why it became iconic and has stayed iconic for more than forty years. What will become of it as we all career into the digital age?

Well, of course, there's Anglophilia, an affliction I've had since I was ten, apparently shared by several generations and many millions of people. In speeches to *Masterpiece* fans, I joke around and say that Anglophilia is not a dirty word—it's an honorable and manageable condition. But what really fascinates me is our deep attraction to the way the British talk, think, decorate their houses, cultivate their gardens, cook their food, and manage their personal and professional crises. We mock it and imitate it, but we are drawn to the orderliness and balance and resolve that we perceive there. It's Jane Tennison's and Miss Marple's pluck and independence; it's Jane Eyre's and Elizabeth Bennet's steadfast level-headedness, even as they fall in love with difficult, elusive men. It's the way John Jarndyce, Lord Grantham, and even Horace Rumpole persist in doing the right thing. We seem to find this aspect of Britishness reassuring.

*Masterpiece* lives on and on because it brilliantly does one of the things television is supposed to do: it entertains and distracts. Its programs are high-class escapism, but they don't leave you feeling that you've wasted your time. *Downton Abbey* may be high-end soap opera, but it's satisfying—and it makes you feel something. You cheer when Matthew gets down on his knees to propose to Mary in the snow. Watching a program like *Bleak House*, you weep when Lady Dedlock tells Esther in the garden that she is the mother who abandoned her. You melt when Robson Green kisses Francesca Annis in the pouring rain in *Reckless*.

I think *Masterpiece* persists and lives on because it has the very special good fortune to be *allowed* to persist and live on in the face of internal and external challenge. It has had fairy godmothers at crucial

moments in its life. In the beginning, Mobil pumped it full of the money and the publicity necessary for the audience to know it and to develop a taste for it. It flourished. Then when Exxon bought Mobil and ExxonMobil withdrew its support, when the British costume-drama pipeline dried up, and when its audience dribbled away, the series was preserved and protected by PBS and loyal viewers until things began to look up with the rebranding and the production of shows like *Sherlock* and *Downton Abbey*. *Masterpiece* has been allowed to stay part of the national conversation—an extraordinary phenomenon in television, one that I suspect we will never see again.

So how long can *Masterpiece* last? Because the series is so utterly connected to the judgment and good taste of our British co-producers, the question might be better phrased, "How long will the British continue to make the kinds of television programs that appeal to *Masterpiece*'s audience?" I see no end in sight there. These programs are formed in the likeness of stories such as *David Copperfield* and *Pride and Prejudice*. Interest in them has not flagged; why should interest in *Masterpiece*?

And I think the digital age has given quill pen *Masterpiece* an extraordinary lucky break. Time shifting and on-demand viewing fit our viewers like a glove. You can watch in your own sweet time, just as you might read the novels on which so many of the programs are based. You can get comfortable on the couch on a rainy Sunday and watch the entire first season of *Endeavour* or *Mr. Selfridge* or the three episodes of *Sherlock* that you missed last year. The stories are timeless, and you'll never fall behind. You can build a library with them, or clean them out with the click of a button.

My private theory about *Masterpiece Theatre*'s longevity has to do with the company we keep when we watch it. In the early days, families watched *Masterpiece Theatre* together. Viewing it was a shared, almost ritualistic event. Memories like those stick with us and create

a lasting affinity. It's somehow the pleasant family feeling that has sealed the deal.

Did you by any chance watch the original *Upstairs, Downstairs* on *Masterpiece Theatre* with your parents, or maybe with your children? Did you call your daughter to discuss the tragic events on *Downton*? Did you tweet your sister with delight and amazement when Sherlock jumped off the roof, splattered himself on the sidewalk, and then showed up behind a tree at his own gravesite? The programs on *Masterpiece* seem to connect people across generations and up and down family trees.

I've thought constantly about families, communities, and generations as I've written this memoir, starting with the Forsytes, through the Bellamys, the Jarndyces, the Dorrits, the Bennets, and the Crawleys. And of course I've thought about the dramas in my own family.

On a hot September day several years ago, I moved from our family house of twenty-five years into this apartment in Cambridge. A group of friends helped me unpack. It was like a military maneuver: one person washed the china, another made up the beds, and someone else put the books on shelves. It was a spectacular act of friendship. Somebody—I'm not sure who—deployed all the framed family pictures. They were placed rather randomly on mantelpieces, tables, and countertops. I've never rearranged them because I love the effect. Everyone's here: my grandmother in her 1900 lace dress, Katherine wearing a pair of cockeyed sunglasses, my brother Jeremy and I having a fistfight. I feel surrounded and buoyed by these pictures and their backstories as I write and pace and rewrite and rip up.

Somewhat eerily, there is only one family picture in my bedroom. It was placed on an antique dresser across from my bed in such a way that it's the first thing I see in the morning and the last thing I see at night. I've never moved it. It's a black-and-white portrait of my mother, Katherine, taken when she was just a little older than my

daughter Katherine is now. My mother was living in New York at the time and just beginning her career in theater. So is Katherine. It's a posed publicity shot, and my mother looks serene and pensive. It's not the way I remember her, but I know it's the person she tried to be.

I used to find this picture incredibly glamorous, and I wished I could be as perfect as my mother seemed to be. Now I find it complicated and touching, and I understand that because of her life in drama, and because she shared it so well with me, and because of my merry father's love for words, I have a job that I love and am able to write a book about a program famous for its great drama and exemplary writing.

I think back and see the bookworm that I was, and I see the younger me who used to wander around the house, lost in the fantasy of becoming whatever character I'd seen in a movie, and I see my good luck. I've had the enormous good fortune to grow up and work as I used to play—there's nothing better.

# ACKNOWLEDGMENTS

To name the British producers, directors, writers, and broadcasters who, over the past forty-two years, have made the programs that put *Masterpiece* on the map would be to create a glittering list the size of a phone book. You know and love their work, and it's the very reason *Masterpiece* exists. Many of them appear in this book, but there are some additional people with whom it's been a true pleasure to do business. At the BBC, Ben Stephenson, Kate Harwood, Faith Penhale, Anne Pivcevic, Matt Forde, and Jemma Adkins; at ITV, Kate Bartlett, Kate Lewis, and Tobi de Graaff; and in the risky world of independent producers, Liz Trubridge, Sally Haynes, Sue Vertue, Michele Buck, George Faber, Charlie Pattinson, Justin Thomson-Glover, Louise Pedersen, Hilary Bevan Jones, Jill Green, Pippa Harris, David Thompson, Paula Milne, and Sally Head.

As lucky as I've been in my work, I've been even luckier in the various families I've been a part of throughout my life. Writing this book has allowed me to think long and hard about them.

First among equals: my brother, Jerry, teased me and toughened me when we were kids, as only an older brother can do. I drove him crazy with my goody-goody-ness. Now as adults we talk a lot about

those years, trying to figure out who our parents really were. He is a smart, good man, and we are each other's witnesses to the past. He married beautiful and gentle Karen over forty years ago, and with their sons, "my boys," Timothy and Jeremy, I have always, always felt that I have a home.

Nell Hamlen, Sally Emery, and Anne Dailey—the Emery girls— are independent and strong women. We talk and laugh about our Alabama and Maine roots . . . and about who got the family silver.

To look at my cousin Tom Tinker is to look at my father and to see his wonderful smile. Tom's wife, Rocky, asked me to be her brides-maid years ago when I hardly knew her, signaling that family comes first for her too.

When Paul and I married, I became one of the Coopers, and no one has held me closer than his sister Marga and her husband, Glenn Sproul. Adrian and Daniel, with their wives, Erin and Katie, are, with Katherine, and Grayson, Ethan, and Sarita Schaffer, vital and inter-esting new branches of the Cooper family tree.

Bert Wiesel and luminous Brigitta Kunz Wiesel came into my life through Paul. They have been deeply attentive to the ups and downs of our family and to each of us individually.

Candace McNulty, Serena Eastland, Margo Winslow, and Mary Dick became my co-conspirators very early, and they are still dear friends. Although there is true magic in those girl friendships, I was able to extrapolate and include a grown-up—the sharp and witty Dawn Cobb.

Vassar brought me Ann Ryan Sarowsky, Susan Allard, and Susan Rosenberg McAlden, as well as the Cape Cod crowd. Professors Julia McGrew and Ken Weedin fanned the fire of my love of words, and insisted that I write and speak with clarity.

In my life, Vassar actually *did* merge with Yale, although the two institutions never made it official. As an undergraduate I spent as

much time in New Haven as I did in Poughkeepsie—much to my father's dismay. Those years brought many blessings, in particular Ed Mitchell. Over these forty-three years, Eddie has listened carefully to my sagas, given me free legal advice, made me laugh every time we talk, and lovingly taught me about music, architecture, literature, foreign travel, and food. And he introduced me to Alan Montelibano.

When I eventually got from Pasadena to Boston and walked into WGBH, I struck it rich in friendships. Kate Taylor, Elizabeth Deane, Nancy Porter, Judy Stoia, Paula Apsell, Austin Hoyt, and Susie Dangel joined public broadcasting, too, in those early days. We have all loved the sense of purpose and community it offered us, and even better, we've all loved and supported each other.

Dr. Jeanne Smith, Linda Ward, Deborah Langshaw, Julie Gleason, Victoria Heflin, and Dave Fredette have helped me keep body and soul together.

WGBH has been my professional home and family since 1971, and many, many people there have worked hard to help *Masterpiece* and to help me, none more than Henry Becton.

The station's current president is Jon Abbott, who believes in public broadcasting with an unparalleled fervor, working tirelessly in its interest. He inherited me from Henry, but has always been gracious and helpful to a fault—may The Force be with him. Margaret Drain helped me weather recent storms with great patience and understanding.

Mimi Curran has had the final say in all the *Masterpiece* budgets. No one massages numbers better, or makes them more fun. Win Lenihan and Ellen Frank have helped build the Masterpiece Trust from scratch, and have led me to the loyal donors who support it. They are charm and savvy itself. Sue Kantrowitz and Susan Rosen have guarded *Masterpiece* fiercely, and for years, as our lawyers, they've argued and negotiated for long hours in order to protect it. Alison Kennedy and Chris Pullman have watched over the design of every-

thing *Masterpiece* for as long as I can remember, and Ron Bachman and Kathleen Cahill have been elegant wordsmiths and honest critics.

The WGBH family is of course a member of the larger PBS and CPB family—and *Masterpiece* has had many, many friends in these high places. Paula Kerger, dedicated, modest, and passionate about our mission, is PBS's current president; and Patricia Harrison, with her mixture of skillful diplomacy and candor, is exactly the president and CEO that the Corporation for Public Broadcasting needs these days.

My colleagues at PBS stations all over the country passionately support *Masterpiece* and help their audiences embrace it.

And now there's a *Masterpiece* book. It initially found a home at Viking Penguin because of the excellent relationship we had with Penguin's president and publisher, Kathryn Court, and with its former editor in chief, Stephen Morrison. Stephen introduced me to the powerhouse who would become my Viking editor, Wendy Wolf, who, when we met, fell to her knees in worship of *Masterpiece*, and who has ended up waving her fist at me for my slowness in writing a book about it. Wendy is brisk, knowledgeable, and fearsome in her advocacy. Her assistant editor, Maggie Riggs, has kept all the wheels turning throughout. The designer, Amy Hill, made a beautiful book. Production editor Kate Griggs and director of production Fabiana Van Arsdell efficiently and patiently saw the book through to the last comma. Carolyn Coleburn, Ben Petrone, Nancy Sheppard, and the crack Viking Penguin publicity and marketing team came in near the end, leaving no stone unturned in the book's launch.

Wendy suggested Patricia Mulcahy as my guide and project manager. Patricia has been unfailingly positive and available to me over this past year, pretty much putting her own life on hold. As I wrote this book, she continually reminded me of the story I was trying to tell.

There would be no book without the generosity of all those who shared memories and keen observations: Gillian Anderson, Eileen

Atkins, Russell Baker, Hugh Bonneville, Kenneth Branagh, Katherine Cooper, Paul Cooper, Simon Curtis, Andrew Davies, Julian Fellowes, Sally Haynes, Susan Cooke Kittredge, Bob Knapp, Jean Marsh, Elizabeth McGovern, Steven Moffat, Gareth Neame, Daniel Radcliffe, Diana Rigg, Christopher Sarson, Herb Schmertz, Mary Silverman, and James Wolcott.

At WGBH, David Bernstein shepherded the deal with Viking Penguin; Jeff Garmel championed the book and wrangled all legal aspects to ensure that no laws would be broken, no reputations sullied, and no relationships soured by what I had written. Mary Cahill Farella was the book's first official reader, and as I delivered it to her, timidly and in batches, her gentle and warm enthusiasm kept me writing.

This book simply could not have been written without the efforts of a key group of people at WGBH. They are the ones who make *Masterpiece* successful, book or no book. Every day Susanne Simpson, Steven Ashley, Erin Delaney, Deb Gibbs, Lisa Lokshin, Tsering Yangzom, Ellen Dockser, Olivia Wong, Laura Garvey, Bruce Kohl, Barrett Brountas, Matt Midura, Victoria Yuen, and Gay Mohrbacher think of ways to make *Masterpiece* thrive and blossom. They plow through the petty details, and they come up with the big ideas. They have created a *Masterpiece* family that is smart, honest, creative, thoughtful, attitude-free, fun, and loyal. What a gift to have co-workers whom you look forward to seeing every day. They have patiently tolerated my many absences this year and uncomplainingly picked up the slack. But even more importantly, they are *Masterpiece*'s most knowlegeable and devoted fans.

My thanks and love go to all of them. Especially to Steven.

# INDEX

# ILLUSTRATION CREDITS